Photo Editing on the iPad® for Seniors

Studio Visual Steps

Photo Editing on the iPad® for Seniors

Have fun and become a photo editing expert on your iPad

www.visualsteps.com

This book has been written using the Visual Steps™ method.
Cover design by Studio Willemien Haagsma bNO

© 2015 Visual Steps
Author: Studio Visual Steps

First printing: March 2015
ISBN 978 90 5905 731 9

Resources used: A number of definitions and explanations of computer terminology are taken over from the *iPad User Guide.*

Do you have questions or suggestions?
Email: info@visualsteps.com

Would you like more information?
www.visualsteps.com

Website for this book:
www.visualsteps.com/photoipad

Subscribe to the free Visual Steps Newsletter:
www.visualsteps.com/newsletter

Table of Contents

Foreword

You can do lots of different things on the iPad. But surely one of the most popular and enjoyable activities is working with photos. The apps that are available for photo editing will help you turn your photos into gorgeous pictures that can be saved or shared with others. And what about creating a collage, slideshow, or a photo album? With this user-friendly book you will be able to jump right in and create your own projects in no time at all.

You will be using a number of apps that can be downloaded for free. These apps offer numerous options for editing your photos. And if you want to have even more options, you can purchase other apps or additional options at quite a low cost. You will learn how to work with the apps by following our clear, step-by-step instructions, and by using a set of practice photos. The knowledge and skills you acquire will help you feel at ease editing your own photos later on. You will be surprised to find out what things you can do with the photos on your iPad.

Yvette Huijsman
Studio Visual Steps

P.S. We welcome your comments and suggestions.
Our email address is: info@visualsteps.com

Visual Steps Newsletter

All Visual Steps books follow the same methodology: clear and concise step-by-step instructions with screenshots to demonstrate each task.
A complete list of all our books can be found on our website **www.visualsteps.com**
You can also sign up to receive our **free Visual Steps Newsletter**.
In this Newsletter you will receive periodic information by email regarding:
- the latest titles and previously released books;
- special offers, supplemental chapters, tips and free informative booklets.

Our Newsletter subscribers may also download the free informative guides and booklets listed on the web page **www.visualsteps.com/info_downloads.php**

Introduction to Visual Steps™

The Visual Steps books are the best instructional materials available for learning how to work with mobile devices, computers and software applications. Nowhere else can you find better support for getting to know an iPad, the Internet, *Windows*, *Mac*, Samsung Galaxy Tab and various software applications.

Characteristics of the Visual Steps books:
- **Comprehensible contents**
 Addresses the needs of the beginner or intermediate computer user for a manual written in simple, straight-forward English.
- **Clear structure**
 Precise, easy to follow instructions. The material is broken down into small enough segments to allow for easy absorption.
- **Screenshots of every step**
 Quickly compare what you see on your screen with the screenshots in the book. Pointers and tips guide you when new windows are opened so you always know what to do next.
- **Get started right away**
 All you have to do is turn on your iPad and have your book at hand. Perform each operation as indicated on your own device.
- **Layout**
 The text is printed in a large size font and is clearly legible.

In short, I believe these manuals will be excellent guides for you.

Dr. H. van der Meij
Faculty of Applied Education, Department of Instructional Technology, University of Twente, the Netherlands

Website

This book is accompanied by a website: **www.visualsteps.com/photoipad**
Check this website regularly, to see if we have added any additional information, supplemental chapters or errata for this book.

What You Will Need

In order to work through this book, you will need a number of things:

An iPad 2, a third generation iPad, a fourth generation iPad, iPad Air, iPad Air 2, iPad mini, iPad mini 2, or iPad mini 3 with Wi-Fi or 3G/4G.

If you have a more recent iPad model, you can probably still use this book. If necessary, you can find additional information on **www.visualsteps.com/photoipad**

An *Apple ID* for downloading apps.

Optional:

A stylus pen. This is a special pen that can be used on your iPad. It lets you click and select items more accurately than with your fingers.

An *iTunes Gift Card*. You can use this card if you want to purchase an app. In *Chapter 2 Other Photo Editing Apps* you can read more about this subject.

Your Level of Knowledge

In order to work with this book, you will need to have basic skills for operating an iPad. You should feel comfortable doing the following activities:
- tapping and dragging;
- typing on the onscreen keyboard;
- opening and closing apps;
- downloading apps;
- opening photos;
- going back to the previous screen, or to the home screen.

If you are new to an iPad and do not yet possess these skills, you can visit the **www.visualsteps.com** website to view a list of the books available for the iPad.

How to Use This Book

This book has been written using the Visual Steps™ method. The method is simple: place the book on a surface where you can easily read it. Hold you iPad and perform each task as described, step by step, directly on your own device. With the clear instructions and the multitude of screenshots, you will always know exactly what to do next. By working through all the tasks in each chapter, you will gain a full understanding of photo editing on your iPad.

In this Visual Steps™ book, you will see various icons. This is what they mean:

Techniques
These icons indicate an action to be carried out:

 The index finger indicates you need to do something on the iPad's screen, for instance, tap something, or type a text.

 The keyboard icon means you should type something on the keyboard of your iPad or your computer.

 The mouse icon means you need to do something on your computer by using the mouse.

 The hand icon means you should do something else, for example, rotate the iPad, or turn it off. It can also point to a task previously learned.

In some areas of this book additional icons indicate warnings or helpful hints. These may help you avoid common mistakes and will alert you when a decision needs to be made.

Help
These icons indicate that extra help is available:

 The arrow icon warns you about something.

 The bandage icon will help you if something has gone wrong.

 The hand icon is also used for the exercises. The exercises can be found at the end of each chapter. By repeating the activities described in the chapter, you gain confidence and feel more at ease performing certain tasks.

1 Have you forgotten how to do something? The number next to the footsteps tells you where to look it up at the end of the book in the appendix *How Do I Do That Again?*

In separate boxes you will find tips or additional background information.

Extra information
Information boxes are denoted by these icons:

 The book icon indicates extra background information that can be read at your own convenience. This extra information is not necessary for working through the book.

 The light bulb icon indicates an extra tip for using the iPad.

Test Your Knowledge

After you have worked through this book, you can test your knowledge online, on the **www.ccforseniors.com** website.

By answering a number of multiple choice questions you will be able to test your knowledge of the iPad. Participating in the test is **free of charge**. The computer certificate website is a free service offered by Visual Steps.

For Teachers

The Visual Steps books have been written as self-study guides for individual use. They are also well suited for use in a group or a classroom setting. For this purpose, some of our books come with a free teacher's manual. You can download the available teacher's manuals and additional materials from the website: **www.visualsteps.com/instructor**

The Screenshots

The screenshots in this book indicate which button, file, or hyperlink you need to tap on your screen. In the instruction text (in **bold** letters) you will see a small image of the item you need to tap. The lines will point you to the right place on your screen.

The small screenshots that are printed in this book are not meant to be completely legible all the time. This is not necessary, as you will see these images on your own iPad's screen in real size and fully legible.

Here you see an example of an instruction text and a screenshot of the item you need to tap. The lines indicate where to find this item on your own screen:

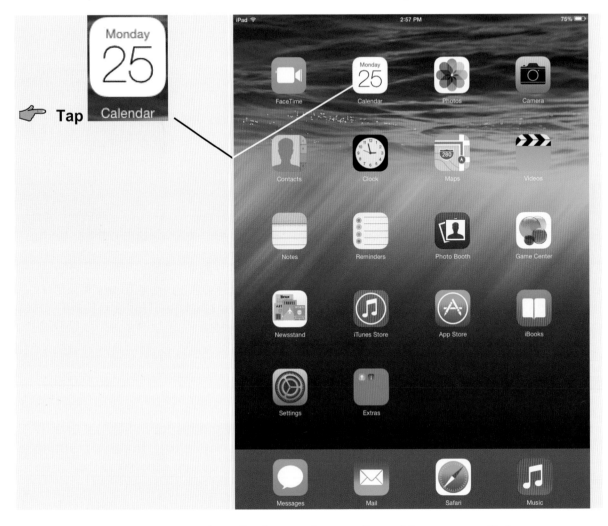

In some cases, the screenshot displays only a portion of the screen. Below you see an example of this:

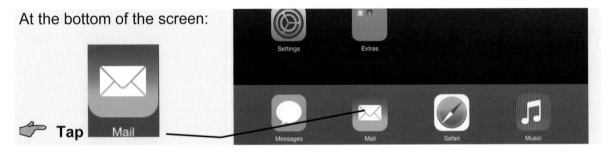

We would like to emphasize that we **do not intend you** to read the information in all of the screenshots in this book. Always use the screenshots in combination with the larger display on the screen of your iPad.

1. Photo Editing with Aviary

In the old days, you may have thrown away a photo that was improperly exposed or where the main object appeared slanted. Nowadays you can use photo editing software on your computer to correct these imperfections. There is also an ever increasing amount of photo editing apps available for your iPad. The options in these apps are usually a bit more basic than the options on your computer, but have enough features to handle the most common photo editing requirements. The results are sufficient for making prints or creating slide shows.

There are limits to the possibilities of such apps. If a picture has been taken with a low resolution and you try to enlarge a specific area of the photo, the results will be disappointing. A faulty exposure can be corrected, but the results would have been better if the exposure had been set right in the first place. Even if you have taken a good picture, some correction may still be necessary. For instance, the red eyes that occur when using the flash or when a certain hue (color cast) dominates the photo. A photo editing app can correct these faults automatically and may also offer options for more subtle, manual correction or further fine-tuning.

There are several apps you can use for this purpose. In this chapter you will get acquainted with the *Aviary* app.

In this chapter you will learn how to:

- enhance and crop photos automatically;
- use the Focus function;
- rotate and straighten photos;
- sharpen or blur photos;
- apply manual corrections;
- add text and titles;
- use color effects;
- correct red eye;
- retouch photos;
- make photos whiter;
- blur parts of a photo;
- delete a photo.

 Please note:

In order to follow the steps in this book, you will need to transfer the practice photos that can be downloaded from the website to your iPad. In *Appendix B Download the Practice Files* at the end of this book you can read how to do this step by step.

1.1 Opening a Photo

The first app you will be using is the *Aviary* app. You need to download and install the app onto your iPad. In the *App Store*, you can search for the app named *Photo Editor by Aviary*. Once the app has been downloaded, it is simply called *Aviary*:

☞ **Download the** [Photo Editor by Aviary — Aviary ★★★★☆ (375)] **app** 👣¹

When the app is downloaded, a new icon will appear on your iPad's Home screen, or on the next page (depending on the number of apps you have already installed).

☞ **Press the Home button** ⬛

☞ **Open the *Aviary* app** 👣²

The screenshots of the *Aviary* app that were made for this book show the iPad held in landscape mode. We recommend you hold the iPad in the same way (horizontally). The images on your screen will then be similar to the screenshots in this book:

☞ **If necessary, rotate the iPad a quarter turn**

This is how you open a photo:

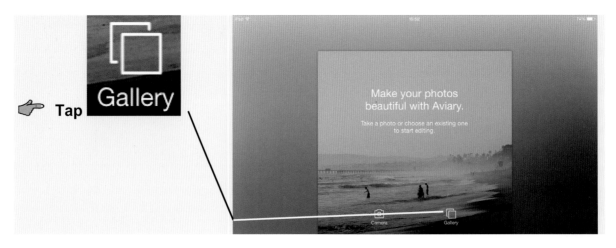

👉 **Tap** Gallery

To function optimally, *Aviary* needs to access the photos on your iPad:

☞ **Tap**
Give Access

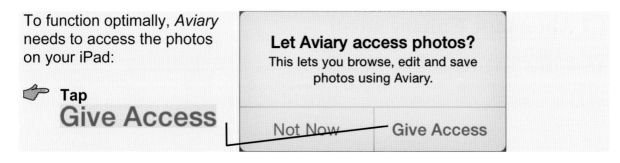

You need to confirm this request:

☞ **Tap** OK

Select the album with the practice photos:

☞ **Tap**
Practice Photos

The photos are displayed. Open a photo:

☞ **Tap**

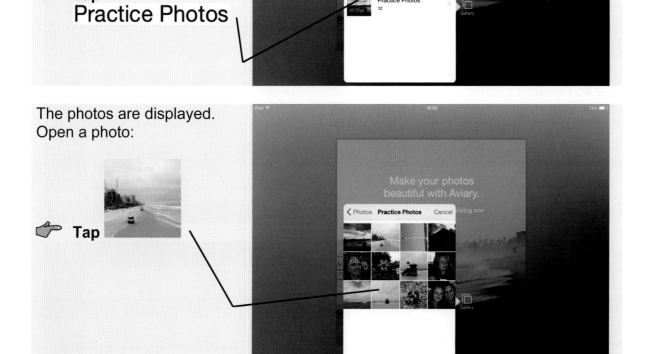

The photo will be displayed on the screen, in a larger format.

1.2 Automatic Enhancement

Aviary has a function that allows you to enhance a photo automatically.
This means you will not need to correct the exposure and colors by hand.
It is best to start by using this function, and then apply manual corrections afterwards, if necessary.

 Please note:

Various functions can be performed by tapping the icons shown at the bottom of your screen in the *Aviary* app. If a particular icon is not in view, just drag the toolbar from right to left, until you see the desired icon.

Here you see the photo you opened in the previous section, and the toolbar below showing the icons that represent the various editing tools:

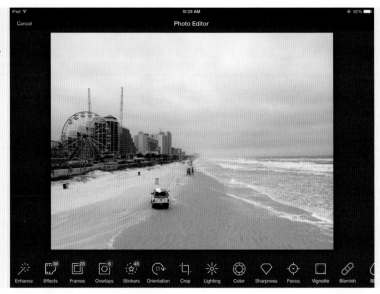

In this step, you can practice using the enhance tool:

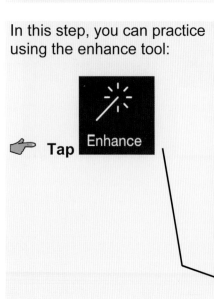

☞ **Tap**

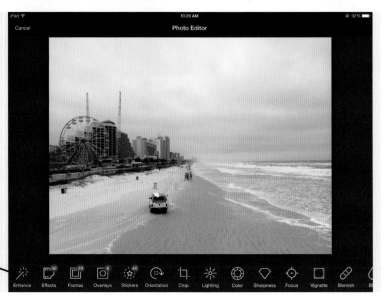

You can choose between various options. Try the Scenery option:

👉 **Tap**

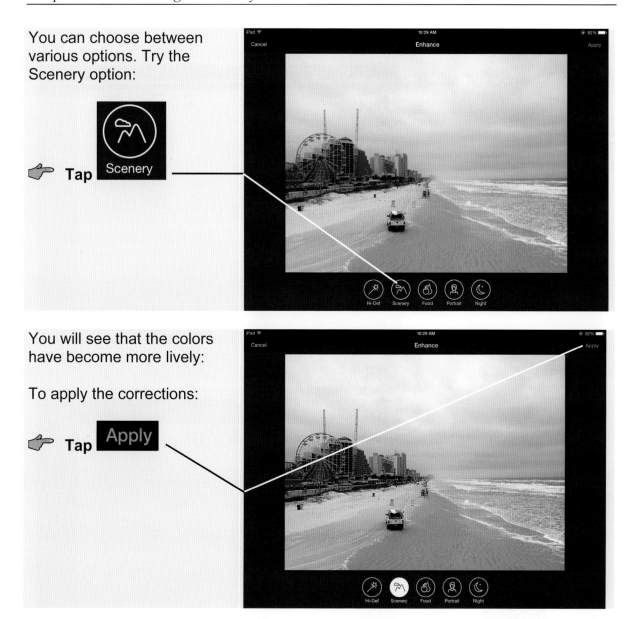

You will see that the colors have become more lively:

To apply the corrections:

👉 **Tap** Apply

1.3 Undo

Once you have applied an edit, it is still possible to undo it. You may see a screen tip about this subject:

👉 **Tap the screen**

Swipe to undo or redo edits

This is how you undo an edit:

☞ **Drag across the screen from left to right** ——————

The edit will be undone and the original, bleaker color can be seen again.

Here you see the text

Undo :

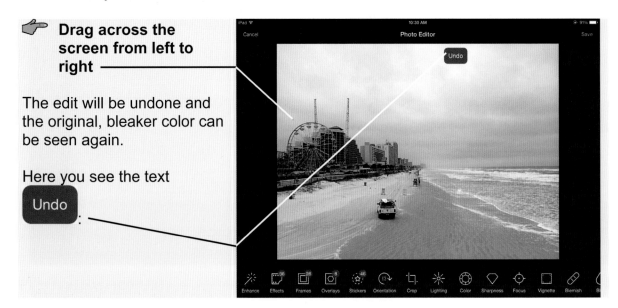

You can also redo the edit:

☞ **Drag across the screen from right to left** ——————

By doing this, you apply the edit once more. You will see the more brighter colors again:

Now try another type of correction:

☞ **Tap Enhance** ——————

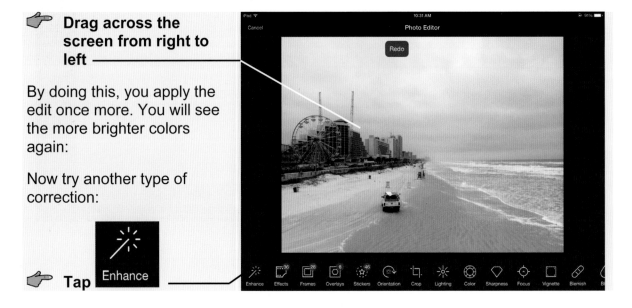

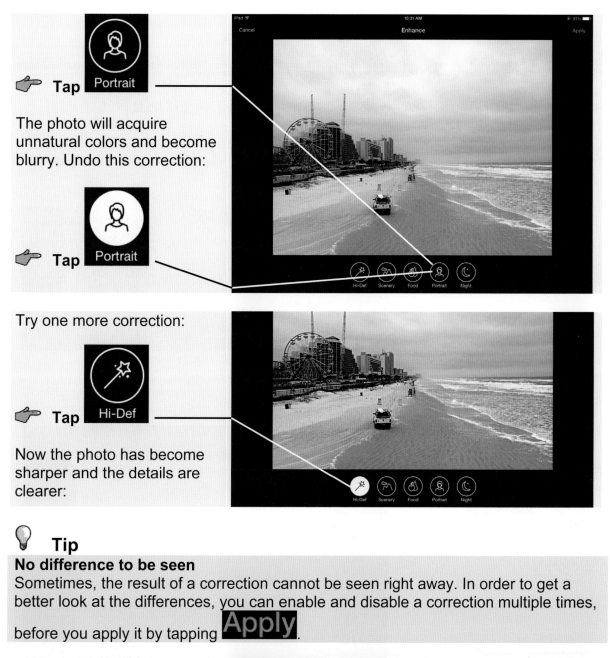

Tap Portrait

The photo will acquire unnatural colors and become blurry. Undo this correction:

Tap Portrait

Try one more correction:

Tap Hi-Def

Now the photo has become sharper and the details are clearer:

💡 Tip

No difference to be seen
Sometimes, the result of a correction cannot be seen right away. In order to get a better look at the differences, you can enable and disable a correction multiple times, before you apply it by tapping Apply.

Apply the correction:

Tap Apply

The edits have been applied to the photo, but have not yet been saved. Once you are completely done, you can save the photo on your iPad.

1.4 Cropping

A photo often contains more information than the actual subject. You may even find it useful to include larger parts of the surroundings in your pictures, as you can always crop a photo with a photo editing app later on and save only the best part.

On the practice photo you see Daytona Beach and on the left a carnival. A lifeguard truck is driving across the beach. You can try using the cropping tool to eliminate some of the sea.

By default, the entire picture is shown within a frame. You can select a different aspect ratio, if you want:

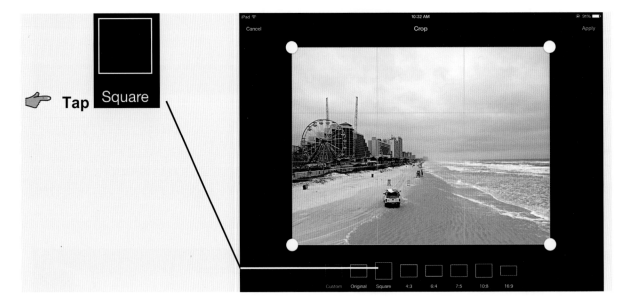

 Tip

Which aspect ratio do you select?
When you select an aspect ratio, keep in mind the type of screen you want to use to view the photos later on. Or if you want to print your photos, how large do you want them to be. Since the emergence of the *Instagram* online photo service, the square format has become very popular. Nowadays, most print services offer square prints in various sizes, such as 4x4 inches (10x10 cm) and 5x5 inches (13x13 cm). In *Chapter 5 Sharing Your Photos* you can read more about *Instagram*.

Now you can see that a square frame surrounds the photo:

The handles in the corners can be moved:

☞ **Drag the handle in the upper right corner downwards**

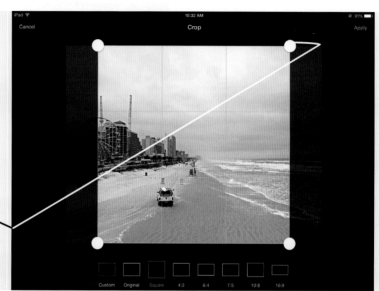

You can also move the entire frame:

☞ **Place your finger in the frame**

☞ **Drag the frame to the left**

If you are satisfied with the size and position of the frame:

☞ Tap

The photo has been cropped:

1.5 Using Focus

With the Focus tool you can make part of the photo sharper, while the surroundings become blurred:

The area within the round frame will stay sharp: ————

The frame will disappear after a while.

This is how you create a rectangular frame:

👉 **Tap** Linear

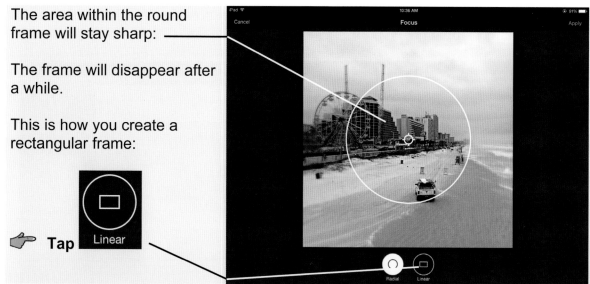

With the rectangular frame, the effect is less clearly visible:

Go back to the round frame:

👉 **Tap** Radial

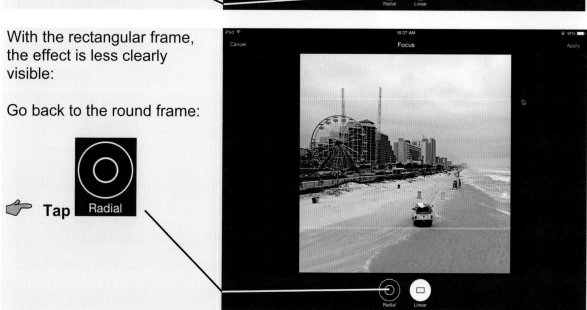

By adjusting the size and position of the frame, you can create some interesting and unexpected effects. Just give it a try:

 Place your thumb and index finger on the photo

It does not matter very much which part of the photo you touch.

 Move your thumb and index finger towards each other

The round frame appears again, and becomes smaller:

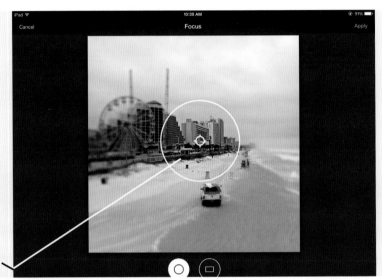

 Resize the frame and make it the same size as in this example

 Drag the frame on top of the car

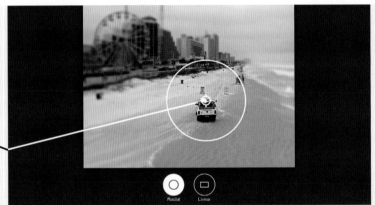

Now the car is in focus and the surroundings are hazy:

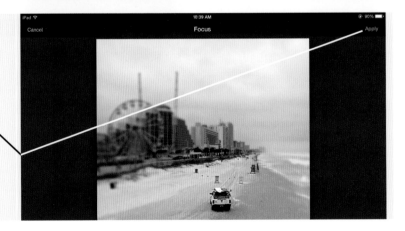 **Tap Apply**

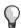 **Tip**

Rectangular frame

You can adjust the size and position of the rectangular frame in the same way as the circular frame.

If you rotate your thumb and index finger, the frame will rotate too, and appear slanted:

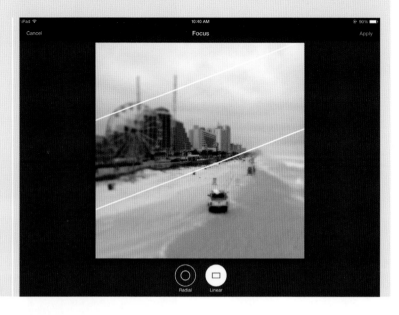

After you have finished editing the photo, you can save it as follows:

☞ **Tap** Save

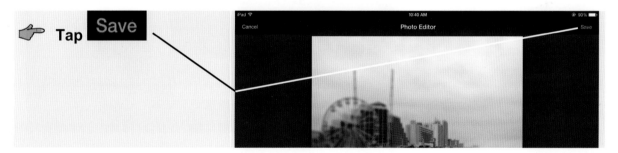

When you save a photo, you may see a message saying that the photo will be saved to your Camera Roll:

☞ **If necessary, tap Finish and Share**

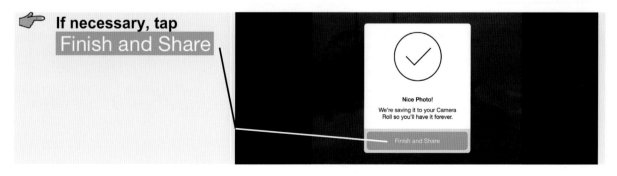

You can share the photo on social media right away, or send it by email:

If you just want to save the photo on your iPad:

☞ **Tap** **Done**

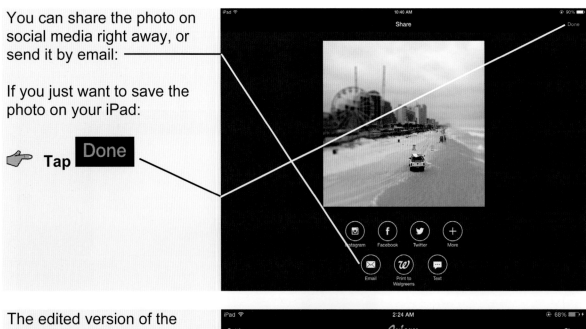

The edited version of the photo will be saved separately:

This means the original photo will be preserved as well.

Please note: the photos on your screen may be arranged in a different order.

1.6 Rotate and Straighten Photos

Photos that are not displayed in the right direction can easily be rotated. Here is how you rotate a photo:

☞ **Open the photo** 👣³

 # HELP! I see an ad.

Aviary is a free app. The developers get their revenues by offering additional tools and functions for a fee (so-called *in-app purchases*). Because of this, you will occasionally see some advertisements.

If you do not want to download the additional functions:

☞ **Tap**

This picture was taken in the vertical (portrait) position, but is displayed here in the landscape position. You can change this:

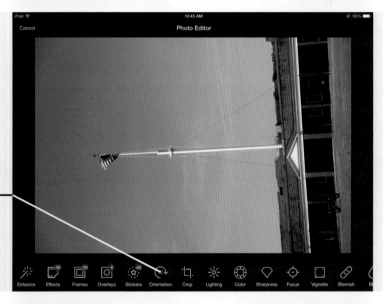

☞ **Tap**

Rotate the photo to the right:

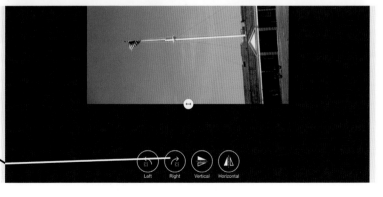

☞ **Tap**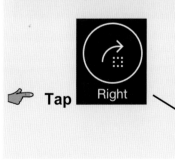

Now the photo is vertical:

With the [Vertical] and [Horizontal] buttons you can mirror the photo:

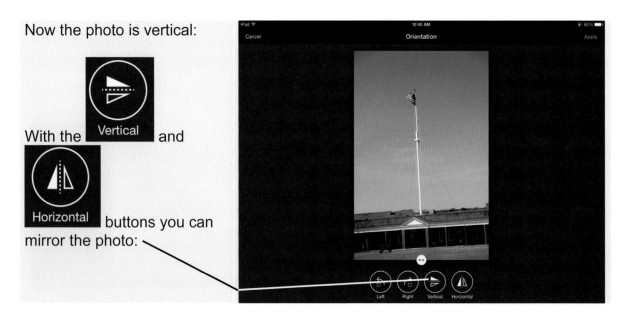

The building and flagpole in this photo appear slanted. In order to straighten them:

☞ **Drag ⟷ to the left a bit**

You will see a grid that will help you straighten the objects:

If you try to line up the white trim on the building along one of the horizontal lines, the flagpole will be straightened as well:

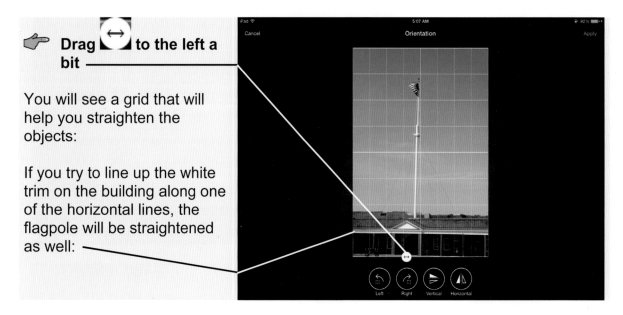

Now the building and the flagpole are straightened:

 Tap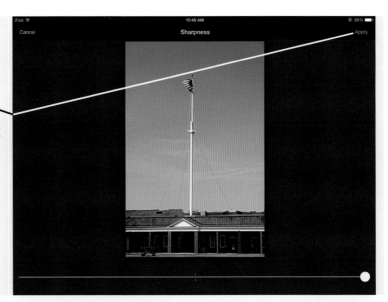

The portion of the picture that remains is shown within the clear frame. The rest will be cut off. This means a small portion of the original photo will disappear.

Here is the result:

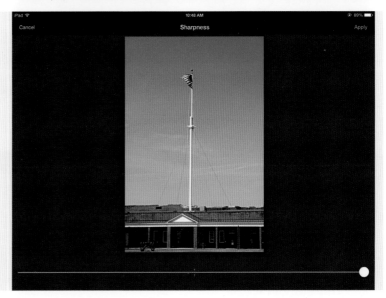

1.7 Sharpening or Blurring Photos

Pictures that have been taken from a great distance are not always sharp. Here is how to sharpen or blur a photo:

☞ Tap **Sharpness**

In order to clearly see the effect, you can zoom in on the flag:

☞ **Spread your thumb and index finger**

☞ **Drag the photo until you see the flag**

You can see that the flag is not completely in focus:

You can use the slider shown in the lower part of the photo to make the photo sharper or more blurry:

 Drag the slider to the left a bit ———

The photo becomes blurry:

 Drag the slider to the right ———

The photo becomes sharper:

Zoom out again:

Move your thumb and index finger towars each other (pinch)

Now you see the full picture:

Apply the edit:

Tap Apply

Do not save the edited photo:

👉 Tap Cancel

Aviary will ask if you want to stop or continue editing the photo:

👉 **Tap**

Leave editor

Your edits have not been saved.

Tip: You can always swipe on the
photo to undo or redo.

Leave editor Keep editing

You will see the photos overview screen again.

1.8 Manual Corrections

Along with the tools for automatic enhancement that you practiced using in *section 1.2 Automatic Enhancement*, there are plenty of other options to manually correct your photos.

👉 **Open the photo** ℘³

The house shown in this practice photo is quite dark. You can improve this by increasing the brightness:

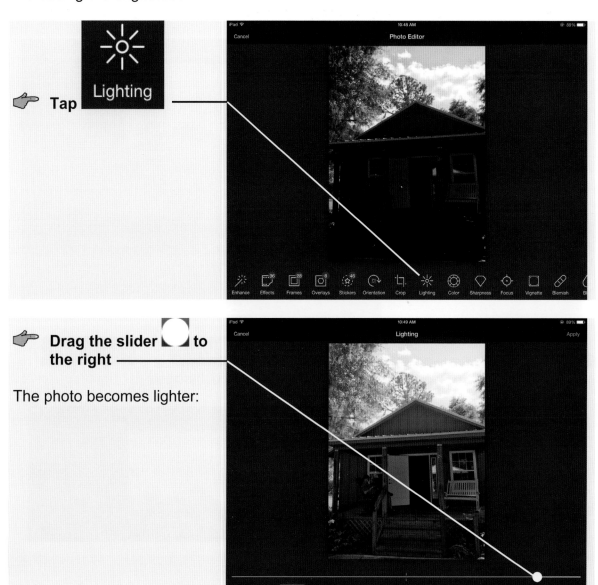

☞ **Tap** Lighting

☞ **Drag the slider ⬤ to the right**

The photo becomes lighter:

Now the house and the person on the porch can be seen more clearly. But the photo still looks a bit faded. You can change this by slightly increasing the contrast between the darker and lighter areas of the photo:

Tap **Contrast**

Drag the slider to the right

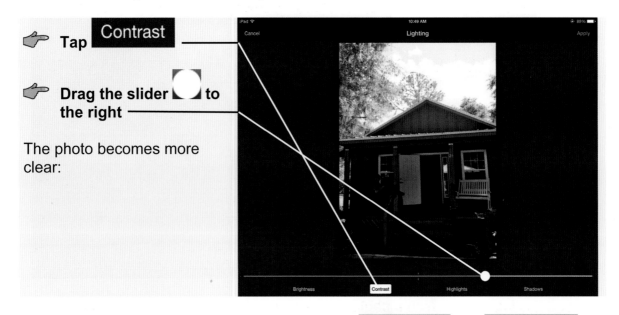

The photo becomes more clear:

On the next photo you can practice adjusting the **Shadows** and **Highlights** (red/blue balance). Close this photo and do not save the changes:

Tap **Cancel**

Tap **Cancel** once again

You will see the photo overview again.

Open the photo

This picture was taken in a hall, prior to a concert. The red lighting in the hall has caused the photo to have a dominant red hue.

👉 **Tap** Lighting

Before adjusting the colors in a photo you need to adjust the lighting first. The faces are a little too bright:

The **Brightness** function is automatically selected:

👉 **Drag the slider ◯ to the left**

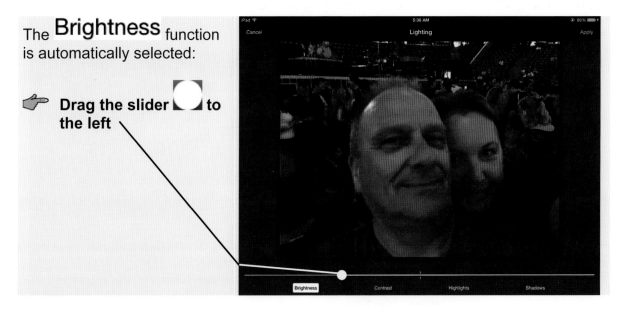

Brightness and contrast always go hand in hand. If you diminish the brightness, you will need to diminish the contrast too, just a little at a time.

☞ Tap Contrast

☞ Drag the slider ⬤ to the left

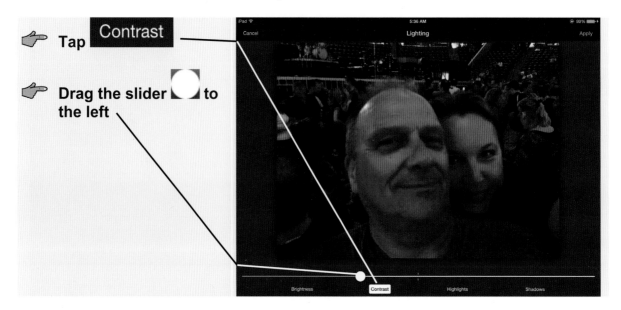

The balance between red and blue can be adjusted with the Highlights function. This photo is too warm (red) and can be improved by adding blue:

☞ Tap Highlights

☞ Drag the slider ⬤ all the way to the left

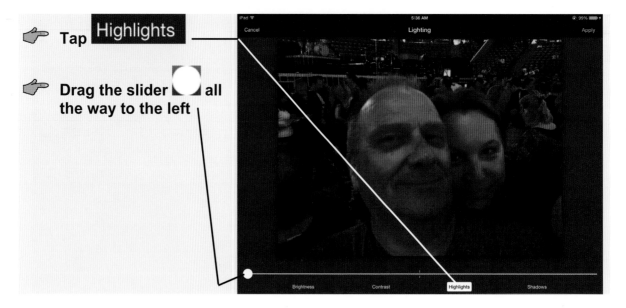

The last thing you can change is the saturation:

☞ Tap **Shadows**

☞ **Drag the slider** 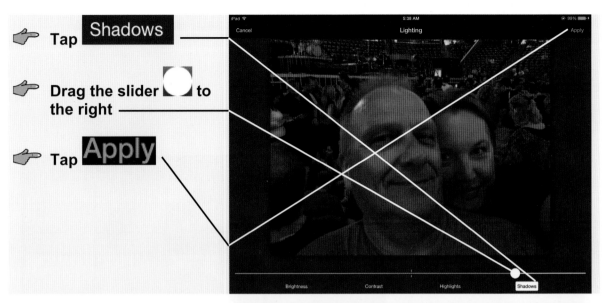 **to the right**

☞ Tap **Apply**

You will see the result of all your edits:

After all the edits have been applied, the photo turns out to be a bit lighter than the example you saw before you tapped **Apply**.

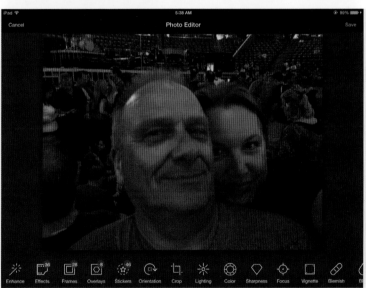

The photo has really improved a lot. Now you can take a look at the difference between the original and the edited photo, by undoing the edits:

☞ **Drag across the screen, from left to right**

You will see the red, unedited photo. In order to apply the edits again:

☞ **Drag across the screen, from right to left**

You will see the edited photo again.

The photo is far from perfect, and will probably never become a great picture. You can still see a red haze, and the photo is not sharp. You could try editing the photo further, but for now this will not be necessary. You can save the edited photo:

☞ **Tap** `Save`

☞ **Tap** `Done`

You will see the overview again, with the edited photo:

1.9 Adding Lines and Text

Not only can you edit your photos, you can also add text or draw something on them. You can try this using another photo:

☞ **Open the photo** $\mathscr{C}\!\mathscr{C}^3$

First, you can try cropping the photo, to remove the board shown on the right:

☞ **Tap** `Crop`

Crop the photo using its original ratio:

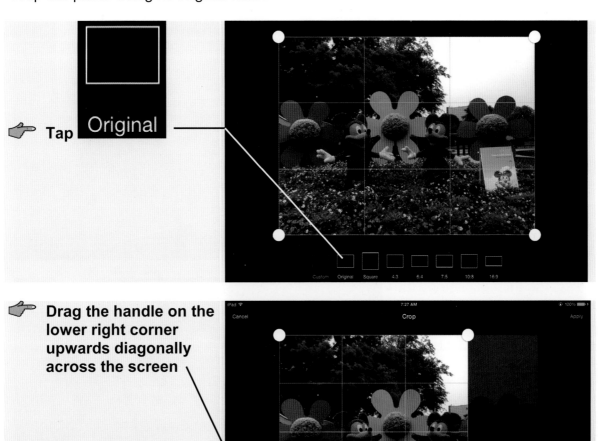

☞ **Tap** Original

☞ **Drag the handle on the lower right corner upwards diagonally across the screen**

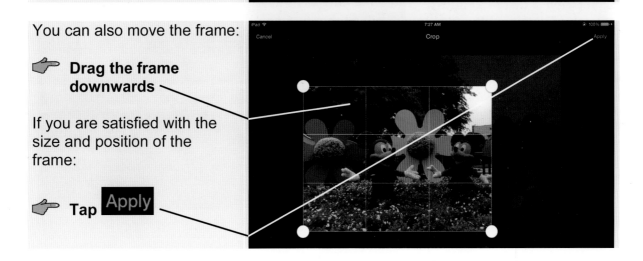

You can also move the frame:

☞ **Drag the frame downwards**

If you are satisfied with the size and position of the frame:

☞ **Tap** Apply

The photo has been cropped. Now you can draw a line. You may not see the icon:

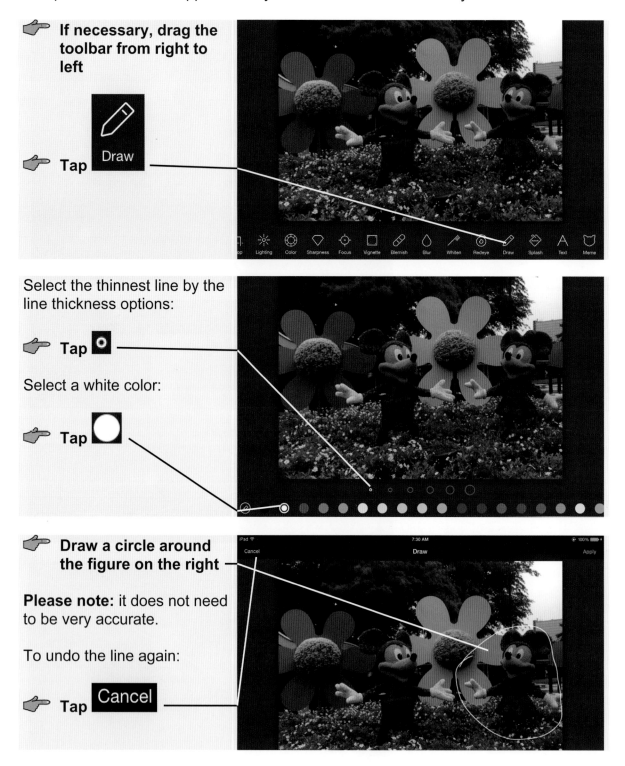

☞ **If necessary, drag the toolbar from right to left**

☞ **Tap** Draw

Select the thinnest line by the line thickness options:

☞ **Tap** ⊙

Select a white color:

☞ **Tap** ⬤

☞ **Draw a circle around the figure on the right**

Please note: it does not need to be very accurate.

To undo the line again:

☞ **Tap** Cancel

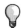 **Tip**

Use the stylus pen

For more precise work you can use a stylus pen. This is a little pen with a rubber tip that is suited for the iPad. In the *Background Information* at the end of this chapter you can read more about the stylus pen.

Here is how you add text to a photo:

☞ **If necessary, drag the toolbar from right to left**

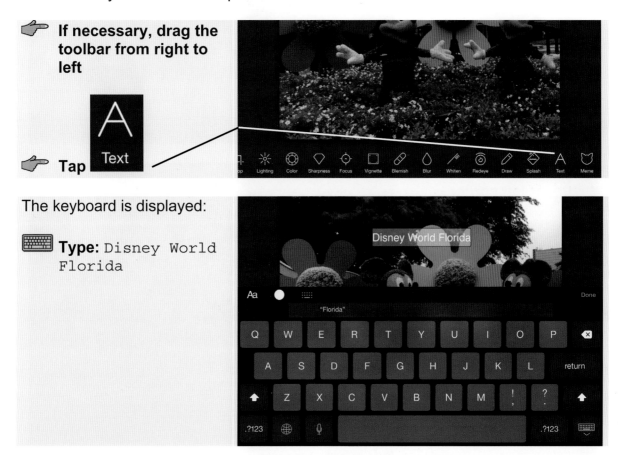

☞ **Tap** Text

The keyboard is displayed:

⌨ **Type:** Disney World Florida

Adjust the text color:

☞ **Tap** ⬤

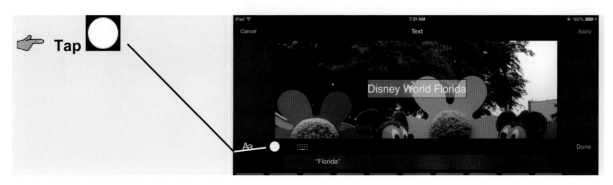

Select a light blue color:

☞ **Tap**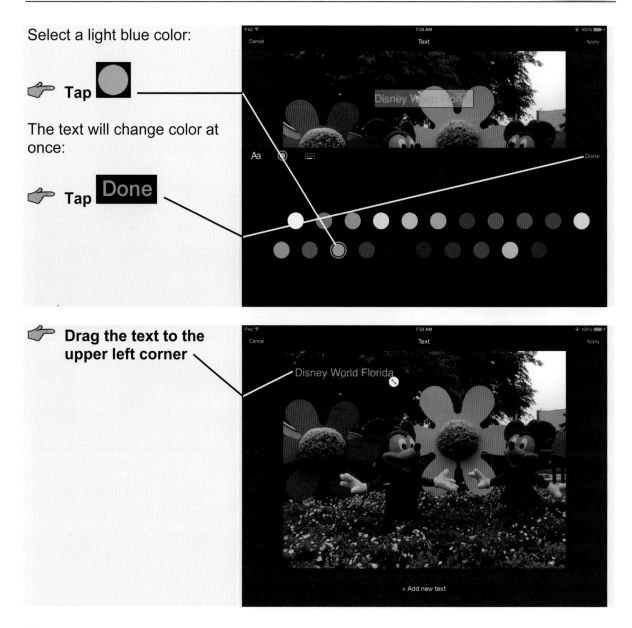

The text will change color at once:

☞ **Tap Done**

☞ **Drag the text to the upper left corner**

You can enlarge the letters like this:

☞ **Drag outwards to the right**

To slant the text to the left:

☞ **Drag** ⟲ **upwards**

☞ **Tap** Apply

You will see the edited photo. You do not need to save it:

☞ **Tap** Cancel

☞ **Tap**

Leave editor

Your edits have not been saved.

Tip: You can always swipe on the
photo to undo or redo.

Leave editor Keep editing

1.10 Effects with Color Settings

With the Splash tool you can change the photo to a black and white picture, and then
slowly bring back one or more colors.

☞ **Open the photo** ✂3

This is a photo of a lifeguard station on Siesta Beach in Florida. The photo is a bit grey. You can quickly change this with the Enhance tool:

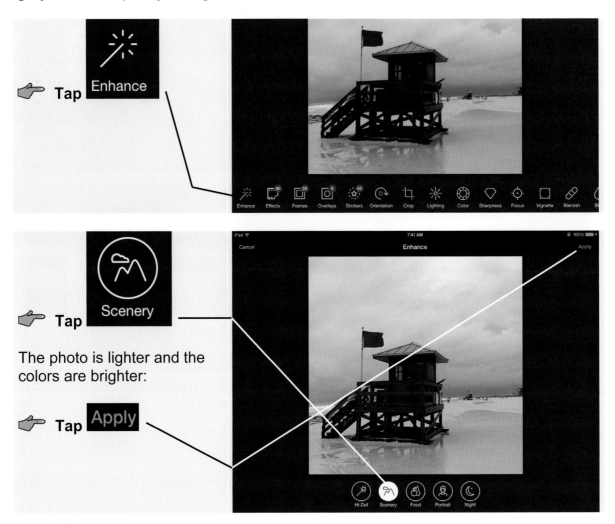

Tap Enhance

Tap Scenery

The photo is lighter and the colors are brighter:

Tap Apply

Now you can try the Splash tool:

If necessary, drag the toolbar from right to left

Tap Splash

You will see a one-time-only tip about the settings for this tool:

Free Color is a setting that displays all the colors in the selected area again: ————

Smart Color will only display the color in the photo that is tapped first: ————

The rest of the photo will remain black and white.

 Tap the screen

By default, the Free Color setting is selected:

Zoom in on the flag:

 Spread your thumb and index finger

 Drag the photo with <u>two fingers</u>, until you can clearly see the flag

 ## HELP! I see a color.

Have you had a problem zooming in, and have colors started to appear? If this happens, you may not have placed both fingers on the screen at exactly the same time.

 Tap Cancel

Tap Splash

☞ **Try again**

You can also zoom in first, and then activate the Splash tool.

💡 Tip

Use the stylus pen
If you want to work more precisely, it is best to use a stylus pen to swipe across the screen.

👉 **Swipe across the flag**

The colors will return:

Usually, you can swipe outside of the area a little bit, as you see here, around the flag:

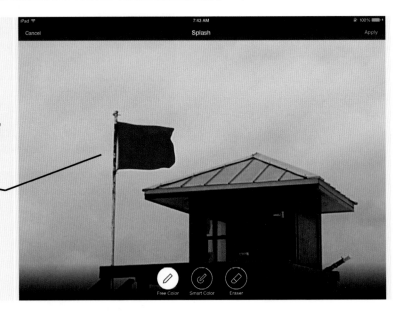

In order to remove the colors surrounding the flag you can use the eraser:

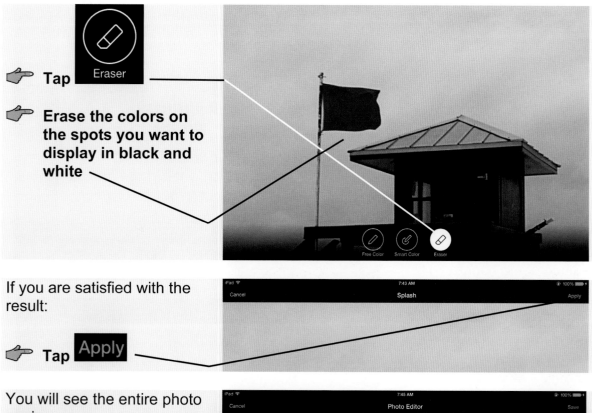

👉 **Tap** Eraser

👉 **Erase the colors on the spots you want to display in black and white**

If you are satisfied with the result:

👉 **Tap** Apply

You will see the entire photo again:

You may have noticed that it is hard to be precise when swiping, even when you use the stylus pen and zoom in. You can undo this edit:

👉 **Drag across the photo, from left to right**

The Smart color option only displays the color you have selected first:

 👉 **Tap** Splash

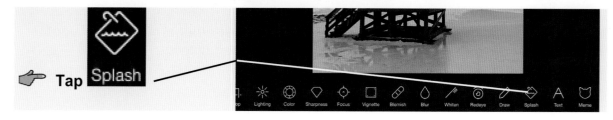

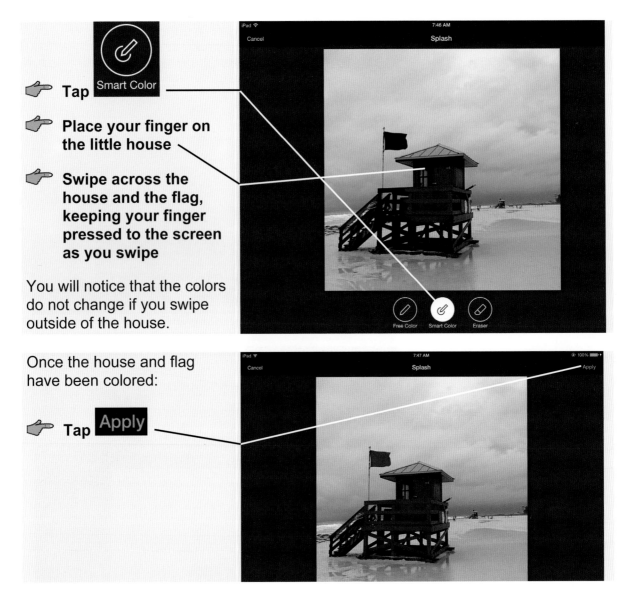

☞ **Tap** Smart Color

☞ **Place your finger on the little house**

☞ **Swipe across the house and the flag, keeping your finger pressed to the screen as you swipe**

You will notice that the colors do not change if you swipe outside of the house.

Once the house and flag have been colored:

☞ **Tap** Apply

 HELP! I see other colors as well.

There can be various reasons for other colors being displayed:

- You have not been precise enough in selecting the right color. It is best to erase the colors and try again.
- You have lifted your finger off the screen and placed it on another color. From that moment on, the other color has been selected.
- Many of the colors are mixed colors. If you swipe over other areas, part of another color may still be displayed. Try to erase the unwanted colors.

Save the photo and the edits:

👉 **Tap** Save

👉 **Tap** Done

You will see both the edited
and the original photo:

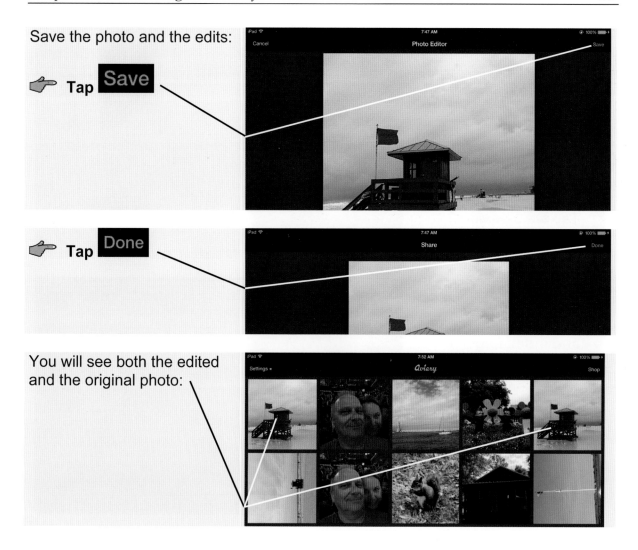

1.11 Correcting Red Eye

When you use flash, the eyes in a photo can become red. Nowadays, many cameras
have a 'red eye function' that will prevent this from happening. If you do not have this
function, or have not enabled the function while taking the picture, you can correct
the red eye effect:

👉 **Open the photo**

You will see the red eyes:

☞ **If necessary, drag the toolbar from right to left**

☞ **Tap** Redeye

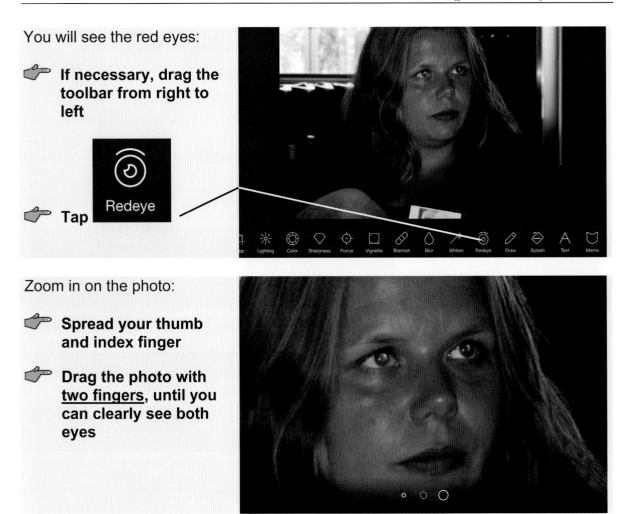

Zoom in on the photo:

☞ **Spread your thumb and index finger**

☞ **Drag the photo with two fingers, until you can clearly see both eyes**

Enlarge the brush, so as to fit the entire pupil:

☞ **Tap**

☞ **Tap the eye on the left**

The correction for this photo cannot be applied in just a single action:

☞ **Tap the eye on the left five more times**

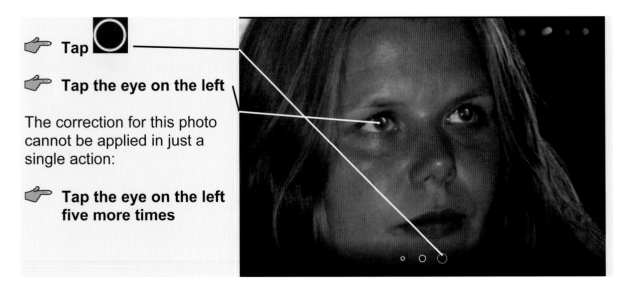

 Please note:

The Red eye function replaces the red color in the eye by grey or black. In order to achieve the best results, the eye needs to be bright red and the red area needs to be accurately tapped. If you use the practice photos you will need a few taps to adjust the eye, and even then you might still see some red. You may achieve faster results with your own photos. Animal eyes cannot be corrected since they do not light up in red, but in another color.

Correct the other eye as well:

☞ **Tap the eye on the right six times**

The right eye has been corrected too:

☞ **Tap** Apply

You will see the result:

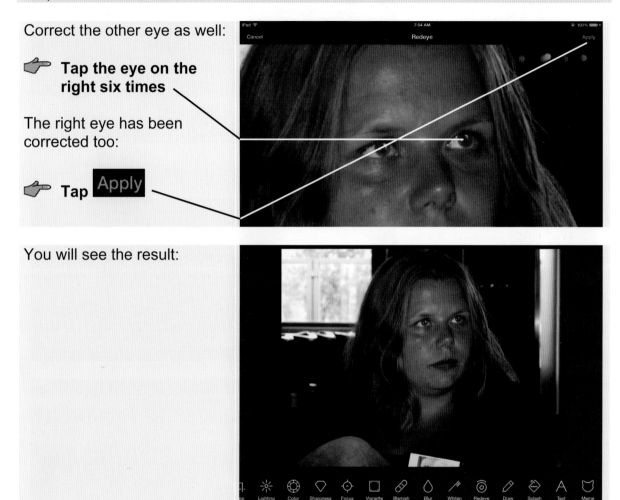

1.12 Retouching

Retouching means correcting small imperfections, such as a bothersome smudge or scratch. To correct this in *Aviary* you can use the Blemish tool. You may not see the Blemish icon right away:

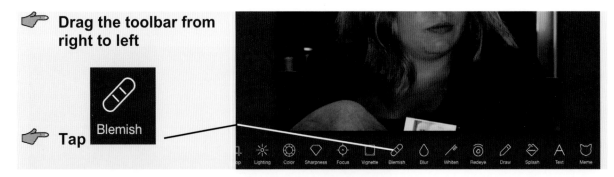

☞ **Drag the toolbar from right to left**

☞ **Tap** Blemish

If you are using the tool for the very first time, you will see an information tip:

☞ **Tap the screen**

Tap imperfections to remove.
You can also pinch to zoom in!

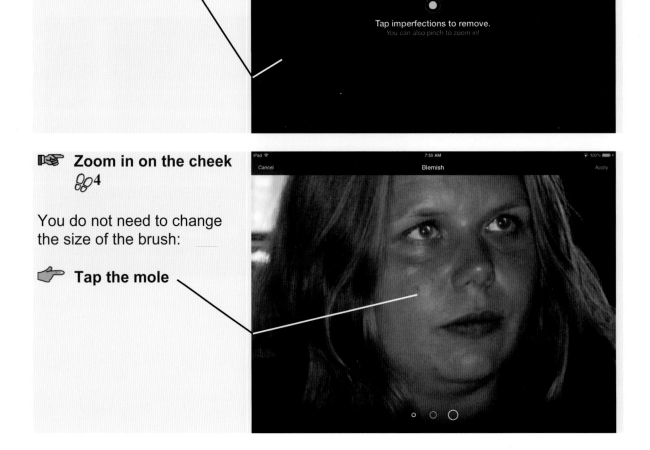

☞ **Zoom in on the cheek** 𝒪𝒪4

You do not need to change the size of the brush:

☞ **Tap the mole**

The mole has been corrected:

If the spot has not completely disappeared, you can tap it a few more times.

☞ Tap **Apply**

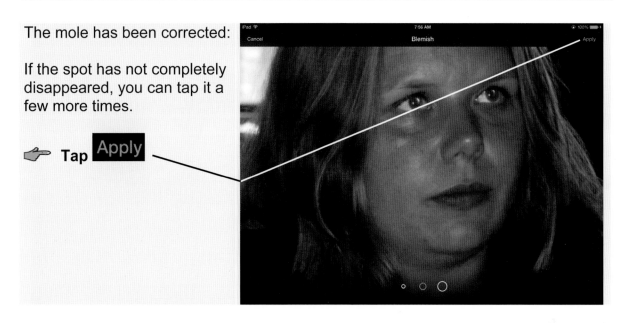

Now you have finished retouching this photo, but you do not need to save it:

☞ **Do not save the edited photo** 🐾[5]

☞ **Open the unedited photo** 🐾[3]

Retouching is not only used for correcting imperfections in portraits. With the Blemish tool you can also remove unwanted objects from a photo, such as the birds on the beach in this photo:

☞ **If necessary, drag the toolbar from right to left**

☞ **Tap Blemish**

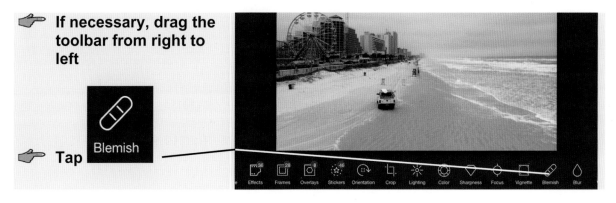

☞ **Zoom in on the bird to the right of the car** 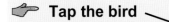4

You will not be able to zoom in much further than in this example:

👉 **Tap the bird**

If the bird has not completely disappeared, you can tap again.

Now the bird is gone:

👉 **Tap the other birds**

All the birds have gone:

👉 Tap

Now you have finished editing this photo, but you do not need to save it:

☞ **Do not save the edited photo** 5

1.13 Adding Titles

With the Meme tool you can easily add a title or short text to the top and bottom of the photo:

☞ **Open the edited photo**

👉 **Drag the toolbar from right to left**

👉 **Tap Meme**

👉 **Tap Enter top text**

Type: greetings from

The text will appear in capital letters:

☞ **Tap** Next

Type: Siesta Beach

You may not immediately see the text or the image when you are still typing. Just keep on typing.

☞ **Tap** Done

You will see the result:

In order to delete a text, you

tap next to the text: ─────

Save the text:

👉 **Tap** Apply

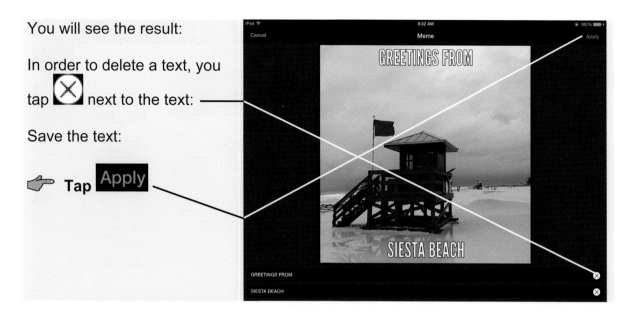

👉 **Do not save the edited photo** 🐾⁵

💡 **Tip**

Meme
In the *Background Information* at the end of this chapter you will find information about the term 'meme'.

1.14 Correcting White

When light is colored, such as in the evening or when light is reflected, the whites in a photo are not really white. This is called the white balance. You can correct the white balance with the Whiten tool:

💡 **Tip**

Radiant white smile
You can also use the Whiten tool to make teeth look whiter in a photo.

👉 **Open the photo** 🐾³

The hands and eyes of the figures are not white:

☞ **If necessary, drag the toolbar from right to left**

☞ **Tap** Whiten

☞ **Zoom in on the figure on the left**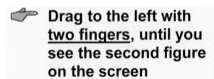

☞ **Swipe across the hand on the left** ─────

The hand will become whiter:

☞ **Swipe across the other hand**

For larger areas you can select a larger brush.

☞ **Swipe across the white of the eyes**

☞ **Drag to the left with <u>two fingers</u>, until you see the second figure on the screen**

☞ **Swipe across both hands** ─────

☞ **Swipe across the white of the eyes**

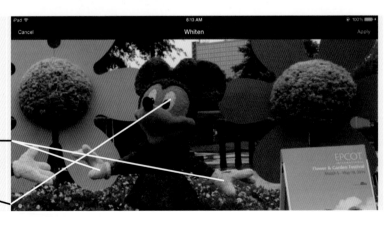

You will see the result:

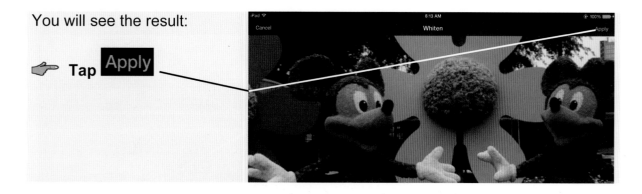

☞ **Tap Apply**

1.15 Blurring Parts of a Photo

You have previously seen how to use the Focus function to sharpen part of a photo, while the rest is blurred. With the Blur tool you can select a specific area to be blurred, while the rest remains sharp.

☞ **If necessary, drag the toolbar from right to left**

☞ **Tap Blur**

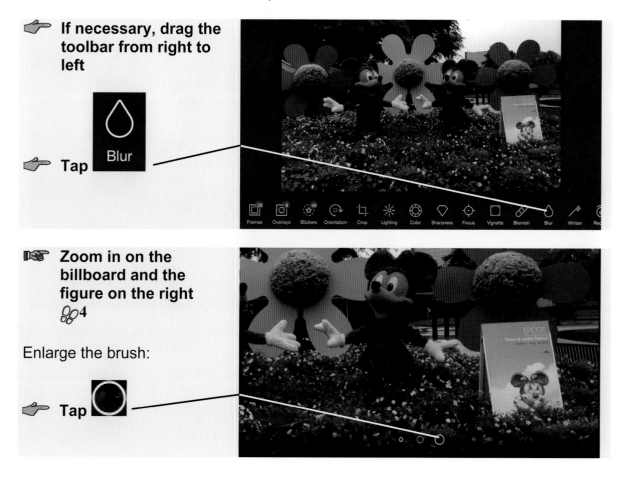

☞ **Zoom in on the billboard and the figure on the right** 🦶🦶4

Enlarge the brush:

☞ **Tap** ⬤

☞ **Swipe across the board** ———

☞ **Swipe across the heart of the purple flower**

☞ Tap **Apply**

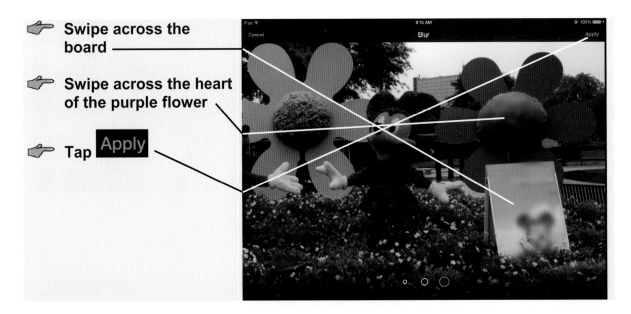

Undo the last edit:

☞ **Drag across the photo from left to right**

Now the photo is sharp again.

☞ **Save the edited photo** ✂6

1.16 Deleting a Photo

Unfortunately, you cannot delete a photo directly in the *Aviary* app. But you can do this in the *Photos* app.

Close the *Aviary* app and go back to the Home screen:

☞ **Press the Home button**

The *Photos* app is usually placed on the iPad's Home screen:

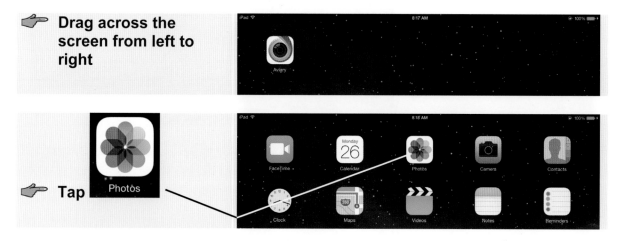

☞ **Drag across the screen from left to right**

☞ **Tap** Photos

An edited photo will be saved separately in the Camera Roll. This means the original, unedited photo is also saved. This is how you delete the last photo you have saved:

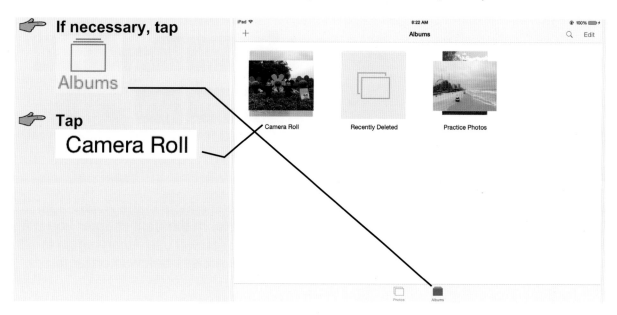

☞ **If necessary, tap** Albums

☞ **Tap** Camera Roll

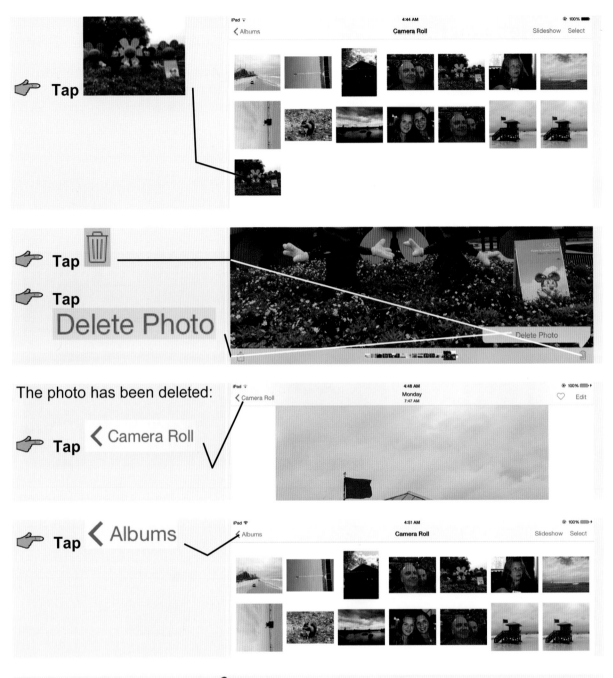

☞ **Tap**

☞ **Tap** 🗑

☞ **Tap**
Delete Photo

The photo has been deleted:

☞ **Tap** ❮ Camera Roll

☞ **Tap** ❮ Albums

☞ **Close the *Photos* app** 👣7

In this chapter you have learned how to work with the basic tools in the *Aviary* app, and you have seen that there are many options available. In the next chapter you will become acquainted with two other photo editing apps. You will use *Aviary* again in *Chapter 3 Special Effects.* You can work through the exercises below in order to practice what you have learned.

1.17 Exercises

The following exercises will help you master what you have just learned. Have you forgotten how to perform a particular action? Use the number beside the footsteps to look it up in the appendix *How Do I Do That Again?*

Exercise 1: Automatic Enhancement and Cropping

In this exercise you can practice cropping and automatically enhancing a photo.

☞ Open the *Aviary* app. 🐾[2]

☞ Open the photo . 🐾[3]

☞ Apply the automatic enhancement called Hi-def. 🐾[8]

☞ Crop the photo to a square. Try to display just the two figures and the orange flower. 🐾[9]

☞ Undo the last edit. 🐾[10]

☞ Apply (redo) the last edit again. 🐾[11]

☞ Do not save the edited photo. 🐾[5]

Exercise 2: Straightening

In this exercise you can practice rotating and straightening a photo.

☞ Open the photo . 🐾[3]

☞ Rotate the photo a quarter turn to the left. 🐾[12]

☞ Rotate the photo a quarter turn to the right. 🐾[12]

☞ Straighten the barrier behind the sailing boat (align it horizontally). ✿✿¹³

☞ Zoom in on the sailing boat. ✿✿⁴

☞ Sharpen the photo. ✿✿¹⁵

☞ Do not save the edited photo. ✿✿⁵

Exercise 3: Red Eye and Splash

In this exercise you can practice using the red eye correction tool and Splash.

☞ Open the photo . ✿✿³

☞ Zoom in on the eyes. ✿✿⁴

☞ Remove the red eyes. ✿✿¹⁶

☞ Zoom out. ✿✿¹⁴

☞ Use the Splash tool to give the face, neck, and hair the normal color while changing the background and clothes to black-and-white. ✿✿¹⁷

☞ Save the edited photo. ✿✿⁶

Exercise 4: Color Brightness

In this exercise you can adjust the brightness.

☞ Open the unedited photo . ✿✿³

☞ Enhance the brightness. ✿✿¹⁸

☞ Do not save the edited photo. ✿✿⁵

☞ Close the *Aviary* app. ✿✿⁷

1.18 Background Information

Dictionary

Aspect ratio	The ratio between the width and height of a photo, for example 4:3.
Brightness	The amount of light you see in a picture. At a low brightness the colors will fade and when the brightness is high the colors will become brighter.
Color hue	A certain tint that dominates a photo.
Color saturation	Saturation or purity of color. If there is little saturation, the colors will be pale and grey.
Contrast	Difference in color or in light and dark between adjacent areas of a photo.
Crop	Cutting off a portion of a photo that you do not want to display.
Enhance	A tool that automatically corrects photos and adjusts the exposure and color. You can choose between various preset adjustments, for example, for scenery and portraits.
Instagram	*Instagram* is a free app with which you can exchange digital photos or videos. The photos and videos can be edited and shared on social network sites, such as the *Instagram* website, or *Facebook*. *Instagram* works with square photos.
Meme	An image (often with a text) that is frequently shared through websites or social media, because it is noticeable or funny.
Red eye	The way in which a pupil lights up in red when you have used flash while taking a picture.
Resolution	The amount of detail a photo holds. It is the number of dots of which a digital photo is made. The higher the resolution, the sharper the photo. This can be important when you crop or cut out a particular area in a photo and try to enlarge it.

- Continue on the next page -

Retouch	Getting rid of ugly smudges, scratches, imperfections, or unwanted objects in a photo.
Stylus	A pen with a rubber or silicon tip that is used to input commands on an iPad or other type of touchscreen.
Warmth	Also called color temperature. The degree in which a photo is rather more red (warm) or blue (cold).
White balance	The part of a photo that can be considered to be white. White balance will correct the color that is displayed, if it is not truly white.
Zoom	Viewing part of a photo in close up (zoom in) or from further away (zoom out).

Source: Wikipedia

Photo sizes and aspect ratios

Traditional photos have an aspect ratio of 2:3 (or 3:2 in vertical mode). Well-known sizes are: 4x6 inches (10x15 cm), 5x7 inches (13x18 cm) and 8x12 inches (20x30 cm). But a digital camera often have completely different aspect ratios, such as 4:3.

Due to the popularity of the social media app *Instagram*, an app with which people can share their photos with others, the square photo size has become very popular. The advantage of this size is that it is very suitable for use on smartphones, iPads and other tablet devices.

Photo printing services have also kept up with these new developments. You can now print square photos in sizes of 4x4 inches (10x10 cm) or 5x5 inches (13x13 cm), and other aspect ratios are offered too, for example 4:3, with a print size of 6x8 inches (15x20 cm). This is an improvement, since not every digital photo can be fully printed on standard photo paper of 4x6 inches (10x15 cm), for example. Parts of the photo may be cut off, or you will see a white border. If you still want to print your photos in the traditional 4x6 inches (10x15 cm) format, it is recommended to crop the photo beforehand, to the size in which you want to print it. In this way you can control the part that is printed yourself, and decide which part can be cut off.

Stylus

A stylus pen (also called a touchscreen pen) is a useful pen that allows you to draw or write and accurately input commands on your iPad or another tablet. A stylus pen is slender and it has a special bulbous tip made of rubber or silicon. You may be able to operate your iPad more precisely with a stylus pen than with your finger.

Why does a stylus pen work and an ordinary plastic pen not? An iPad has a *capacitive* touchscreen. This type of screen uses a light electrical charge that is spread out across the whole screen. When you touch the screen with your finger, the electrical current is interrupted (rerouted), because your body conducts electricity. The spot where this happens is perceived as a touch of the screen by the software. The material at the tip of a stylus pen is able to interrupt this electrical current, just like a human finger.

Another frequently used type of touchscreen is the *resistive* touchscreen.
A resistive screen is sensitive to pressure. Most e-readers have a resistive screen. Below the screen are two layers, with a layer of air between them. One of the layers has an electrical charge, and when you press the other layer with a finger or another object, this will be registered by the electrical layer. With this type of screen, it does not matter if you wear gloves when you operate the screen. A rubber-tipped stylus pen will not be necessary in this case, a simple plastic pen will work as well.

Stylus pens are available in many types and sizes. For example, with a ball pen on the other end, or in a miniature size on a string. You can by a stylus pen for just a few dollars or euros.

Meme

On the Internet, a meme is a picture (often with some text) that is very frequently shared through websites or social media, because it is so noticeable or funny.

This *Grumpy Cat* photo has been shared millions of times, with varying texts.

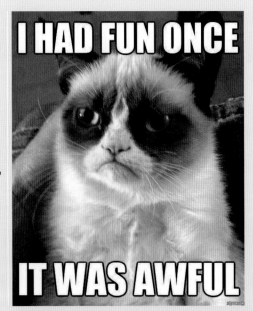

With the *Meme* tool in *Aviary* you can easily create these pictures yourself:

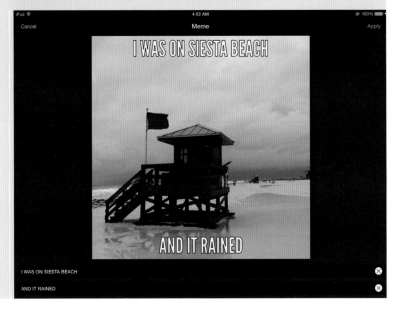

1.19 Tips

 Tip

Arrange the tool icons shown in Aviary

If you hold your iPad in portrait mode (vertically), you will only see some of the tool icons. You can adjust the arrangement of the icons to display the tools you most frequently use, for instance on the bottom left.

☞ Tap **Settings**

☞ Tap **Tool Order**

☞ Tap **Edit**

To move a tool to another spot in the list:

☞ **Drag the ☰ symbol by the desired tool to the desired spot**

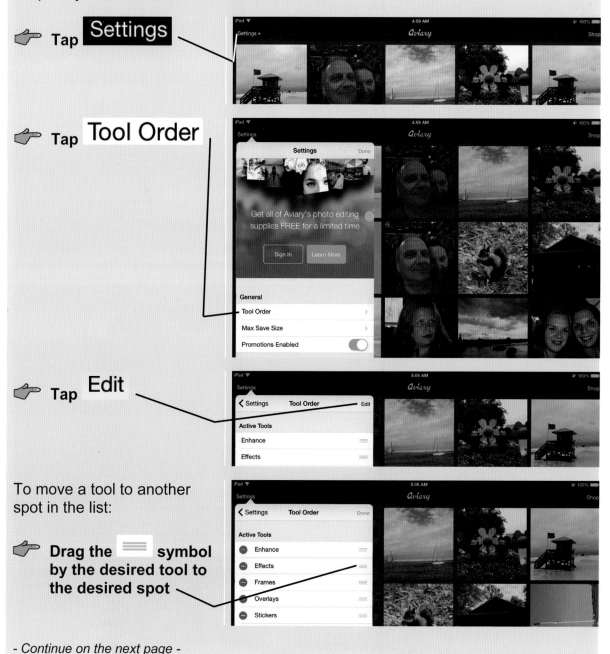

- Continue on the next page -

To hide the **Effects** tool, for example:

☞ By **Effects**, tap ⊖

☞ Tap **Disable**

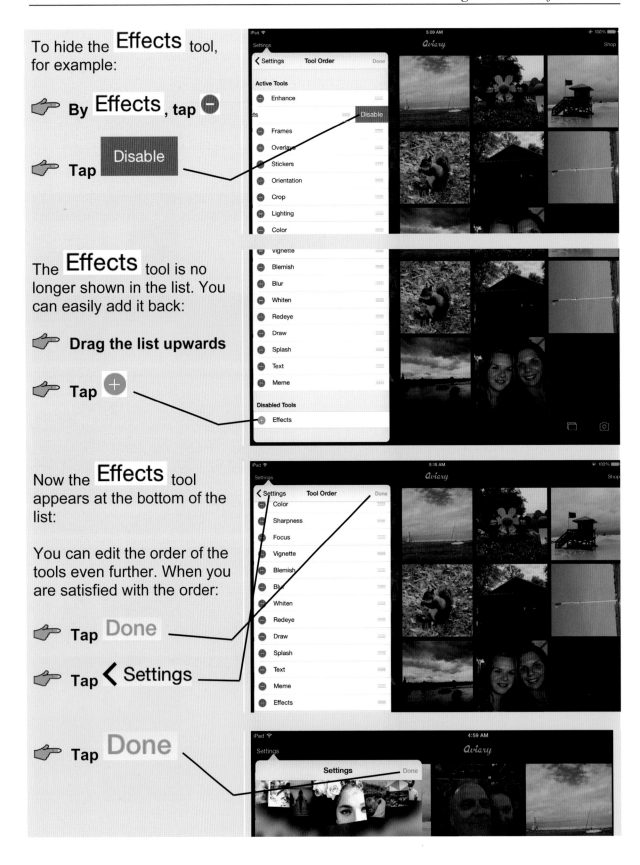

The **Effects** tool is no longer shown in the list. You can easily add it back:

☞ **Drag the list upwards**

☞ Tap ⊕

Now the **Effects** tool appears at the bottom of the list:

You can edit the order of the tools even further. When you are satisfied with the order:

☞ Tap **Done**

☞ Tap **< Settings**

☞ Tap **Done**

 Tip

Transfer photos from a camera, memory card, or Micro SD card to the iPad with a Camera Connection Kit or Lightning-to-SD-card reader

The *Camera Connection Kit* is a useful accessory for your iPad. It is a set of two connectors with which you can quickly and easily transfer photos from your digital camera or memory card to your iPad. The *Camera Connection Kit* costs around $29 (29 euros, pricing as of February 2015) from your Apple retailer.

One of the connectors can be used for your camera's USB cable: ———

If you do not have one, you can insert your memory card into the other connector: ———

For the latest iPad, iPad Air and iPad mini models you can use a *Lightning-to-SD-card camera reader*.

You can insert your memory card into the connector: ———

In case you use a micro SD card, you can insert it into the Camera Connection Kit by using a memory card adaptor. A memory card adaptor is a card in which you place the micro SD card, in order to adjust it to the size of a regular memory card.

 Connect the broad connector to your iPad

 Connect your camera's USB cable, or insert the SD card into the connector

The *Photos* app will automatically open:

 Tap Import

- Continue on the next page -

With the Import All option you can import all the photos from the camera or memory card to your iPad. But you can also select specific photos:

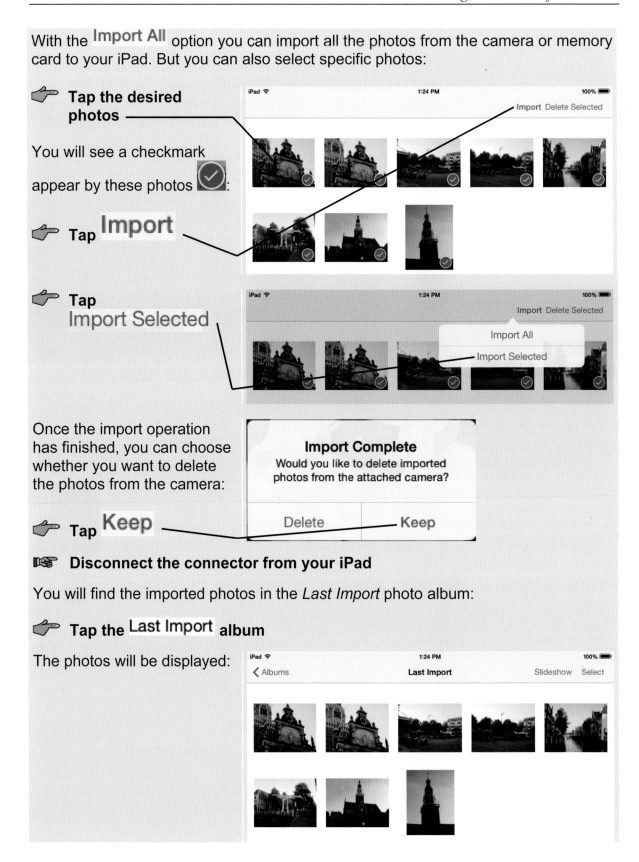

☞ **Tap the desired photos**

You will see a checkmark appear by these photos:

☞ Tap **Import**

☞ **Tap Import Selected**

Once the import operation has finished, you can choose whether you want to delete the photos from the camera:

Import Complete
Would you like to delete imported photos from the attached camera?

Delete — Keep

☞ Tap **Keep**

☞ **Disconnect the connector from your iPad**

You will find the imported photos in the *Last Import* photo album:

☞ **Tap the Last Import album**

The photos will be displayed:

 Tip

Transfer photos from the computer to the iPad through iTunes

You can transfer photos from the computer to your iPad by synchronizing a folder with photos with your iPad through *iTunes*. Unfortunately, you cannot transfer photos directly to your iPad through *Windows Explorer*.

☞ **Open the *iTunes* program on the computer** ℘℘**19**

☞ **Connect the iPad to the computer**

⊕ **Click** ▢

⊕ **Click** 📷 **Photos**

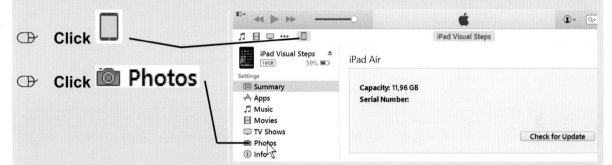

In this example, the photos are synchronized from a subfolder of the *Pictures* folder. You can select a folder of your own choice:

⊕ **Check the box ☑ by** Sync Photos

The **Pictures ⇕** folder is already selected:

In this example, not all the subfolders of the *Pictures* folder are synchronized:

⊕ **Click the radio button ⊙ by Selected folders**

- Continue on the next page -

Select the folder(s) you want to synchronize with your iPad. Of course, the folders on your own screen will differ from this example:

⊕ **Check the box ☑ by the desired folder(s), for example
🗀 Vacation Barcelona**

⊕ **Click** Apply

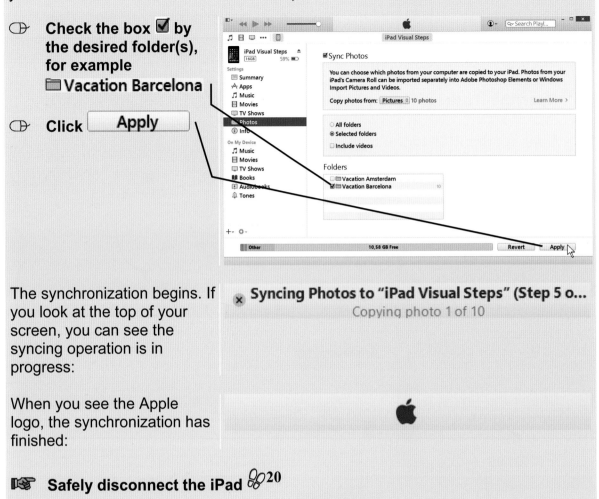

The synchronization begins. If you look at the top of your screen, you can see the syncing operation is in progress:

Syncing Photos to "iPad Visual Steps" (Step 5 o...

Copying photo 1 of 10

When you see the Apple logo, the synchronization has finished:

☞ **Safely disconnect the iPad** 🦶²⁰

☞ **Close *iTunes*** 🦶²¹

Your photos have now been added to the *Photos* app. This app now contains an album with the same name as the folder you selected on your computer.

- Continue on the next page -

If, on second thought, you do not want to save one or more synchronized photos and/or videos on your iPad, you will need to remove them through *iTunes*. There are different ways of doing this. You can delete specific photos as follows:

☞ **Delete the unwanted photos from the synchronized folder on your computer, or move them to another folder**

☞ **Synchronize the folder with your iPad once more, just as you previously did**

Synchronizing means that the content of the folder on the iPad is the same as the content of the folder on your computer. The deleted or moved photos will also be removed from the iPad.

You can also delete one or more synchronized folders:

⊕ **Uncheck the box ☑ by the folder you do not wish to synchronize any longer, for example**
🗀 Vacation Barcelona

⊕ **Click** **Apply**

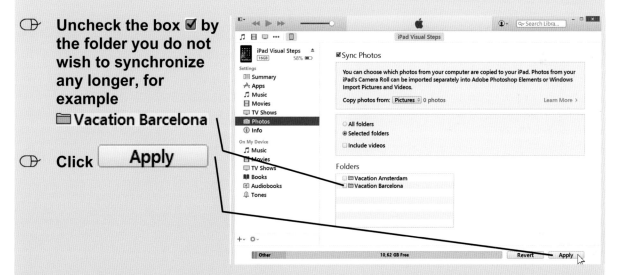

The synchronization will start and the folder will be deleted from your iPad.

If you do not want to synchronize any photos at all with your iPad, you can delete them like this:

⊕ **Uncheck the box ☑ by**
Sync Photos

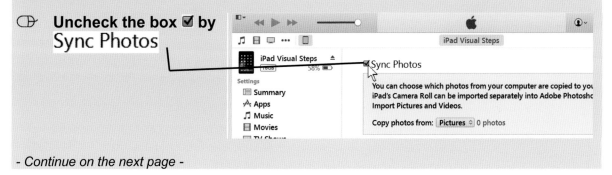

- Continue on the next page -

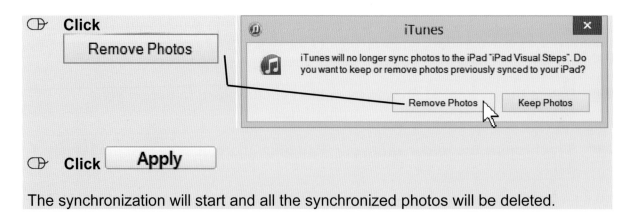

Click

 Remove Photos

Click Apply

The synchronization will start and all the synchronized photos will be deleted.

2. Other Photo Editing Apps

There are many different photo editing apps available for the iPad. In this chapter you will get acquainted with two more apps: *Handy Photo* and *Adobe Photoshop Express*.

The *Handy Photo* app has a distinctive layout and a unique user interface. It works in quite a different way as compared to the *Aviary* app. Along with the familiar photo editing tools, *Handy Photo* also offers some surprising new options that you will be using in this chapter.

The *Handy Photo* app is not a free app, but for the small amount it costs, it is well worth its price.

You can use the Magic Crop tool, for instance, to 'uncrop' a photo, that is to say, drag the photo outside its own frame; the extra space will then be filled in by repeating selected areas of the original photo. You can also straighten horizons without losing so much of the photo, as was the case in *Aviary*. With the Move Me tool, you can select and move an object in a picture and fill in the area where the object was originally located. Other great options include: duplicating and mirroring objects, and moving objects to another photo.

In this chapter you will also practice applying manual corrections to selected areas of a photo, cloning an object, and removing larger objects using the Retouch tool.

The second app you will get to know in this chapter is the free *Adobe Photoshop Express* app, a powerful photo editing app. This app is similar to the *Aviary* app, but has more extensive options to handle other photo editing needs.

In this chapter you will learn how to:

- use the *Handy Photo* app;
- use the Auto Levels feature;
- zoom in and zoom out;
- sharpen a photo;
- use the Magic Crop tool;
- retouch large objects;
- apply manual corrections to a selected area of a photo;
- clone objects;
- use the Move Me tool;
- use the *Adobe Photoshop Express* app;
- remove red eye;
- apply manual corrections.

2.1 Handy Photo

In this section and the following few sections, you will be working with the *Handy Photo* app. This app can be purchased in the *App Store* for a small fee (at the time this book was written it was available for under 3 dollars), but the app is worth every penny. The *Handy Photo* app has a number of interesting features that are not available in many other photo editing apps.

 Tip

Use an iTunes Gift Card
With an *iTunes Gift Card* you can easily purchase apps without using a credit card. You can buy an *iTunes Gift Card* for amounts between $10 and $100, in supermarkets, bookstores, or online in the Apple Store. Select the **Redeem**

option at the bottom of the Featured screen in the *App Store* to link the amount on the card to your *Apple ID*. Then you can purchase the app with your credit.

 Tip

Read the text first
If you are not sure you want to buy this app, then just read through the following sections concerning the *Handy Photo* app. If you like the options this app has to offer, you can always decide to purchase this app later on.

In order to be able to use the app, it first needs to be downloaded to your iPad.

 Handy Photo
Adva-Soft

☞ **Download the** app 🐾¹

Once the app is downloaded, a new icon will appear on the iPad's home screen, or on the next page (depending on the number of apps you have already installed).

☞ **Press the Home button**

☞ **Open the *Handy Photo* app** ²

You will need to let *Handy Photo* have access to the photos on your iPad:

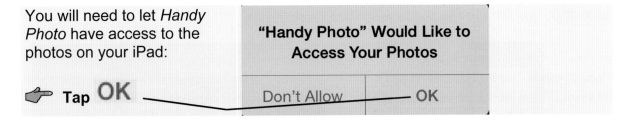

☞ **Tap OK**

This app is always used in landscape mode:

☞ **If necessary, rotate the iPad a quarter turn**

You will see a screen regarding app usage data (user statistics) by *Handy Photo*. You do not need to enable this option:

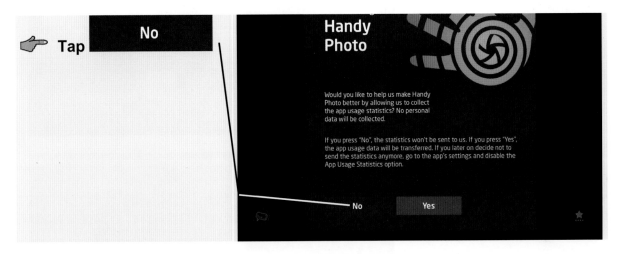

☞ **Tap No**

This is how you open a photo:

☞ **Tap Gallery**

Select the album with the practice photos:

☞ **Tap**

The photos will be displayed.
Open a photo:

☞ **Tap**

The large photo will be
displayed on the screen. If
you are using this app for the
first time, you will see a tip
regarding the main tools
palette:

☞ **Tap the screen**

2.2 Automatic Enhancement

Just like *Aviary*, *Handy Photo* has a tool that will automatically enhance a photo. You can practice using this function. You will notice right away that the way in which *Handy Photo* operates is different from *Aviary*.

Here you see the photo that was opened in the previous section. You can display the main tools palette:

👉 **Tap**

You will see the main palette:

If you turn the main palette, even more tools are shown:

 Tap and drag the main palette upwards

Please note: it is best to swipe across the text of the tools, not across the icons.

The main palette will turn clockwise, and you will see different tools:

Turn the main palette back again:

 Tap and drag the main palette downwards

The automatic enhancement tool is part of the Tone & Color group:

Tap

Since you are using this tool for the first time, you will once again see a tip:

Tap the screen

If you want to see this tool tip again, later on, tap :

In the lower left corner a palette with controls has appeared. These belong to the Tone & Color tool:

You can select the Auto Levels control:

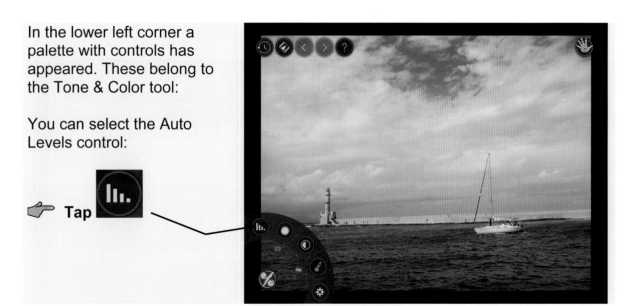

☞ **Tap**

The *Handy Photo* app does not have sliders with which you can regulate the intensity of the effect. You need to drag across the screen instead. Just give it a try:

While you drag, the percentage that goes with this control will change, which you can see at the top of your screen:

☞ **Slowly drag the screen from left to right, until you see**
Auto Levels: 50%

While you are dragging, a circle will appear around the

icon:

If you drag the other way, the effect will become less intense:

☞ **Slowly drag the screen from right to left, until you see** **Auto Levels: 30%**

While you are dragging, the

circle around the icon becomes smaller too:

It is very easy to view the difference between the original and the edited photo in *Handy Photo*:

☞ **Press and hold**

You will see the original photo:

☞ **Release**

You will see the edited photo again.

The colors in the edited photo are livelier, and you will see more contrast, for example, in the waves.

To apply the edit:

👉 **Tap**

The edit is processed:

2.3 Zooming In

In *Handy Photo* there are two ways of zooming in. Before you try this, you need to disable the Auto Levels control. This will prevent you from unintentionally editing the photo for a second time:

👉 **Tap the photo**

The icon turns from ▮▮. to ▮▮.

In order to zoom in to the true size of the photo:

 Tap the sailing boat twice in rapid succession

At the top you will see for a brief moment. This means the photo is now displayed in its actual size:

You can zoom in even further:

Spread your thumb and index finger

To view the correct part of the picture again:

Drag the photo until you see more or less the same image as in this example

2.4 Sharpening

You can try working with another control from the Tone & Color group, to get more used to the way *Handy Photo* operates. Here is how to select the Sharpen control:

Turn the palette with the controls:

 Drag the controls palette upwards

 Please note:

Have you tapped an icon instead of swiped? You can tell by the icon becoming

lighter, for example . This is how you disable the control again:

 Tap the photo

The icon becomes duller .

Select the Sharpen control:

☞ **Tap**

You are going to sharpen the photo 25%:

☞ **Slowly drag the screen from right to left, until you see**
Sharpness: 25%

Notice that the circle around

the icon moves as you drag:

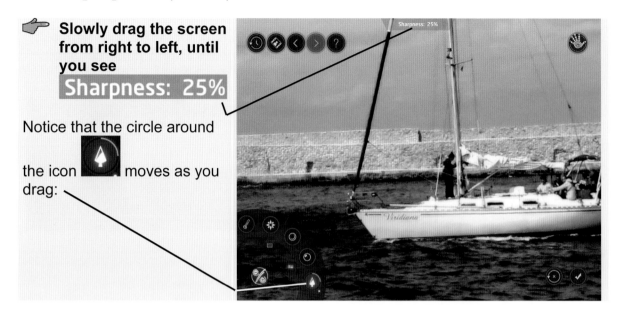

💡 **Tip**
Dot

The dot next to the icon ![] tells you that the setting of the control has changed.

The dot will remain visible, even if you have selected another control: ![]. In this way, you can tell at a glance which controls have been applied to this photo.

2.5 Undo

This is how you undo an edit:

☞ **Tap** ![]

The last edit will be undone. You will see that the outline of the waves and the boat have become less sharp. This is how you redo an edit:

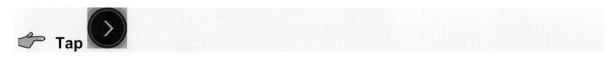 **Tap**

This is how you zoom out:

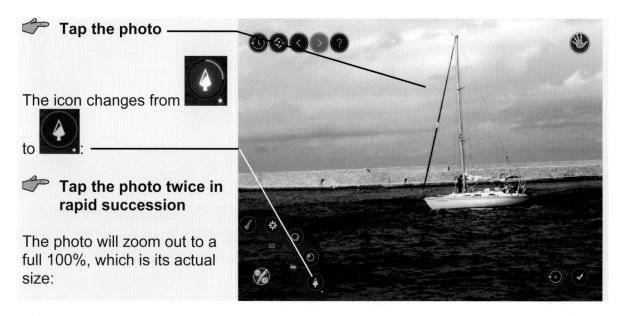

☞ **Tap the photo**

The icon changes from

to :

☞ **Tap the photo twice in rapid succession**

The photo will zoom out to a full 100%, which is its actual size:

Now you can display the photo on a full screen again:

☞ **Tap the photo twice in rapid succession**

Apply the edit to this photo:

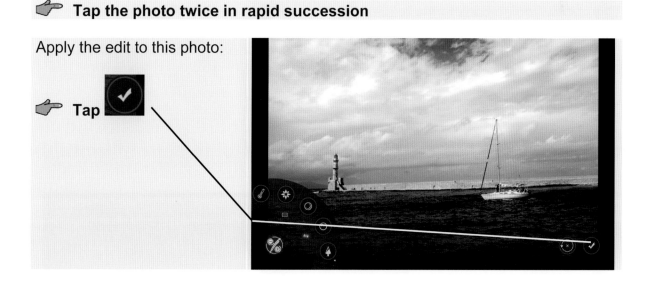

☞ **Tap**

Now you have applied two edits to this photo: Auto Levels and Sharpen. You can no longer undo these edits.

The Undo and Redo icons are no longer active:

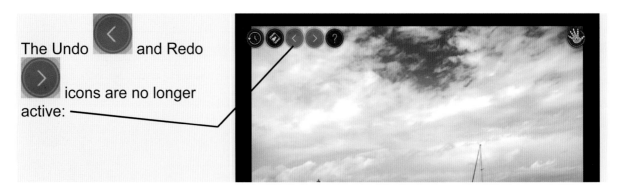

As long as you do not close the photo, you can still go back to a previous version of the edited photo. Every time you tap , the previous version will be saved as well. This is how to view the editing history:

☞ **Tap**

Two Tone & Color edits have been applied:

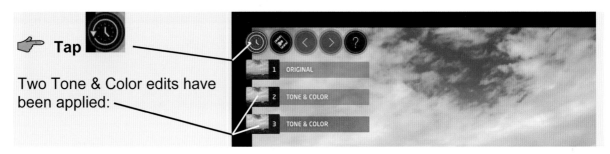

This is how you go back to the original photo:

☞ **Tap**

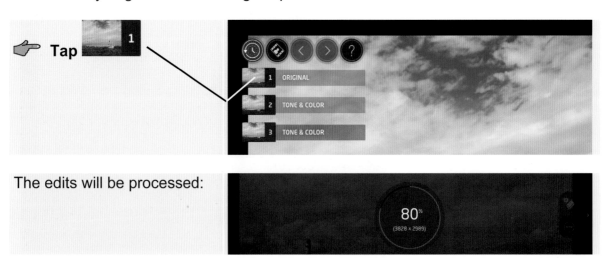

The edits will be processed:

has changed to

, to indicate this is the version you see:

☞ **Tap**

The Auto Levels edit will be applied again. Close the editing history:

☞ **Tap**

2.6 Magic Crop

You can also crop a photo in the *Handy Photo* app. To do this, you need to select the Magic Crop tool from the main palette:

☞ **Tap**

☞ **Drag the main palette upwards**

☞ **Tap**

Your screen may now turn dark and you will see a tip regarding this tool:

 Tap the screen

It may seem as if the photo has been placed on a larger sheet: ⎯⎯⎯⎯⎯

Within this sheet, you can expand or crop the photo.

Practice by removing a slice off the right-hand edge of the photo:

 Drag the handle ⬜ in the lower right corner a little to the left

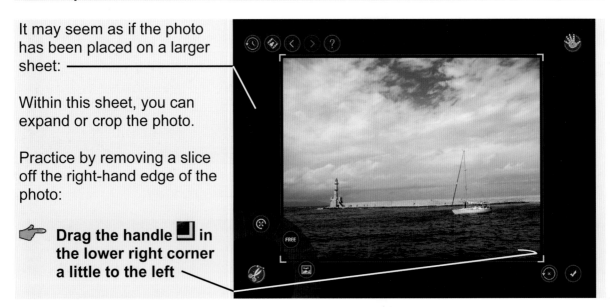

Apply this edit to the photo:

☞ **Tap**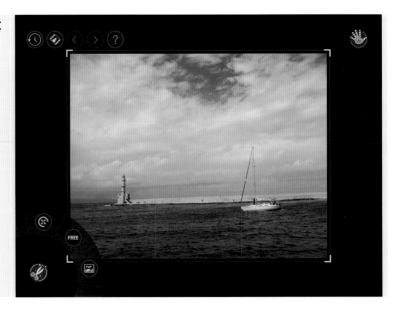

The photo has been cropped:

In *Handy Photo* you can also use the Magic Crop tool to rotate the photo and crop it to a fixed or flexible ratio. And you can also 'uncrop' a photo. This means you can drag a photo outside of its own borders. *Handy Photo* will then fill in the missing parts. This is truly magic cropping:

Drag the handle ▣ in the lower right corner to the right and downwards

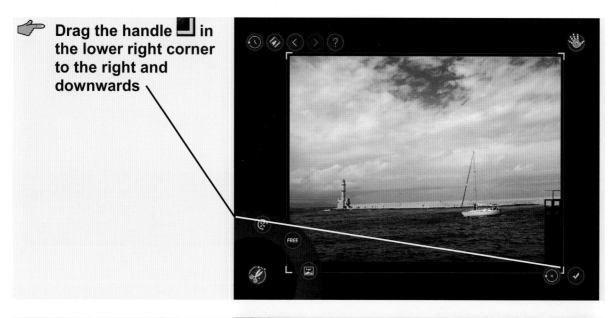

The section between the border and the photo will be filled in:

The photo has become larger. Undo the last edit:

☞ **Tap**

With the ⊙ icon you can set the parameters of the tool controls all together. All the edits you applied with the controls will be undone.

With the ⦿ button you can undo the edits you applied with various tool controls, one by one.

💡 **Tip**

Type of background
Magic Crop is especially suited for photos with a background of sea, grass, or sand. The tool will fill in the missing parts with surrounding pixels, but has trouble filling in buildings or objects.

Magic Crop can also be used to straighten a photo. In *Aviary* you may have noticed that part of a photo is cut off when you straighten it, in order to change the photo into a rectangular shape again. With Magic Crop, the missing parts are filled in, so the size of the photo remains the same.

Here you see that the sea barrier is slanted when compared to the grid:

You are going to try to let the barrier run parallel to the grid:

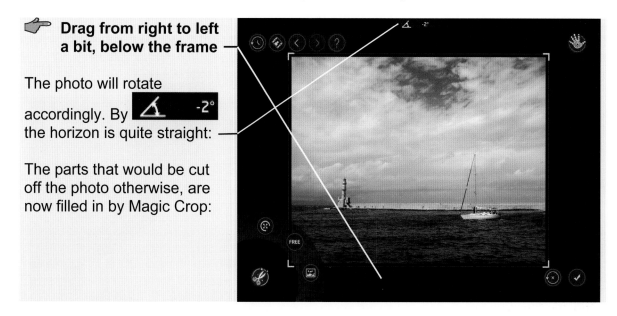

 Drag from right to left a bit, below the frame —

The photo will rotate accordingly. By the horizon is quite straight: —

The parts that would be cut off the photo otherwise, are now filled in by Magic Crop:

Save the edit:

 Tap ✓

💡 **Tip**

Different results with Aviary and Handy Photo
On the left you see the result of straightening the photo in *Aviary*.
The straightened photo is smaller than the original, because the borders have been cut off:

On the right you see how Magic Crop has filled in the grass, the sky, and the building in *Handy Photo*, so the photo remains the same size:

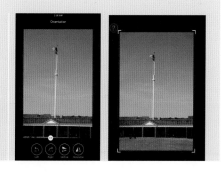

2.7 Retouching

In the previous chapter you learned how to use the Smudge tool in the *Aviary* app to remove small imperfections and objects from photos. In *Handy Photo* you can remove even larger objects. You do this with the Retouch tool:

☞ **Tap**

☞ **Drag the main palette downwards**

☞ **Tap**

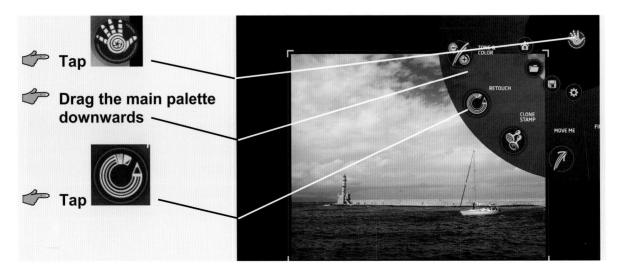

Your screen may turn dark and you will see a tip regarding the use of this tool:

☞ **Tap the screen**

Zoom in on the sailing boat, so it will become easier to select it:

☞ **Spread your thumb and index finger**

☞ **If necessary, drag the sailing boat into the frame**

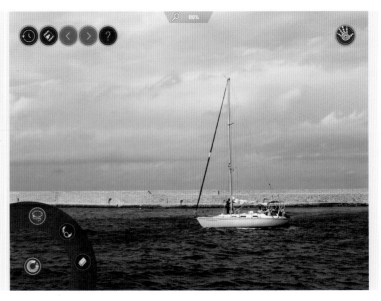

You can select the sailing boat by using the lasso . This tool is already selected:

👉 **Drag along the outline of the sailing boat**

It is easier to do this with a stylus pen than with your fingers. It does not matter if the action is not very precise.

In the magnifying glass you can get a better look at what you are doing:

👉 **Connect the beginning and end of the red line**

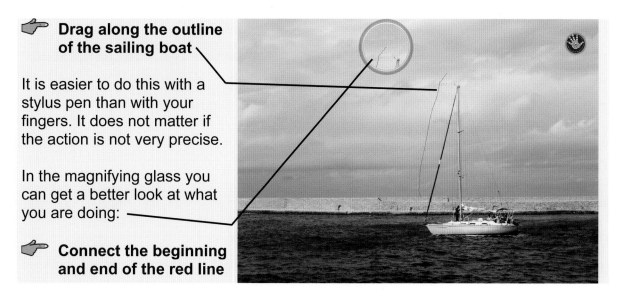

When the entire sailing boat is selected, you may also see a tip:

👉 **Tap the screen**

You can use the eraser tool to fine-tune the selection. Just erase the parts that you do not want to include in the selection:

👉 **Tap**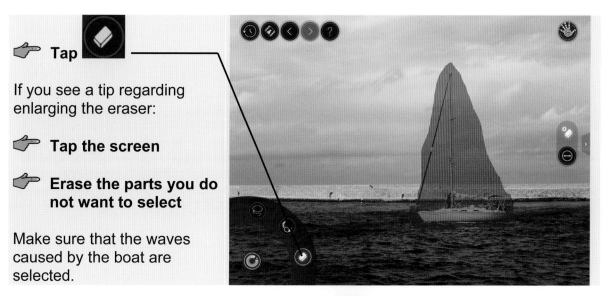

If you see a tip regarding enlarging the eraser:

👉 **Tap the screen**

👉 **Erase the parts you do not want to select**

Make sure that the waves caused by the boat are selected.

You can select additional parts with the brush tool, if you wish.

 HELP! An edit is being processed.

If you try to use the eraser or
the brush and you see this:

Then you have tapped instead of swiped with the brush or eraser. The selected part
of the photo will be removed. You can undo this action like this:

 Tap

☞ **Try again**

 Tip

Adjust size of eraser or brush
This is how you enlarge the eraser or the brush:

☞ **Tap** ⬛ **or** ⬛

☞ **Tap** ⬛

☞ **Drag from left to right
across the screen**

You will see that the
diameter of the eraser has
become larger:

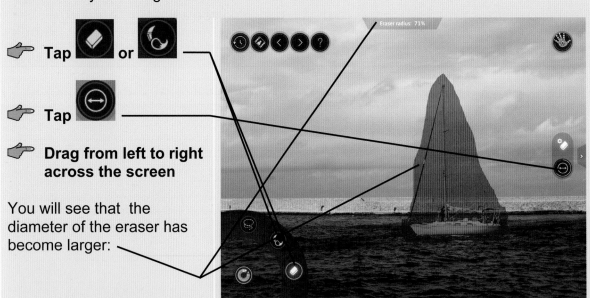

To decrease the diameter of the eraser or brush, you drag from right to left.

When you have completed your selection, you can remove the sailing boat:

☞ **Tap the screen**

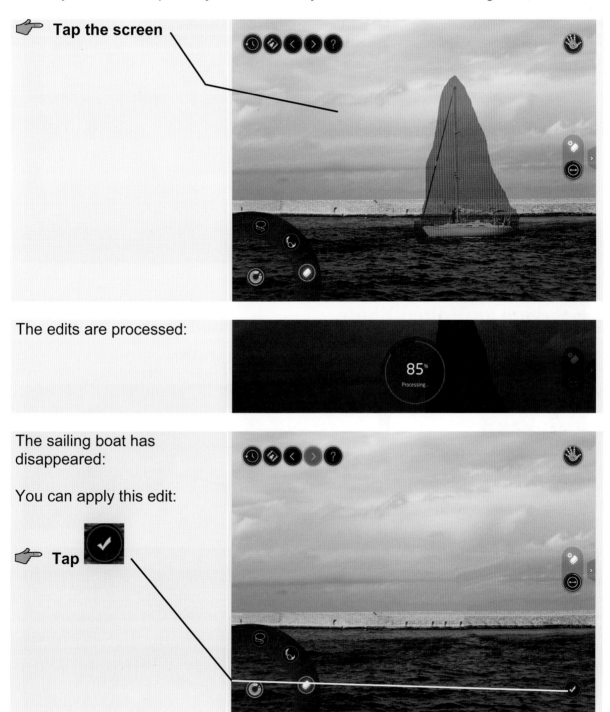

The edits are processed:

The sailing boat has disappeared:

You can apply this edit:

 Tap ✓

Now zoom out again:

☞ **Move your thumb and index finger towards each other (pinch)**

This is the result:

2.8 Saving an Edited Photo

After you have finished editing a photo, you can save it like this:

👉 **Tap**

👉 **Tap**

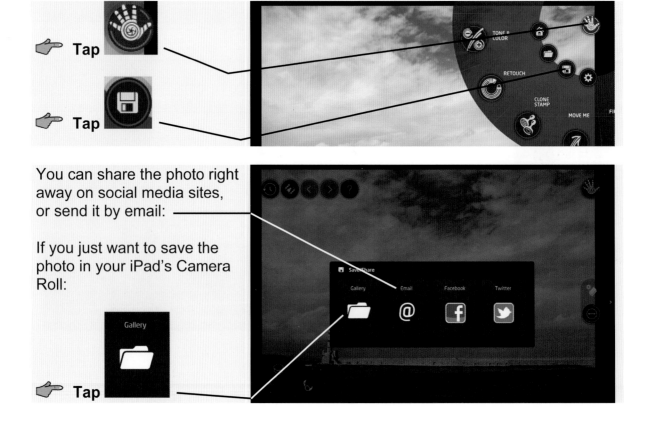

You can share the photo right away on social media sites, or send it by email: ———

If you just want to save the photo in your iPad's Camera Roll:

Gallery

👉 **Tap**

The photo is saved:

You can view the saved photo:

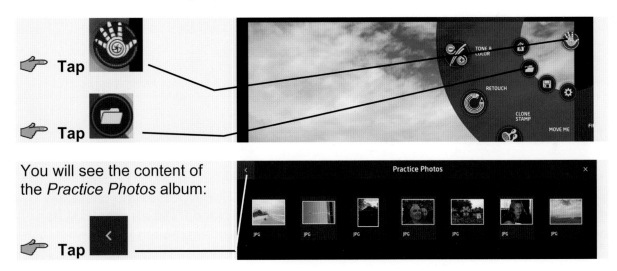

☞ **Tap**

☞ **Tap**

You will see the content of
the *Practice Photos* album:

☞ **Tap**

The edited photo has been saved in the Camera Roll:

☞ **Tap Camera Roll**

You will see the edited photo:

To go back to the practice files:

☞ Tap ▓◁▓ in the upper left corner of your screen

☞ Tap **Practice Photos**

2.9 Manual Corrections

In the previous chapter you have manually corrected the brightness, contrast, warmth, and color saturation of a photo with *Aviary*. In *Handy Photo* you can apply these edits on different areas of a photo. This way you can darken an area that has been overexposed, and lighten an area that has been underexposed.

☞ Open the photo 🐾³

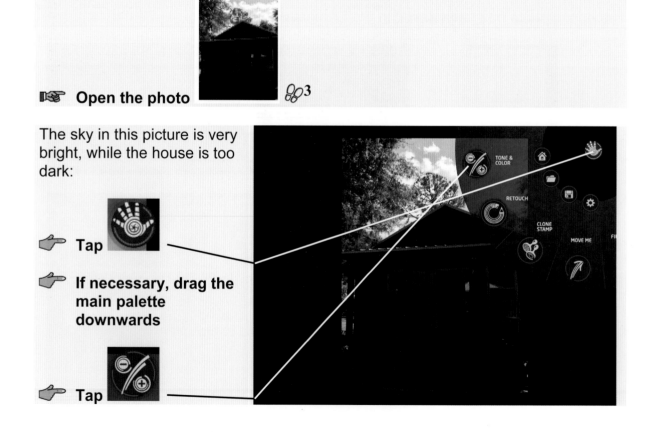

The sky in this picture is very bright, while the house is too dark:

☞ Tap

☞ If necessary, drag the main palette downwards

☞ Tap

You will see the controls of the Tone & Color tool again:

To select the area you want
to edit:

☞ **Tap** ▨

Your screen may turn dark and you will see yet another tip:

☞ **Tap the screen**

You can decide which part of the photo will be edited by laying a *mask* over this area.
This is a transparent layer in which an edit can be applied. By shaping the mask in
the same way as the area you want to edit, the edit will only be applied to the specific
part of the photo you want to adjust.

By default, edits are applied
to the entire photo:

But you can make a more
careful selection by using the
linear ▨, elliptic ▨
gradient mask or a mask
brush ▨:

☞ **Tap** ▨

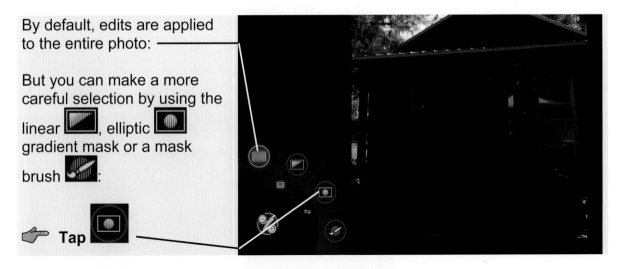

Your screen may turn dark and you will see another tip:

☞ **Tap the screen**

 Place your finger on the dot

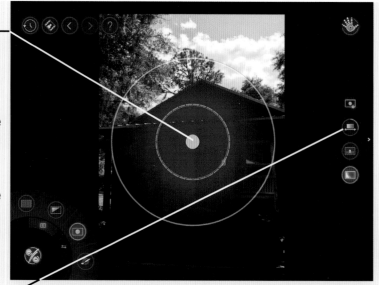

The red color indicates the spot where the effect will be strongest. The edit will be applied less strong toward the edges of the mask.

You can enlarge the diameter of the mask somewhat, so the greater part of the house can be edited:

 Tap

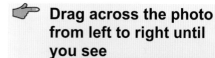 **Drag across the photo from left to right until you see Gradient width: 55%**

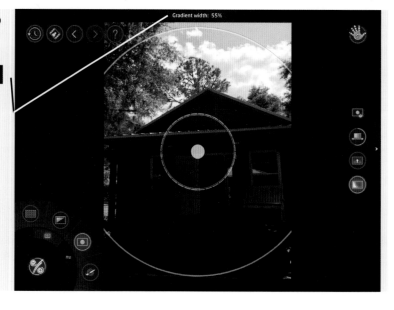

👉 **Drag the mask downwards** ——

Now the red glow is only on the house and not on the sky:

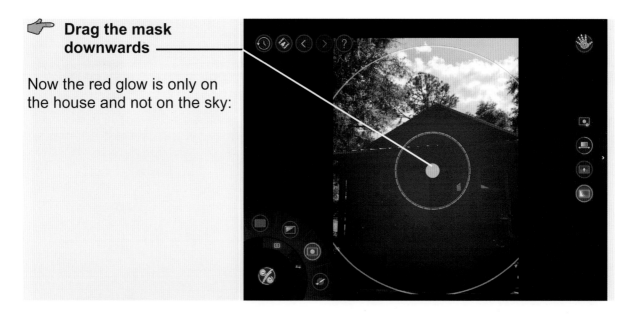

You can adjust the brightness of the area of the photo that is covered by the mask:

👉 **Tap** ——

👉 **Tap**

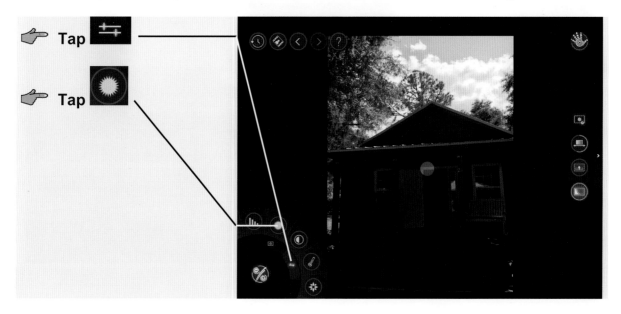

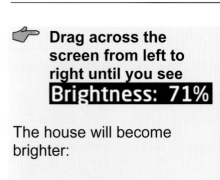 **Drag across the
screen from left to
right until you see
Brightness: 71%**

The house will become
brighter:

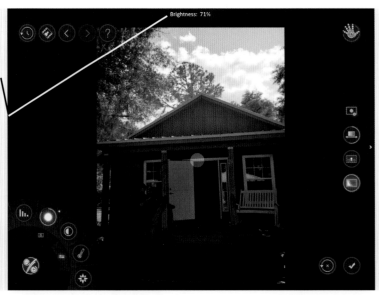

You can also enhance the
contrast:

 Tap

 **Drag across the
screen from left to
right until you see
Contrast: 20%**

The contrast between the
dark and light areas will
become more distinctive:

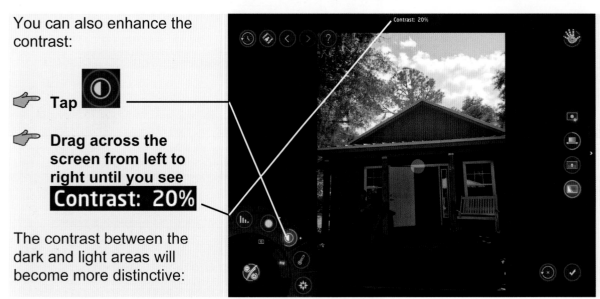

This is how you compare the difference with the original photo:

Press and hold ![icon] **and release afterwards**

You can also make the colors brighter by enhancing the color saturation:

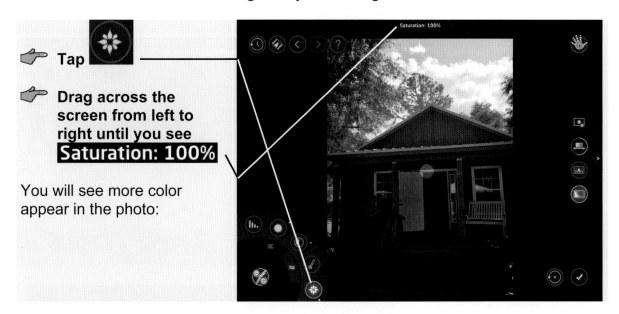

☞ **Tap**

☞ **Drag across the screen from left to right until you see** **Saturation: 100%**

You will see more color appear in the photo:

Notice that due to the brighter colors, the photo now has a reddish glow. You can adjust the warmth of the photo:

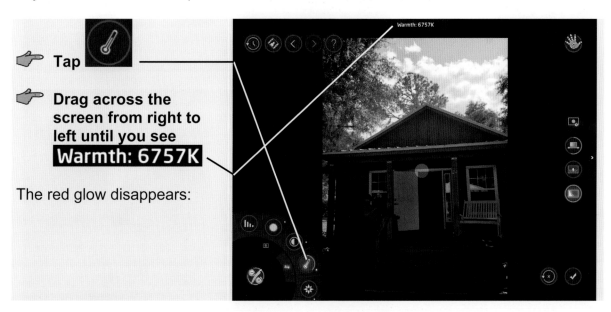

☞ **Tap**

☞ **Drag across the screen from right to left until you see** **Warmth: 6757K**

The red glow disappears:

Apply the edits:

☞ **Tap**

The sky is still very bright and clear, compared to the house. You can adjust this with the mask brush:

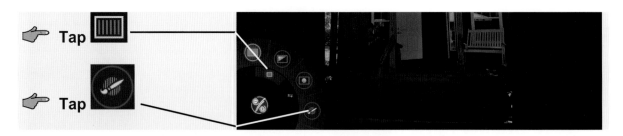

☞ Tap

☞ Tap

Your screen may turn dark and you will see another tip:

☞ **Tap the screen**

Use a sturdy brush to lay a mask over the sky:

☞ Tap

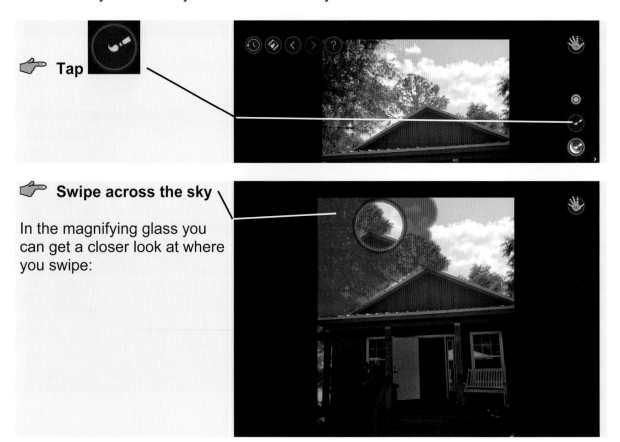

☞ **Swipe across the sky**

In the magnifying glass you can get a closer look at where you swipe:

☞ **Swipe over the area next to the house as well** ─────

If you select too much, you can erase these parts again:

☞ **Tap**

☞ **Swipe across any area that has wrongly been added to the mask**

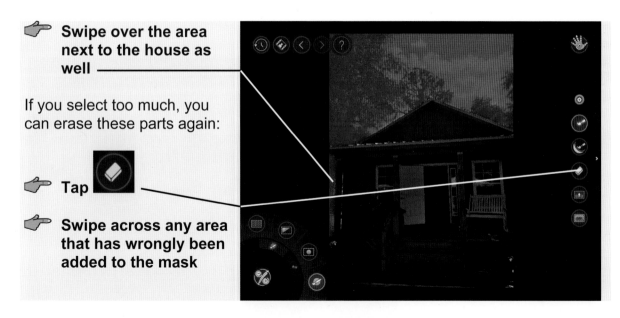

Make the part that is covered by the mask less bright:

☞ **Tap**

☞ **Tap**

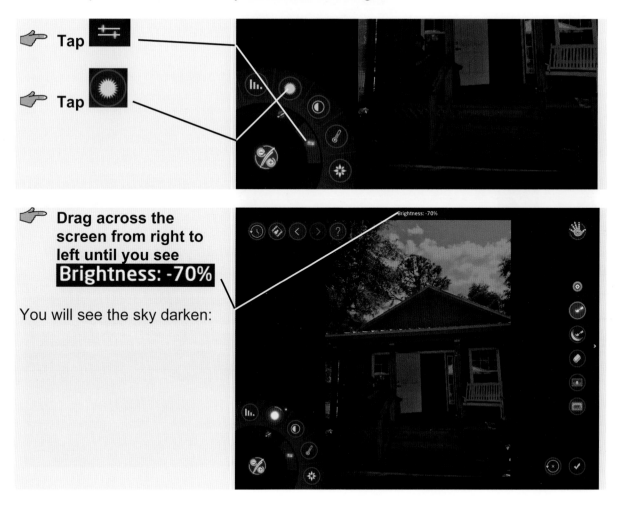

☞ **Drag across the screen from right to left until you see Brightness: -70%**

You will see the sky darken:

Decrease the contrast:

👉 **Tap**

👉 **Drag across the screen from right to left until you see** **Contrast: -20%**

Now the contrast between the dark and lighter areas is less distinctive:

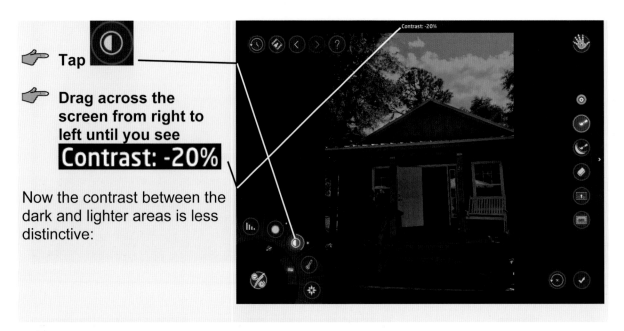

Now compare the difference with the original photo:

👉 **Press and briefly hold**

Apply the edits:

👉 **Tap**

In *Handy Photo* you can just edit one photo at a time. When you try to open a new photo, you will be asked if you want to save the changes in the current photo:

👉 **Tap**

👉 **Tap**

Do not save the edits:

You will see the practice files again:

2.10 Cloning

Cloning means duplicating a certain part of a photo within the same photo. By duplicating an animal, a person, or an object in the photo you can achieve interesting and often very funny effects.

Open the photo

Select the clone stamp:

Your screen may turn dark and you will see another tip:

 Tap the screen

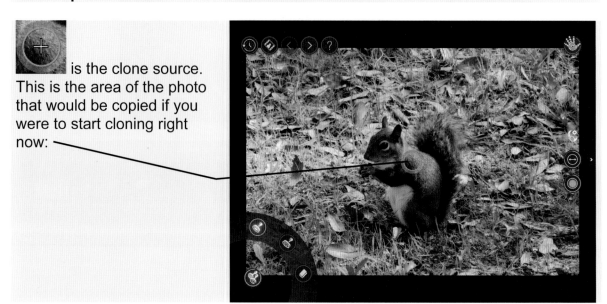 is the clone source. This is the area of the photo that would be copied if you were to start cloning right now:

You can move the clone source to the squirrel's front paws:

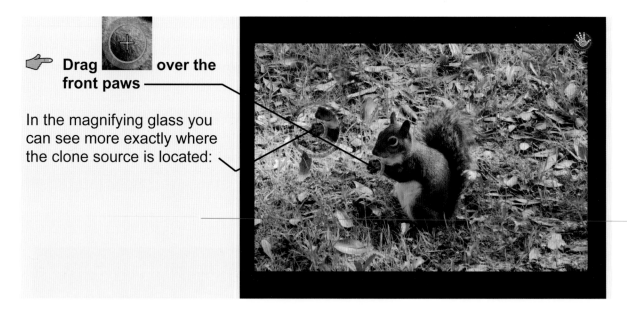 **Drag** over the **front paws**

In the magnifying glass you can see more exactly where the clone source is located:

Make the clone stamp a bit smaller:

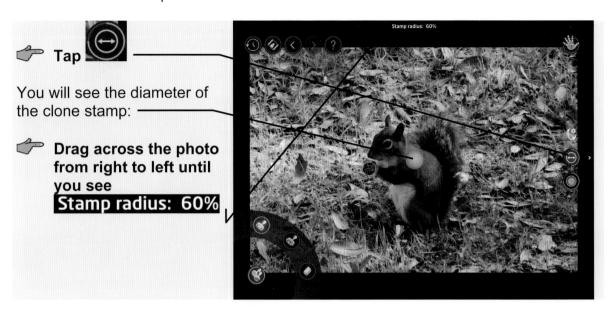

☞ **Tap**

You will see the diameter of the clone stamp:

☞ **Drag across the photo from right to left until you see Stamp radius: 60%**

You can adjust the smoothness of the stamp, this is the degree to which the cloned object blends in with its surroundings:

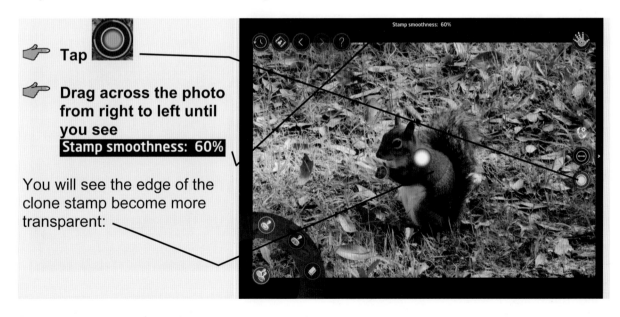

☞ **Tap**

☞ **Drag across the photo from right to left until you see Stamp smoothness: 60%**

You will see the edge of the clone stamp become more transparent:

Place the second squirrel to the left of the first squirrel:

 Place your finger on the spot where you want the front paws of the second squirrel to be and hold it steady

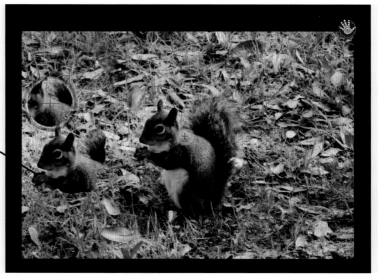

☞ **Drag across the screen to clone the second squirrel**

While you are dragging, the clone source will automatically move, so the entire squirrel will be copied:

When the squirrel is copied, you can hide the controls palette and view the result:

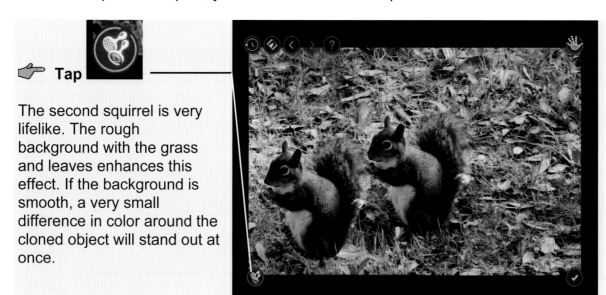

☞ **Tap**

The second squirrel is very lifelike. The rough background with the grass and leaves enhances this effect. If the background is smooth, a very small difference in color around the cloned object will stand out at once.

Save the edits:

☞ **Tap**

☞ **Tap**

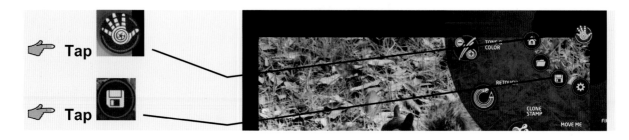

Save the edited photo in the Camera Roll:

Close the photo and go back to the folder with the practice files:

2.11 Move Me

Handy Photo has a powerful tool that lets you select specific areas of a photo to move or copy: the Move Me tool. With the Move Me tool, you can easily create a nice photo montage.

Select the Move Me tool:

If this is the first time you use this tool, your screen turns dark and you will see a tip:

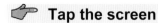 **Tap the screen**

By default, the Lasso control is already selected. Use the lasso to select the squirrel:

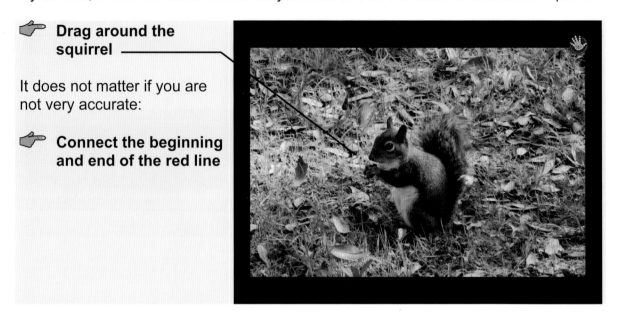

☞ **Drag around the squirrel**

It does not matter if you are not very accurate:

☞ **Connect the beginning and end of the red line**

Your screen may turn dark and you will see another tip:

☞ **Tap the screen**

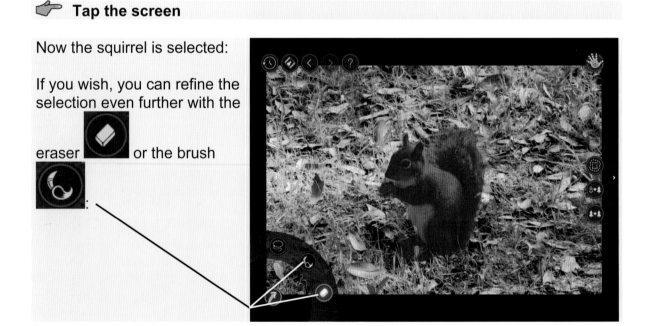

Now the squirrel is selected:

If you wish, you can refine the selection even further with the

eraser or the brush

You can move the selected squirrel to a new layer. The squirrel is extracted from the photo and therefore it can be moved or copied:

☞ **Tap**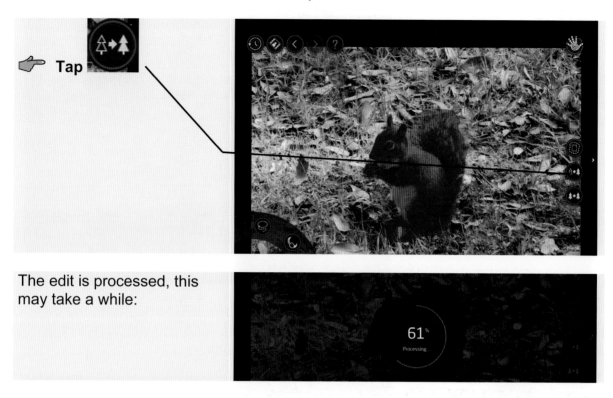

The edit is processed, this may take a while:

If this is the first time you add a new layer, you will also see a tip, just this one time:

☞ **Tap the screen**

The squirrel has been placed within a frame:

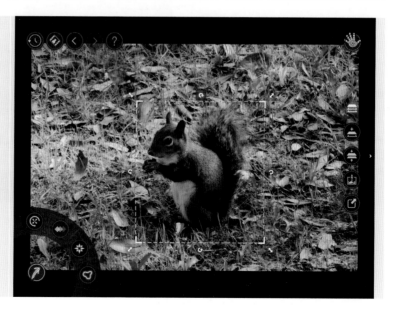

Now the squirrel has been placed on a layer that overlays the original photo.

☞ **Drag the squirrel to the left**

You will see that the original spot where the squirrel was has been filled in with leaves and grass:

Undo this edit:

☞ **Tap**

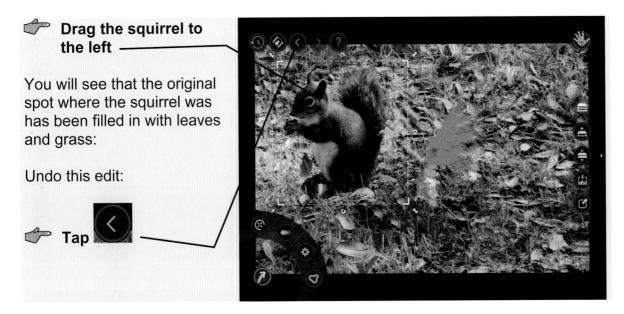

The squirrel will return to its original location. It is also possible to duplicate the layer. In that case, the squirrel will maintain its original position, and you will have a new layer with an additional squirrel that you can adjust and move:

☞ **Tap**

The layer with the new squirrel is on top of the old squirrel:

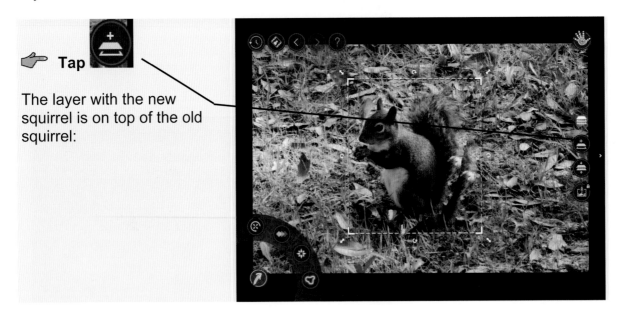

You can even make the new squirrel a little smaller:

👉 **Drag the handle at the top left to the right and downwards**

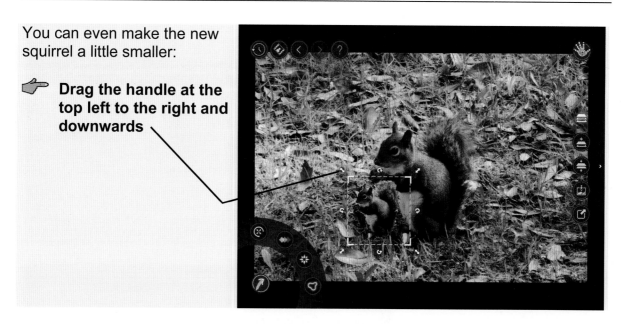

You can reverse the orientation of the small squirrel. This is called mirroring:

👉 **Tap**

You can rotate the squirrel, and mirror it vertically and horizontally:

👉 **Tap**

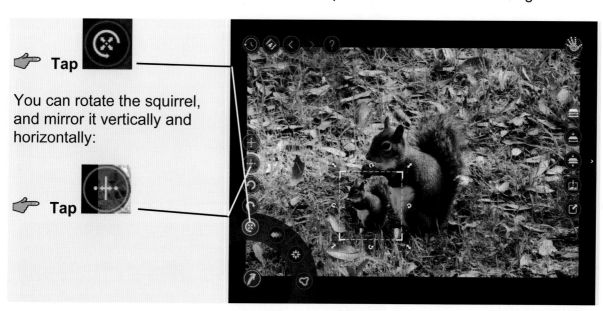

Now the squirrel has been
mirrored:

👉 **Tap**

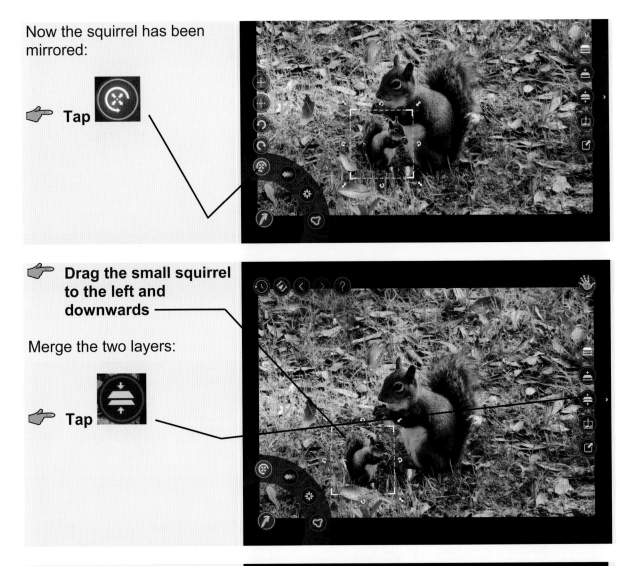

👉 **Drag the small squirrel
to the left and
downwards**

Merge the two layers:

👉 **Tap**

The two layers have merged:

You can clearly see that this
is a composition, due to the
lighter background around the
head and front paws of the
squirrel. If you very carefully
select the object, or if the
photo is more evenly
exposed, this will become
less apparent.

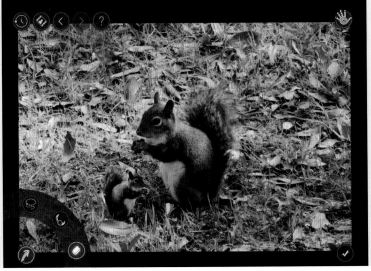

You do not need to apply this edit with . You can close the photo instead:

 Tap

 Tap

Note that since you have not applied the edit, you will not be asked whether you want to save the edited photo.

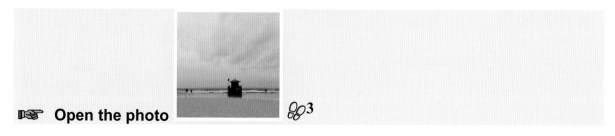 **Open the photo**

In *Handy Photo*, you can move a layer you have created with the Move me tool to another photo:

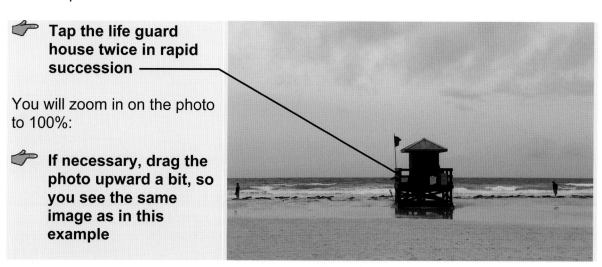

Tap the life guard house twice in rapid succession

You will zoom in on the photo to 100%:

If necessary, drag the photo upward a bit, so you see the same image as in this example

Select the Move Me tool again:

 Tap

☞ **Tap**

The lasso is selected:

☞ **Drag around the house and flag**

Include the reflection of the house in the pool of water too:

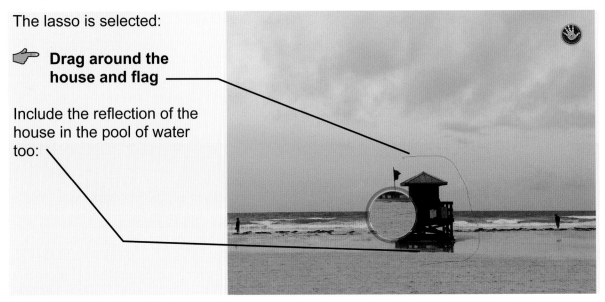

If the object is clearly in contrast with its surroundings, you can optimize the selection automatically:

☞ **Tap**

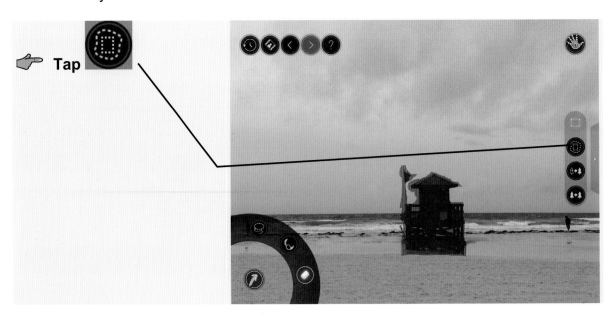

Now you see that the selection has become much more precise:

Part of the roof is no longer selected, because its color is very similar to that of the sky:

👉 **Tap**

👉 **Drag over the edge of the roof**

If necessary:

👉 **Tap**

👉 **Drag over the areas that have wrongly been selected**

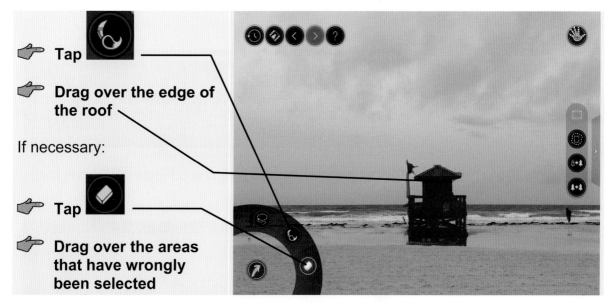

You can now add this selection to a new layer:

👉 **Tap**

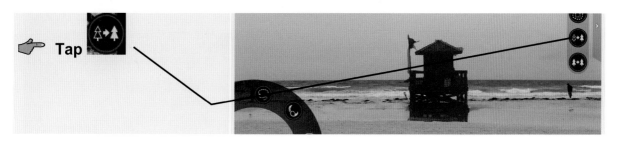

Here you see the new layer:

This is how you copy the layer to another photo:

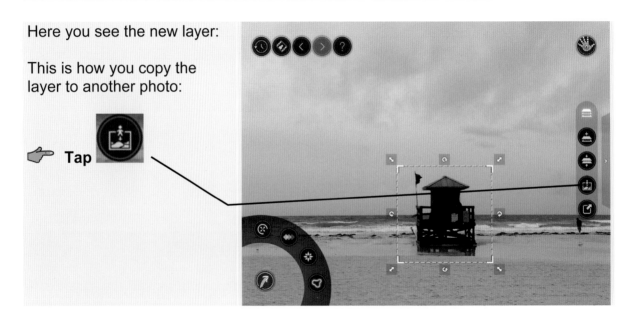

☞ **Tap**

Select another beach photo:

☞ **Tap**

The photo will be opened and you will see the new layer on the photo. You can move the layer with the life guard house:

☞ **Drag the house to the front**

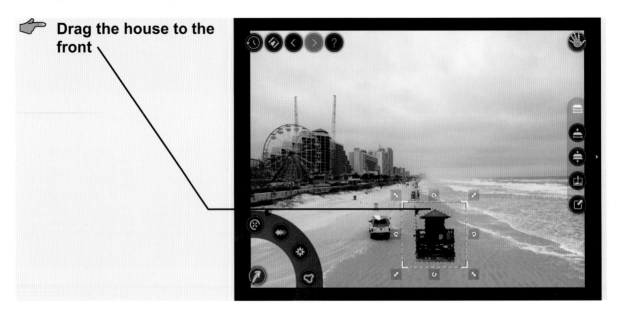

Compared to the car, the house is too small. You can make the house larger:

☞ **Drag the handle 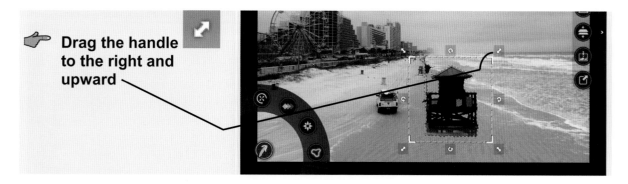 to the right and upward**

To allow the copied object to merge into the background more effectively, you can blur the edges a bit:

☞ **Tap**

☞ **Drag across the screen from left to right until you see Edge smoothness: 40%**

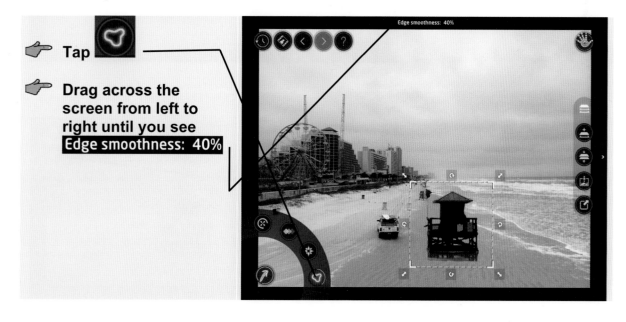

You can also adjust the color saturation of this layer:

👉 **Tap**

👉 **Drag across the screen from left to right until you see Saturation: 100%**

Now the red color has become brighter:

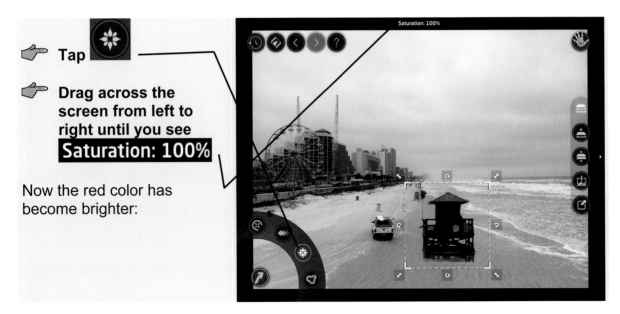

Merge both layers:

👉 **Tap**

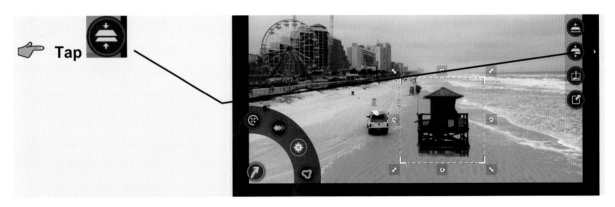

You will see the result:

 Tap

Close the photo and do not save the edits:

 Tap

 Tap

 Tap

☞ **Close the *Handy Photo* app**

By now you may have noticed that the *Handy Photo* app has lots of great features. In the next chapter you will learn how to use the Filters, Textures, and Lists tools. In the following section, however, we will discuss another useful photo editing app.

2.12 Adobe Photoshop Express

Adobe is a very well-known name in the field of photo editing. The company has manufactured a number of photo editing programs such as *Photoshop CS, Photoshop Lightroom* and *Photoshop Elements*. You may also be familiar with the well-known PDF viewer *Adobe Reader*. Adobe now offers a photo editing app: *Adobe Photoshop Express*.

The app can be downloaded for free. Just like the *Aviary* app, there are additional options that can be downloaded for a fee, but you will not be using these options in this book.

☞ **Download the *Adobe Photoshop Express* app**

☞ **Press the Home button**

☞ **Open the *Adobe Photoshop Express* app** PS Express 👣2

This app is always used in landscape mode:

☞ **If necessary, rotate the iPad a quarter turn**

You will see a screen with some information:

👉 Tap Maybe Later

Allow the app to access your photos:

👉 Tap OK

From now on, we will use the abbreviated name for this app, *PS Express*, as shown above in the screenshot.

👉 Tap
Practice Photos (12)

You will see the practice photos again:

2.13 Correcting Red Eye

In the first chapter, you learned how to remove red eye with a tool in *Aviary*. You can do this also with *PS Express*.

☞ **Open the photo** 👣³

Just like in *Aviary*, the toolbar with the various tools is located below the photo:

👉 **Tap** 👁️

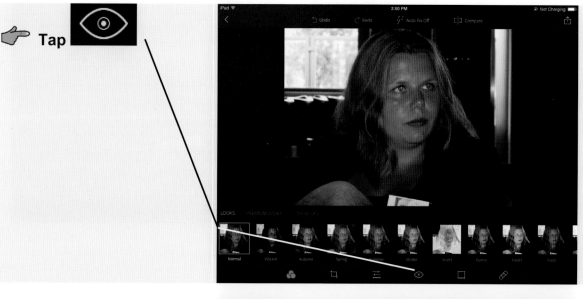

In *PS Express* you can remove red eye from people as well as from pets. By default, the PEOPLE setting is selected: ──────

You can allow the app to automatically detect and correct the red eyes:

👉 **Tap**

Red Eye Auto Detect & Correct

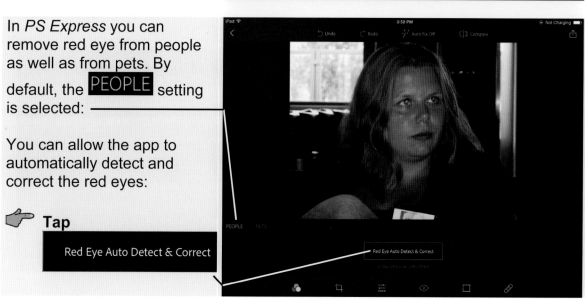

The app will search for red eyes in this picture:

The red eyes have been automatically corrected:

Unfortunately, the automatic detection and correction does not work with every photo. It is a good idea to practice a little using the manual correction options. Undo the first edit:

 Tap

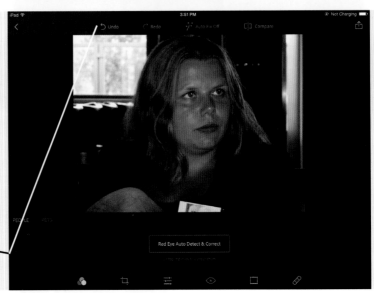

The eyes have turned red again. With manual corrections, it is useful to zoom in on the eyes:

☞ **Tap between the eyes twice, in rapid succession**

Just tap the eye in order to use the manual correction tool:

 Tap the eye on the left

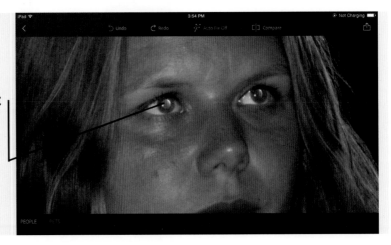

The eye will be corrected:

☞ **Tap the eye on the right**

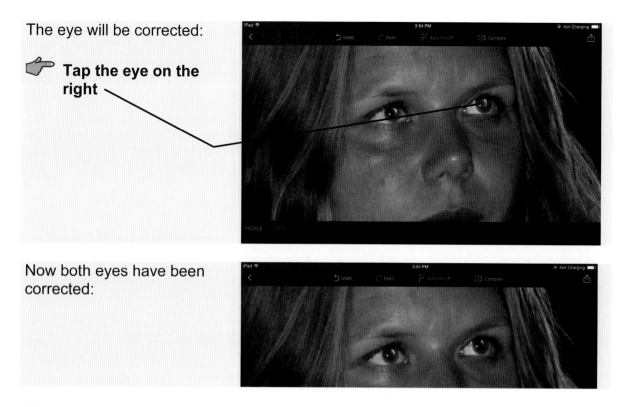

Now both eyes have been corrected:

Zoom out again:

☞ **Tap between the eyes twice, in rapid succession**

Go back to the folder with the practice files:

☞ **Tap** ◀

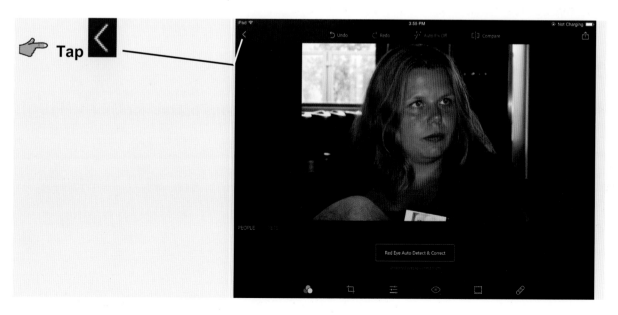

You will be asked whether you want to save the edits before quitting this photo:

Do not save the edits:

You may see a question concerning the sending of usage data to Adobe. For now you will not need to do this:

You will see the album with the practice files again.

2.14 Manual Corrections

Just like *Aviary* and *Handy Photo*, *PS Express* has various options for enhancing photos, both manually and automatically.

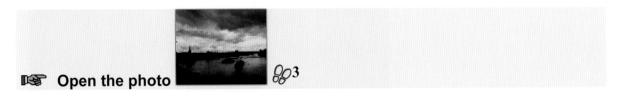

Here you see a picture that was taken on the Charles Bridge in Prague, in cloudy weather at the end of the day. First, you can see what happens with this photo if you use the automatic correction option:

Tap

Auto Fix Off

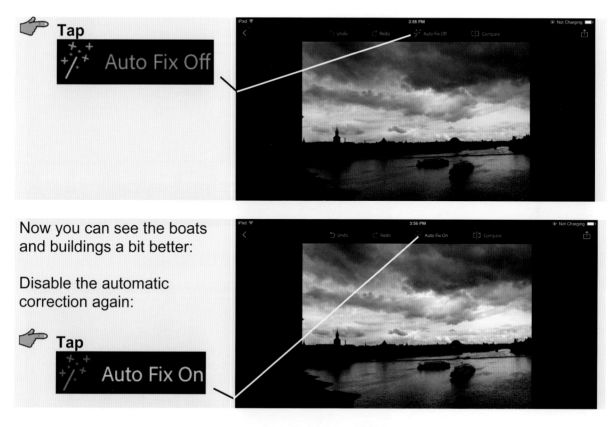

Now you can see the boats and buildings a bit better:

Disable the automatic correction again:

Tap

Auto Fix On

Now you can try some of the manual correction options on this photo:

Tap

Below the photo you see small thumbnail pictures above the diverse array of manual editing options:

If you see a padlock 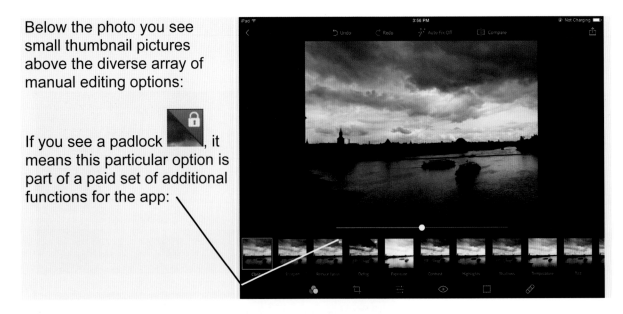, it means this particular option is part of a paid set of additional functions for the app:

First you can practice adjusting the exposure of the photo:

👉 **Tap** Exposure

👉 **Drag the slider ⬤ to the right until you see**

40

The photo becomes lighter:

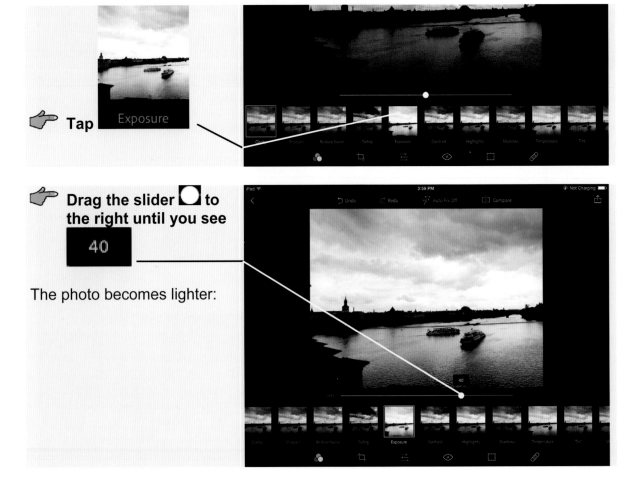

Next, you can try to increase the contrast. This will make the difference between the darker and lighter areas of the photo become clearer:

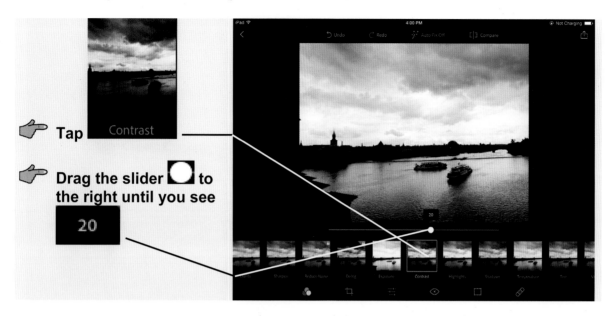

In the front of this photo, the pillars of the bridge are still very dark. You can try to make them along with other darker areas a bit lighter by correcting the shadows:

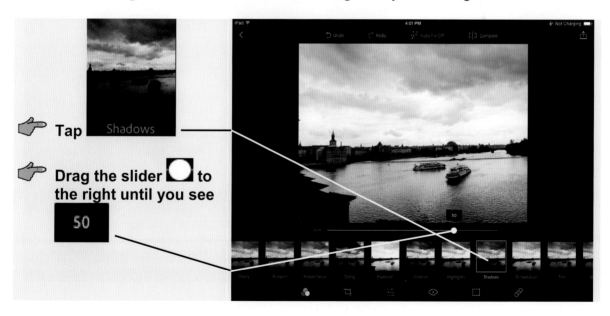

Now the photo is a lot clearer, but the sky is still a bit too bright. You can solve this problem by darkening the lighter areas (the highlights):

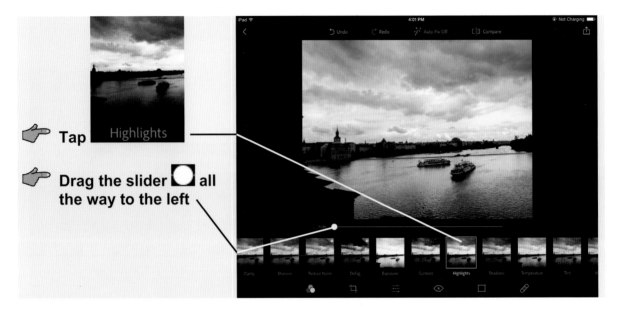

☞ **Tap** Highlights

☞ **Drag the slider ⬤ all the way to the left**

By increasing the color saturation (the vibrancy), the colors become more vivid:

☞ **Drag the toolbar, from right to left**

☞ **Tap** Vibrance

Before applying a correction, you can display the photo full screen, like this:

👉 **Tap the photo**

You will see the photo full screen:

👉 **Drag the slider ⬤ to the right until you see** `60`

Now the photo has acquired more color, but also a bluish tone. You can correct this by increasing the color temperature. First you need to display the toolbar again:

👉 **Tap the photo**

The photo will be displayed a bit smaller:

👉 **Tap** Temperature

👉 **Tap the photo**

You will see the photo on a full screen again:

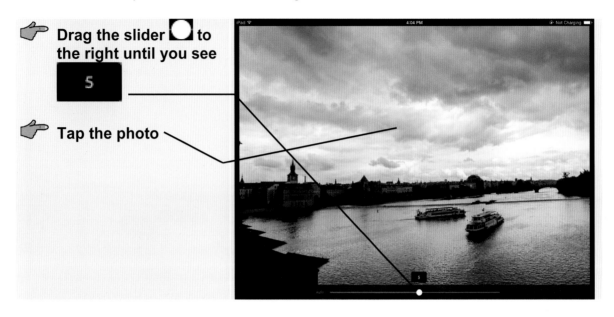

☞ **Drag the slider 🔘 to the right until you see**

5

☞ **Tap the photo**

In *PS Express* you can quickly and easily compare the original and edited photos:

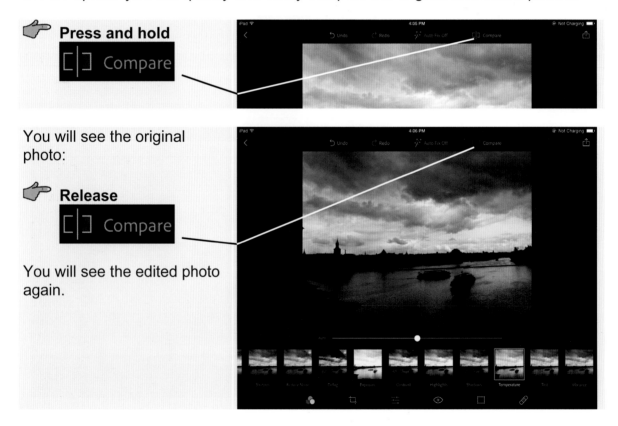

☞ **Press and hold**

[|] Compare

You will see the original photo:

☞ **Release**

[|] Compare

You will see the edited photo again.

In *PS Express* you can separately save the edited photo in the Camera Roll. This way, the original photo will be saved too. You do that like this:

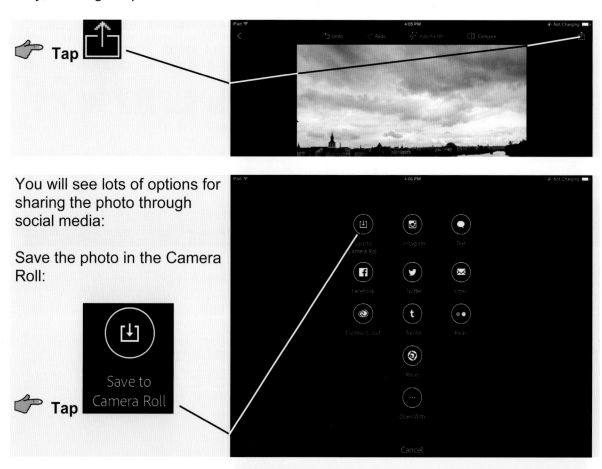

☞ **Tap**

You will see lots of options for sharing the photo through social media:

Save the photo in the Camera Roll:

☞ **Tap**

You will see a notification that the photo has been saved in the Camera Roll:

You can check to make sure:

☞ **Tap**

☞ **Tap**
Camera Roll (19)

The edited photo has been
saved:

You have been given a short introduction to the *PS Express* app. In the next chapter you will learn more about this app by working with the Looks, Edges, and Frames effects.

🖘 **Close the *PS Express* app** ᯓ⁷

In the next few exercises you can practice what you have learned in this chapter.

2.15 Exercises

The following exercises will help you master what you have just learned. Have you forgotten how to perform a particular action? Use the number beside the footsteps to look it up in the appendix *How Do I Do That Again?*

Exercise 1: Automatic Enhancement and Sharpening

In this exercise you will practice using the automatic enhancement and sharpening tools in the *Handy Photo* app.

☞ Open the *Handy Photo* app. ℗²

☞ Open the photo . ℗⁵¹

☞ Set the automatic enhancement Auto Levels control to 50%. ℗²²

☞ Apply the edit. ℗²³

☞ Disable the Auto Levels control. ℗²⁴

☞ Zoom in on the ferris wheel. ℗²⁵

☞ Sharpen the photo to 60%. ℗²⁶

☞ Compare the difference with the original photo. ℗²⁷

☞ Apply the edit. ℗²³

☞ Zoom out. ℗²⁸

☞ Go back to the original photo. ℗²⁹

☞ Do not save the edited photo. ℗³⁰

Exercise 2: Magic Crop

In this exercise you can practice rotating, straightening, and uncropping a photo.

☞ Open the photo . ᨑ⁵¹

☞ Rotate the photo a quarter turn to the right. ᨑ³¹

☞ Apply the edit. ᨑ²³

☞ Straighten the flag and the building. ᨑ³²

☞ Uncrop the photo from the lower right corner. ᨑ³³

☞ Reset the parameters for the tools you have used. ᨑ³⁴

☞ Do not save the edited photo. ᨑ³⁰

Exercise 3: Retouching

In this exercise you can practice using the Retouch tool to extract an object.

☞ Open the photo . ᨑ⁵¹

☞ Zoom in on the car. ᨑ²⁵

☞ Remove the car with the Retouch tool. ᨑ³⁵

☞ Apply the edit. ᨑ²³

☞ Zoom out. ᨑ²⁸

☞ Save the edited photo. ᨑ³⁶

☞ Close the photo. ᨑ³⁷

Exercise 4: Move Me

In this exercise you can practice working with layers.

☞ Open the photo . 🐾**51**

☞ Select the Move Me tool. 🐾**38**

☞ Move the sailing boat to a new layer. 🐾**39**

☞ Move the layer with the sailing boat to the left. 🐾**40**

☞ Undo the last operation. 🐾**41**

☞ Duplicate the layer with the sailing boat. 🐾**42**

☞ Mirror the layer with the second sailing boat vertically. 🐾**43**

☞ Drag the layer with the second sailing boat to the left of the first boat. 🐾**40**

☞ Merge both layers. 🐾**44**

☞ Apply the edit. 🐾**23**

☞ Do not save the edited photo. 🐾**30**

☞ Close the *Handy Photo* app. 🐾**7**

2.16 Background Information

Dictionary

Clone source	The area of the photo you have selected in order to copy it to another spot in the photo.
Clone stamp	The tool that actually duplicates the *clone source* to another spot. While you are moving the clone stamp, the clone source moves along with you. You can also adjust the size of the cloned object, making it larger or smaller.
Cloning	Duplicating an area of a photo to another spot in the photo.
Control	The part of a tool in *Handy Photo*, with which you can adjust a specific setting or perform a particular task.
Magic Crop	A function in *Handy Photo* with which you can *uncrop* and straighten a photo.
Mask	A transparent layer that is laid on top of a photo and in which an edit can be applied. With a mask, you can apply an edit to just one area, instead of the entire photo.
Mask brush	A tool with which you can select a specific area in a photo. The mask will acquire the shape of the selection.
Move Me	A function in *Handy Photo* that lets you select a specific area of a photo to be moved or copied.
Palette	The tools in *Handy Photo* are displayed on a round palette, instead of on a toolbar. The tools are located on the main palette in the upper right corner, the matching controls are placed on a smaller palette at the lower left. You can scroll through options by revolving the palettes.
Uncrop	This is the opposite of cropping a photo; the photo becomes bigger by dragging the frame outwards. The Magic Crop tool fills in the extra space by repeating areas of the original photo. This works well with pictures of scenery, with lots of grass or sea. Magic Crop has a harder time with people, buildings, or objects.

Source: Wikipedia

2.17 Tips

 Tip

Tutorials Handy Photo
Handy Photo offers brief video tutorials, in which various tools and features of the app are explained. These videos are worth watching. They explain how to perform specific tasks, step by step. You can access the tutorials right from within the app:

If you have opened a photo:

☞ **Tap**

☞ **Tap**

☞ **Tap**

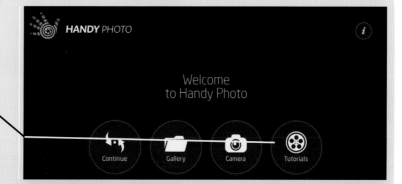

You will see the descriptions for the first three tutorials:

To go to the next page of tutorials:

 Drag the screen from right to left

 If necessary, drag the screen from right to left

- Continue on the next page -

☞ **Tap**

This video is about the filters you will be using in the next chapter.

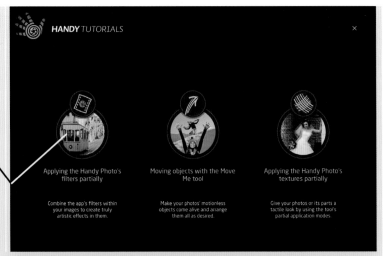

If you have the *YouTube* app installed on your iPad, the video will be displayed in that app. The video will start playing immediately:

Otherwise, the *YouTube* website is opened in *Safari*

and you need to tap ▶ to start playing:

The video is played:

3. Special Effects

You can turn an ordinary photo into an exceptional photo by adding special effects. For example, you can add a color effect with yellow hues to a picture and create the impression of a beautiful summer's day. Other effects can make a photo look older or give the impression that the photo was printed on wooden boards. All the apps you have used in this book until now, contain various effects, also called filters. The special thing about the *Handy Photo* app, is that you can use a mask to apply the effect to just one area of a photo rather than the full photo itself.

In the *Aviary* app, stickers can be added to create humorous effects or give emphasis. A sticker of a moustache could be added to a portrait, for instance. You can change the size of these stickers, rotate them, and place them exactly where you want them to be.

There are many more fun and playful effects for you to experiment with. You can probably find an app for the iPad for every effect you can think of. You could switch the faces of the people in a group photo, or replace a person's head with an animal head, or the other way around. In this chapter you will see some examples of these effects, and get an impression of the options available and how to apply them.

In this chapter you will learn how to:

- add colorful effects to the full photo or to a specific area;
- spice up a photo with stickers or symbols;
- create frames and borders;
- switch faces;
- add animal heads;
- paste a human face onto an animal body.

3.1 Special Effects in the Aviary App

In *Chapter 1 Photo Editing with Aviary* you have learned how to work with the *Aviary* app. Along with the many photo editing tools, the app also lets you add special effects to photos.

☞ **Open the *Aviary* app** 👣²

☞ **Open the photo** 👣³

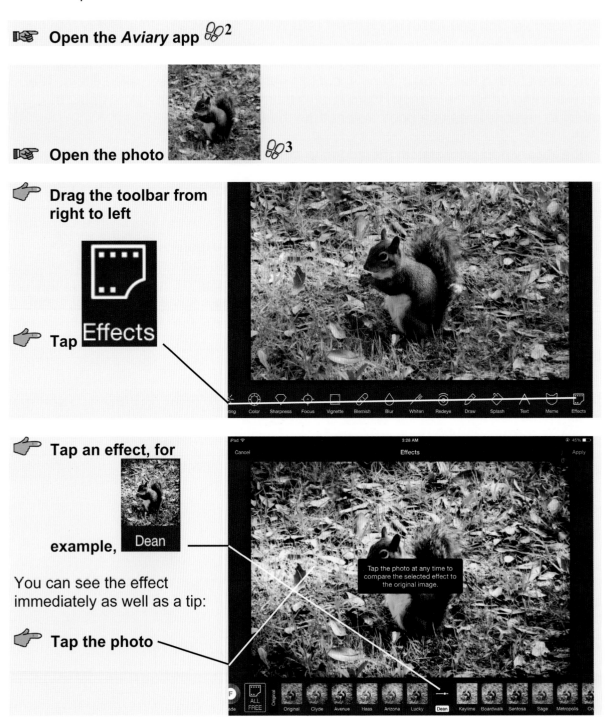

👉 **Drag the toolbar from right to left**

👉 **Tap Effects**

👉 **Tap an effect, for example, Dean**

You can see the effect immediately as well as a tip:

👉 **Tap the photo**

Tap the photo at any time to compare the selected effect to the original image.

Try another effect:

Tap Clyde

The standard effects are free of charge, but other special effects require payment:

👉 **Drag the toolbar from left to right**

You will see the available paid effects:

👉 Tap Winter

The effects change according to the season, so you might

see Autumn instead. Just tap the effect that is available for the season.

The available effects will regularly change, and you may see different sets. You can download these by tapping the price. For now this will not be necessary:

 Tap Cancel

You will see the photo with the effect again. If you want to apply the effect, tap Apply . You do not need to do this right now:

☞ Tap Cancel

☞ Tap Cancel once again

Try another photo:

☞ Open the photo 𝄞𝄞3

☞ Drag the toolbar from right to left

☞ Tap Effects

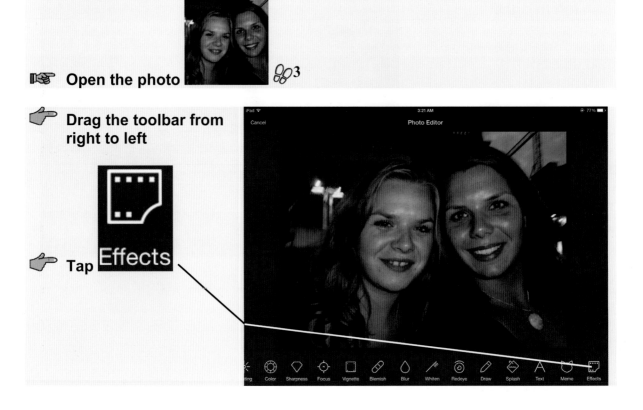

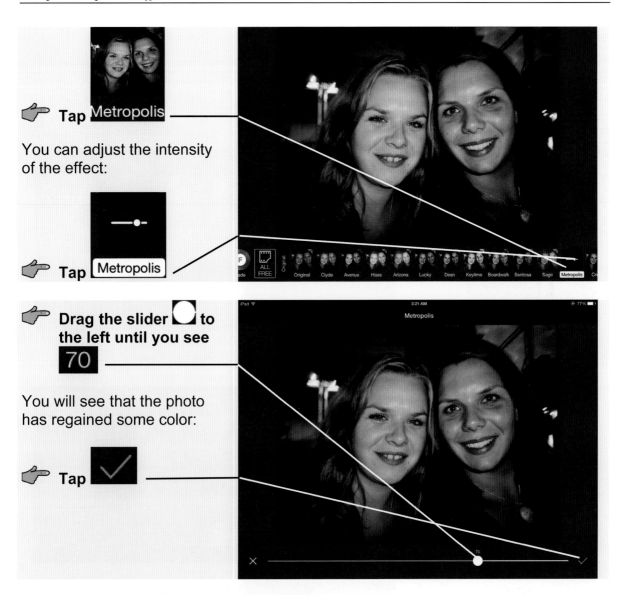

☞ Tap Metropolis

You can adjust the intensity of the effect:

☞ Tap Metropolis

☞ **Drag the slider ◯ to the left until you see** 70

You will see that the photo has regained some color:

☞ **Tap** ✓

Compare the effect with the original photo:

☞ **Place your finger on the photo**

You will see the original colors again:

☞ Tap Cancel

3.2 Adding Stickers

Stickers are small images or symbols that can spice up your photos. You can compare them to the stickers with text and pictures that are used in photo albums. This is how you add a sticker:

☞ **Drag the toolbar from left to right**

☞ Tap Stickers

First, you will need to download the stickers to your iPad. This is free of charge.

☞ Tap Original

You may see a different picture. Tap that picture.

Download the second set of free stickers as well:

☞ Tap Signature

The stickers are downloaded.

Tap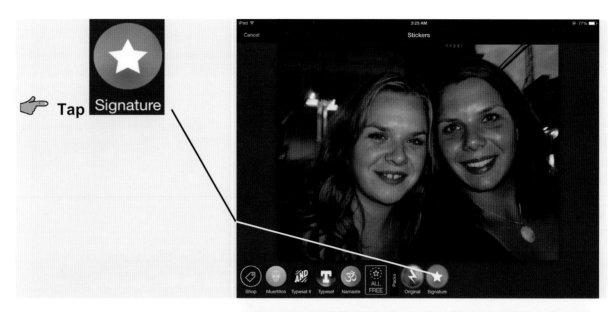

You will see the stickers:

Tap

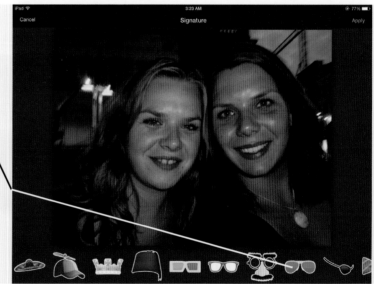

The sticker is placed on the photo within a frame:

Drag the spectacles on to the eyes of the girl on the right

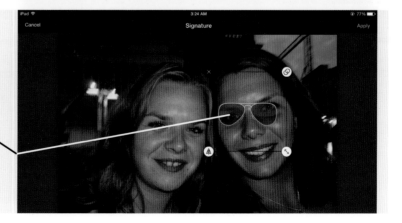

In order to rotate or resize the sticker:

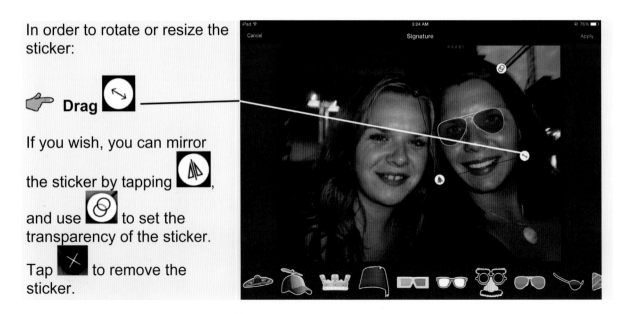

👉 **Drag**

If you wish, you can mirror

the sticker by tapping ![mirror icon],

and use ![transparency icon] to set the transparency of the sticker.

Tap ![remove icon] to remove the sticker.

👉 **Tap** Apply

Now the sticker is placed on the photo. You can undo this operation:

👉 **Drag the photo from left to right**

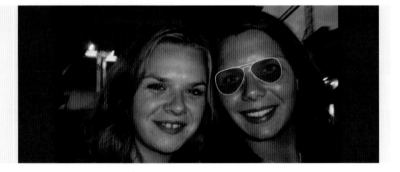

3.3 Adding Frames

There are many types of frames that can be added to your photos:

👉 **Tap** Frames

You will need to download the free frames to your iPad too:

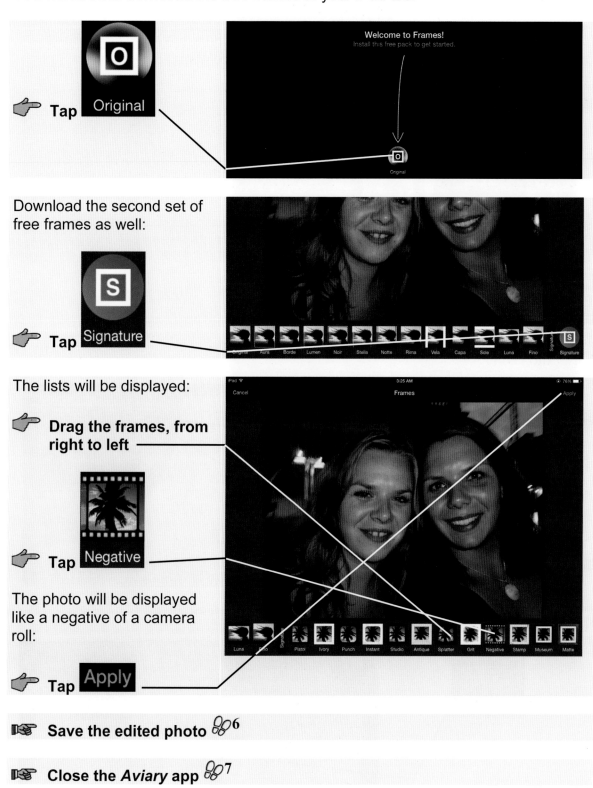

👉 **Tap** Original

Download the second set of free frames as well:

👉 **Tap** Signature

The lists will be displayed:

👉 **Drag the frames, from right to left**

👉 **Tap** Negative

The photo will be displayed like a negative of a camera roll:

👉 **Tap** Apply

👉 **Save the edited photo** 🦶🦶6

👉 **Close the *Aviary* app** 🦶🦶7

3.4 Special Effects in the Handy Photo App

In the *Handy Photo* app, the effects are called filters. There are more adjustment options available in this app than just the intensity of the effect. Just try a few:

☞ **Open the *Handy Photo* app** 𝒬𝒬2

☞ **Open the photo** 𝒬𝒬3

Open the Filters tool:

👉 **Tap**

👉 **If necessary, drag the main palette upwards**

👉 **Tap**

Try out the Vintage filter. This will make the photo look older:

👉 **Tap**

Your screen may now turn dark and you will see a tip:

 Tap the photo

This is how you open the menu in order to change the settings of the filter:

☞ **Tap**

By the Vintage filter, you can age the photo even more by adding scratches:

☞ **Tap**

☞ **Drag the screen from left to right until you see**

Scratches: 80%

The scratches on the photo will intensify:

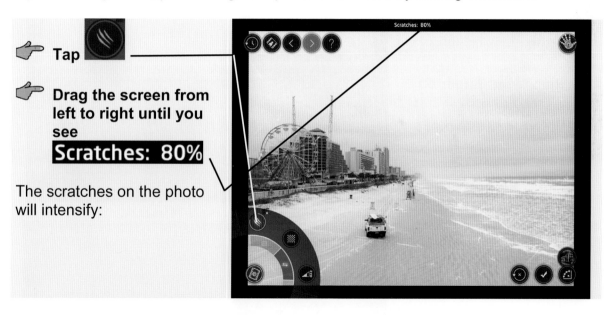

This filter has been applied to the full photo. You can also apply a filter to a small area, by using a mask just like in the previous chapter:

☞ **Tap**

Select the linear gradient mask:

☞ **Tap**

With the current settings of the mask, the filter will only be applied to the top half of the photo:

You can clearly see this if you display the mask itself:

☞ **Place your finger on the circle**

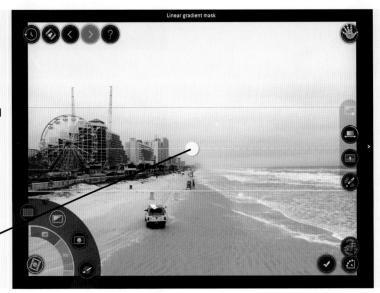

You will see the mask:

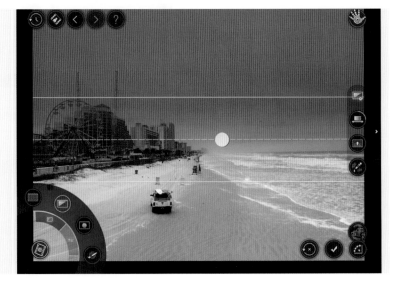

This is how to rotate the mask a quarter turn:

 Place your thumb and index finger between the lines

 Turn your thumb and index finger until the mask is upright

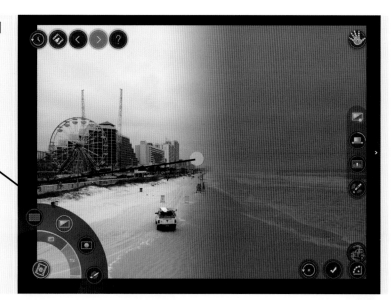

Now the filter will only be applied to the right half of the photo:

You can reverse this:

 Tap

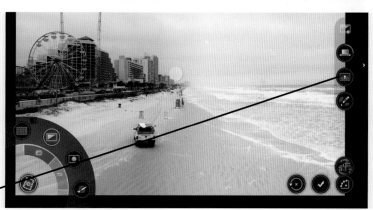

After a few seconds, the mask disappears:

Now the filter has only been applied to the left side:

 Tap

Close the photo and do not save the edits 🔖**30**

3.5 Textures

Textures are patterns that can be added to a photo. A texture can make a photo look like it was printed on wood, or on crinkled paper, for instance.

☞ **Open the photo** 👣**51**

Open the Textures tool:

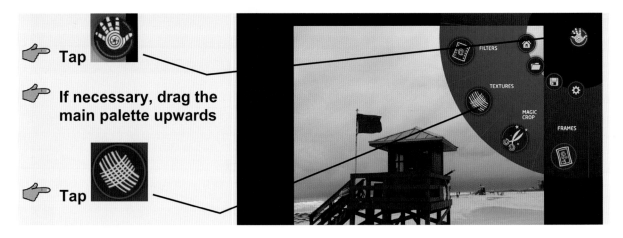

👉 **Tap**

👉 **If necessary, drag the main palette upwards**

👉 **Tap**

Just try out the Paper and Water textures:

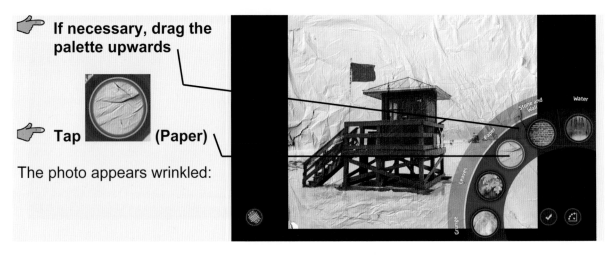

👉 **If necessary, drag the palette upwards**

👉 **Tap** **(Paper)**

The photo appears wrinkled:

☞ Tap 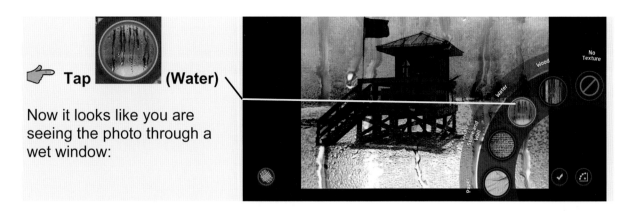 (Water)

Now it looks like you are seeing the photo through a wet window:

You can edit the settings of the textures as well. Just try this with the Wood texture:

☞ Tap (Wood)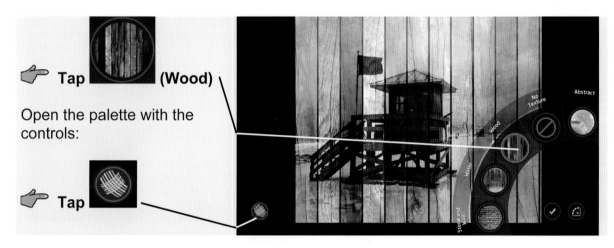

Open the palette with the controls:

☞ Tap

Adjust the scale size of the texture, in order to make the boards wider:

☞ Tap

☞ **Spread your thumb and index finger**

The boards become wider: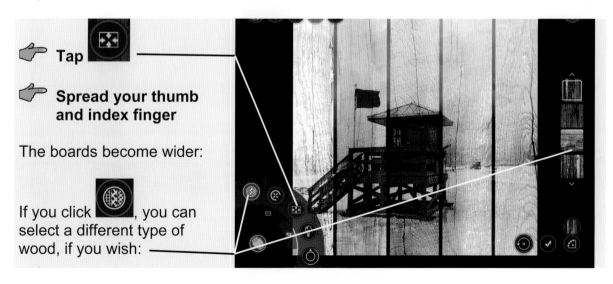

If you click , you can select a different type of wood, if you wish:

☞ **Close the photo and do not save the changes** 👣³⁰

3.6 Frames

Of course, *Handy Photo* also has frames you can use with your photos.

☞ **Open the photo** 🐾**51**

Open the Frames tool:

👉 **Tap**

👉 **If necessary, drag the main palette upwards**

👉 **Tap**

Try the Sea Shell frame:

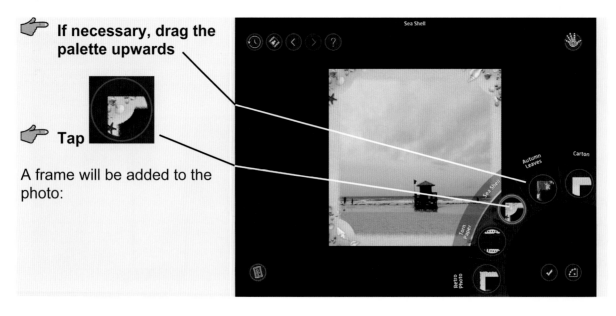

👉 **If necessary, drag the palette upwards**

👉 **Tap**

A frame will be added to the photo:

With the Retro Photo frame you can make your photo look like an old photo print:

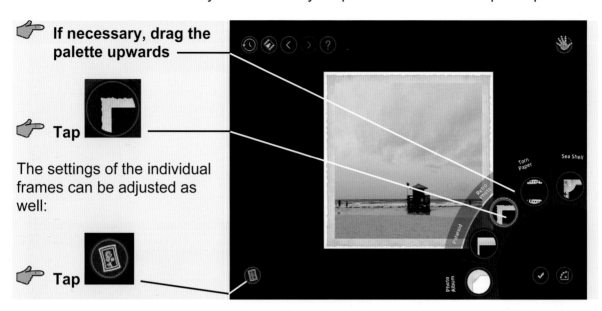

👉 **If necessary, drag the palette upwards**

👉 **Tap**

The settings of the individual frames can be adjusted as well:

👉 **Tap**

This is how you widen the frame:

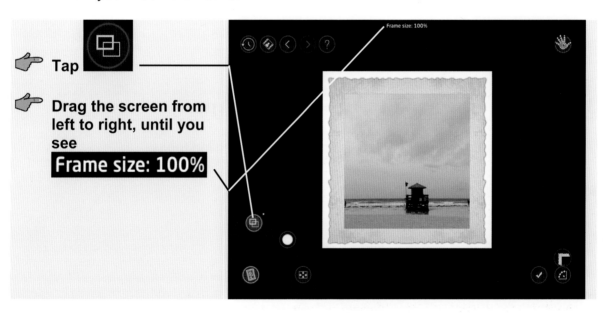

👉 **Tap**

👉 **Drag the screen from left to right, until you see**
Frame size: 100%

Zoom in on the photo:

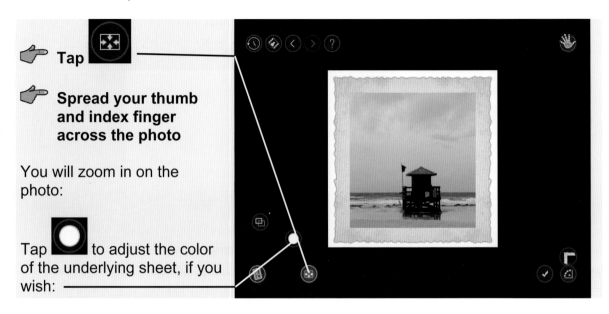

👉 **Tap** [⊠]

👉 **Spread your thumb and index finger across the photo**

You will zoom in on the photo:

Tap [⬤] to adjust the color of the underlying sheet, if you wish:

☞ **Close the photo and do not save the edits** 🦶³⁰

☞ **Close the *Handy Photo* app** 🦶⁷

3.7 Special Effects in the PS Express App

In the *Adobe Photoshop Express* app, the effects are called looks.

☞ **Open the *PS Express* app** 🦶²

☞ **Open the photo** 🦶³

You can give the Winter look a try. Free looks for spring, summer, autumn, and winter are available depending on the season.

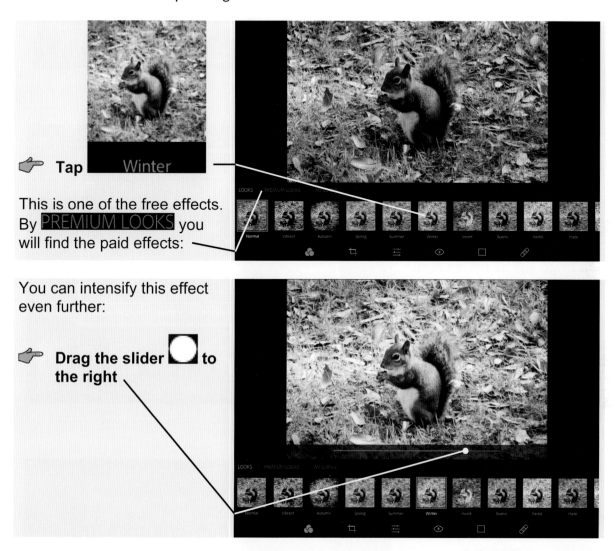

☞ **Tap** Winter

This is one of the free effects. By PREMIUM LOOKS you will find the paid effects:

You can intensify this effect even further:

☞ **Drag the slider to the right**

To go back to the original view of this photo:

☞ **Tap** Normal

You can add a border (called edge in *PS Express*) or frame to the photo:

Tap

First, you select a thin edge from the Basic group:

Tap Thin

The edge will be added right away:

In the Edges group you will find various types of borders:

Tap EDGES

Try a rougher edge:

Tap Rough Edge

Finally, you can take a look at the available frames in the Frames group:

☞ **Tap** FRAMES

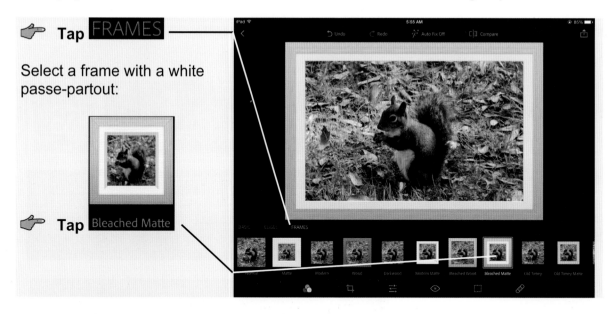

Select a frame with a white passe-partout:

☞ **Tap** Bleached Matte

Do not save the edits:

☞ **Tap** <

☞ **Tap** Don't Save

☞ **Close the *PS Express* app** ✂️7

3.8 Switching Faces

There are all kinds of apps that can be used to create surprising effects. For instance, the apps that let you switch the faces of the persons in a picture. In this section we will discuss the free app called *Face Bomb Fun*.

☞ **Download the *Face Bomb Fun* app**

Face Bomb Fun
- swap faces...
Finger Fun LLC ✂️1

☞ **Press the Home button**

Once you have installed the app to your iPad, it will be called *Face Bomb*.

☞ **Open the** *Face Bomb* **app** ⚹²

This app can be used in portrait (vertical) mode. The first thing you see is a number of ads:

👉 **If necessary, tap** ❌

👉 **If necessary, tap**
No Thanks

👉 **If necessary, tap**
Done

Go to work:

👉 **Tap** →**START**

If you are using this app for the first time, it will offer to let you practice with a sample photo. This will not be necessary:

☞ **Tap** No

You will see some tips about using the app. When switching faces, you will achieve the best effect if both persons look straight ahead and both faces have the same exposure. The app does not work well if someone is wearing a hat or other accessory.

Select an existing photo from the Library (that is to say, the Camera Roll):

☞ **Tap**

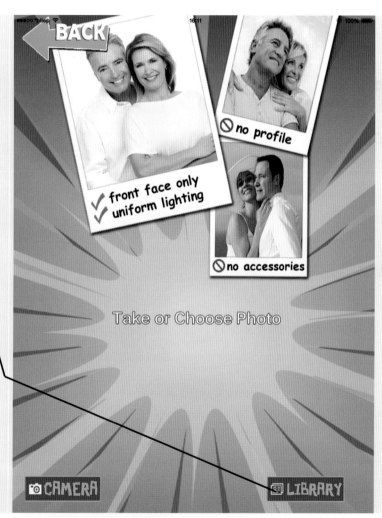

You need to allow the app to access your photos:

☞ **Tap** OK

"Face Bomb" Would Like to Access Your Photos

Don't Allow OK

👉 **Tap the folder with the practice photos**

Practice Photos
12

👉 **Tap the photo**

You will see a tip regarding moving and rotating faces, zooming in, and adjusting colors and brightness after you have switched the faces:

👉 **Tap the photo**

The tip disappears. Now you can switch the faces:

👉 **Tap**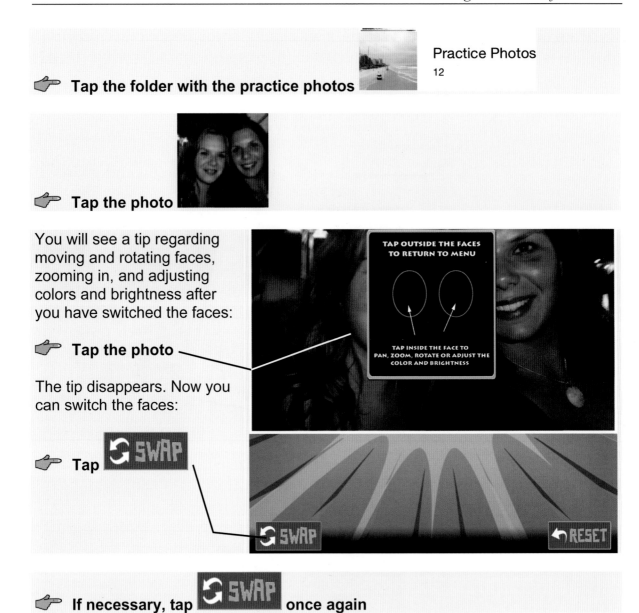

👉 **If necessary, tap** **once again**

The faces have been swapped, but the result is not quite satisfactory:

The face of the girl on the left is placed too far to the right:

The facial color of the girl on the right is a little off:

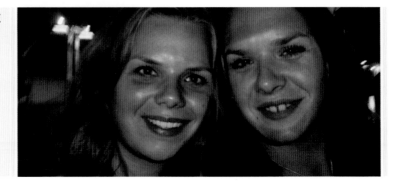

☞ **Tap the face on the left**

☞ **Drag the face to the left a bit**

☞ **Tap the face on the right**

With the sliders below the photo you can adjust the color and brightness:

☞ **Drag the slider** ⬤ **by** ⬤ **to the right a bit**

☞ **Drag the slider** ⬤ **by** ◐ **to the left a bit**

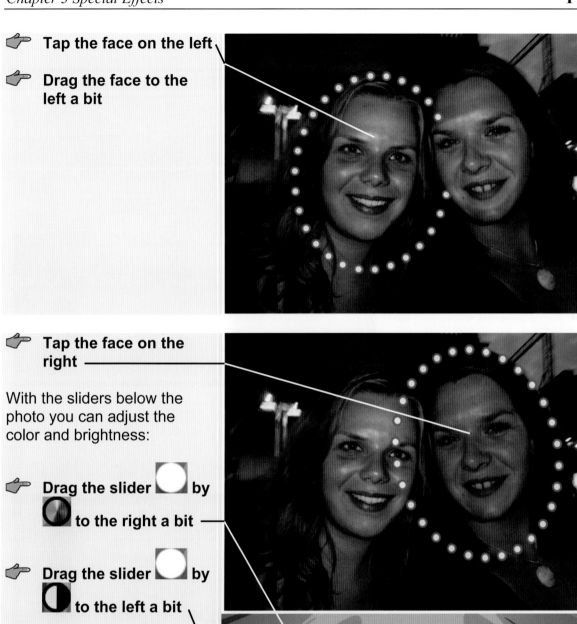

If you are satisfied with the edits, you can save the photo:

☞ **Tap the photo, next to the frame** ——

☞ **Tap**

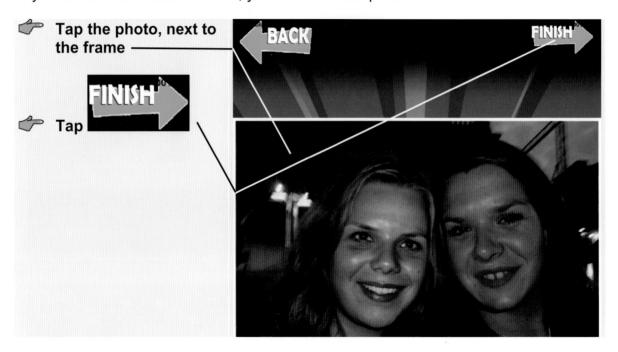

You will see another ad:

☞ **Tap** ✕

This is how you save the photo in the Camera Roll:

☞ **Tap** LIBRARY

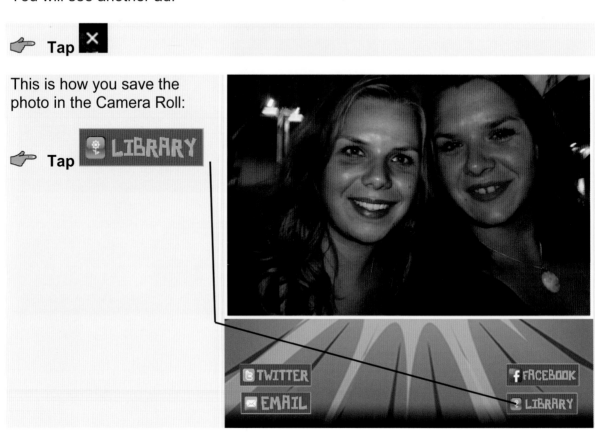

The app will confirm that the photo has been saved:

👉 Tap **Dismiss** —————————— Dismiss

👉 **Close the *Photo Bomb* app** 🐾⁷

3.9 Inserting Animal Heads

With the *Animal Face* app you can quickly create funny effects by replacing the face of a person or an animal with the head of another animal.

👉 **Download the *Animal Face* app** 🐾¹

Animal Face - IG
Photo Editor Booth
Easy Tiger Apps, LLC.
★★★★★ (8)

👉 **Open the *Animal Face* app** 🐾²

👉 **If necessary, tap OK**

You can use this app in portrait mode. Open a photo from the Library and allow the app to access your photos:

👉 Tap **LIBRARY**

👉 Tap **OK**

👉 **Tap the folder with the practice photos**

Practice Photos
12

☞ **Tap the photo**

The app uses a square photo size. If you wish, you can move the frame and zoom in on the photo. For now this will not be necessary:

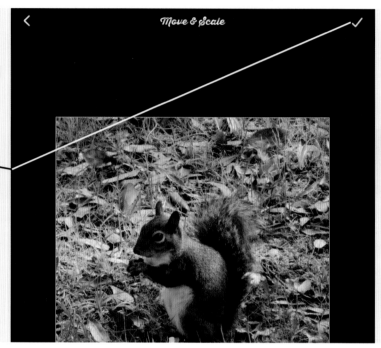

☞ **Tap**

You can add a different animal head:

☞ **Tap**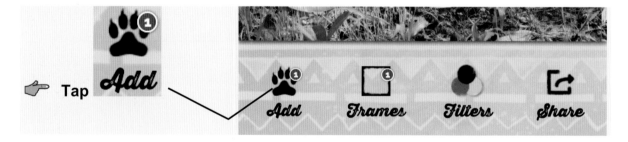

You may see an ad with an offer for upgrading the app:

☞ **If necessary, tap**

These are the heads you can choose from:

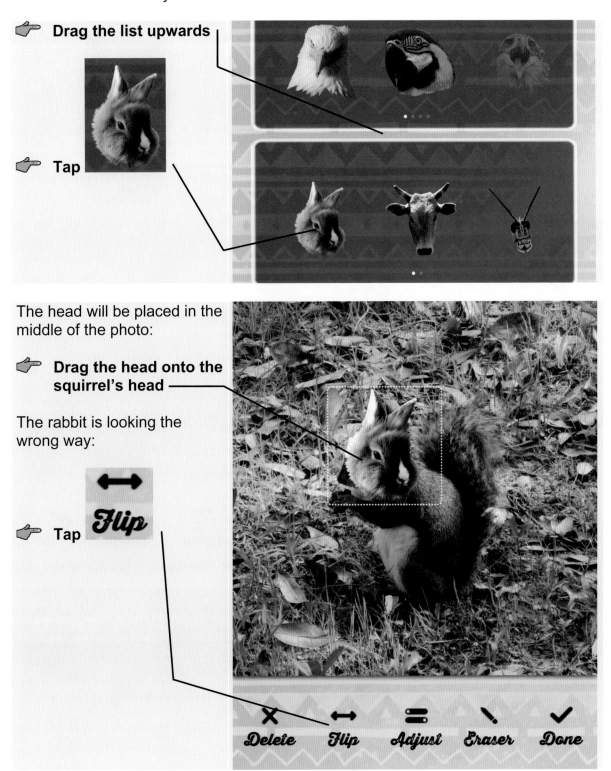

☞ **Drag the list upwards**

☞ **Tap**

The head will be placed in the middle of the photo:

☞ **Drag the head onto the squirrel's head**

The rabbit is looking the wrong way:

☞ **Tap** *Flip*

 Drag the head to the right spot

If you wish, you can enlarge the head by spreading your thumb and index finger. For now this will not be necessary.

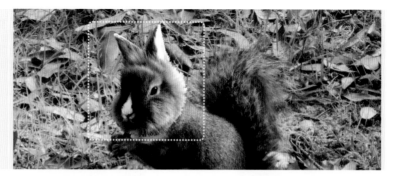

If necessary, you can use

Adjust to adjust the brightness and contrast of the head: ————

Tap **Eraser** to erase part of the head: ————

If you are satisfied with the head:

 Tap **Done**

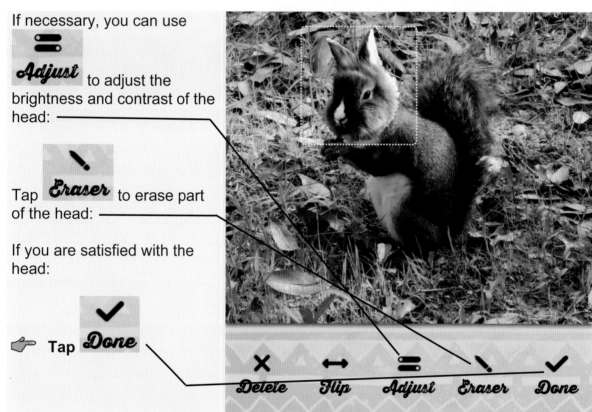

You can also add a frame or filter to the photo, if you wish:

Save the photo:

 Tap **Share**

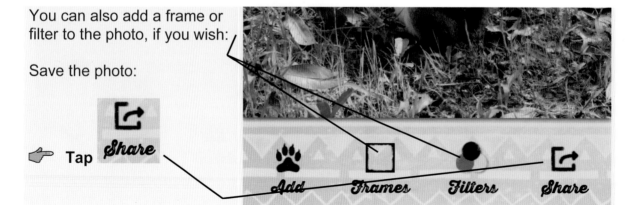

You may see another ad:

👉 **If necessary, tap**

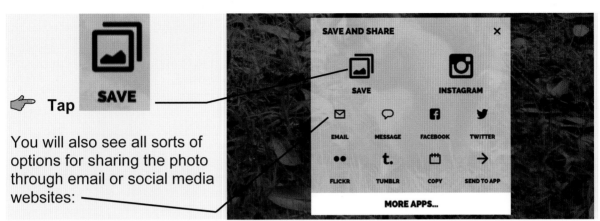

👉 **Tap**

You will also see all sorts of options for sharing the photo through email or social media websites:

You may see yet another ad:

👉 **If necessary, tap** ✕

The photo has been saved:

👉 **Tap** ✕

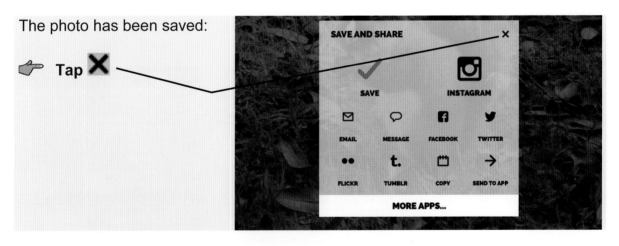

Close the photo and go back to the beginning:

👉 **Tap** Back

👉 **Tap** <

👉 **Close the *Animal Face* app** 👣7

3.10 Inserting Faces in Animal Heads

Instead of pasting an animal head on a person or on another animal, you can do the reverse. With the *Photo Fun Animal* app you can select an animal photo and replace the animal's head by someone's face.

☞ **Download the *Photo Fun Animal* app**

Photo Fun Animal
Reservoir Dev ⌇1

☞ **Press the Home button**

☞ **Open the *Photo Fun Animal* app** ⌇2

You may see an ad right away:

☞ **If necessary, tap** ⊗

☞ **If necessary, tap** Don't Allow

☞ Tap **START**

In this example you will see a photo of a dromedary:

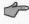 **Drag the screen from right to left**

You will see the next photo:

 Browse through the photos until you see the tiger

Open a photo:

 Tap

Allow the app to access your photos:

 Tap OK

"Photo Fun Animal" Would Like to Access Your Photos

Don't Allow OK

Now you may see another ad. You may also need to wait a few seconds before the icon appears to close the ad:

 If necessary, tap

Tap the folder with the practice photos

Tap the photo

You will see an explanation on how to use the app:

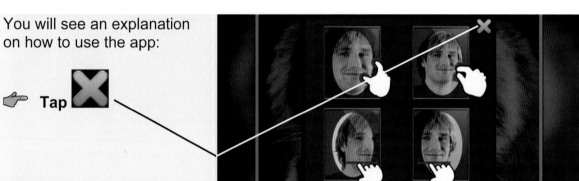 **Tap**

The photo will be placed behind the photo of the tiger:

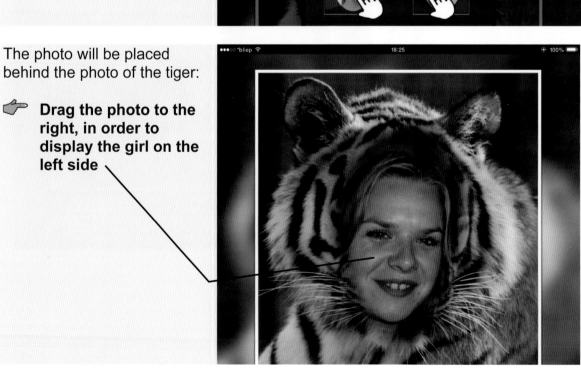 **Drag the photo to the right, in order to display the girl on the left side**

The face is too small, compared to the tiger's head. You can make the face bigger:

☞ **Spread your thumb and index finger**

☞ **Drag the photo to the desired spot**

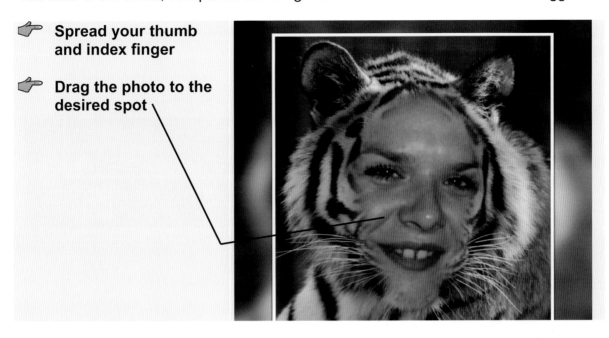

Make the face a bit darker:

☞ **Tap**

☞ **Drag the slider downwards a bit**

The face will become darker:

☞ **Tap**

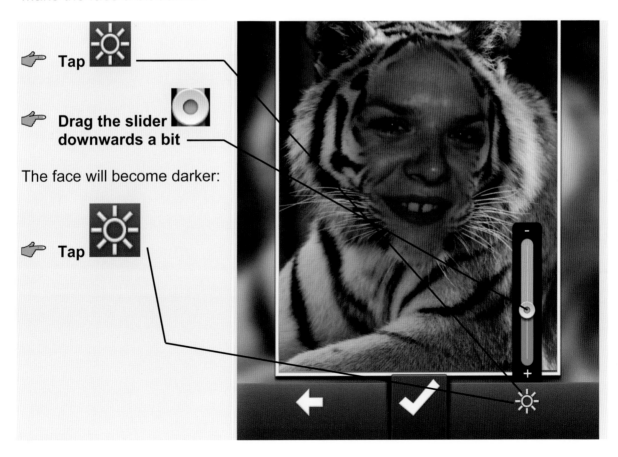

If you are satisfied with the photo:

☞ **Tap**

This is how you save the photo in the Camera Roll:

☞ **Tap**

☞ **If necessary, tap**

☞ **Tap**

You will see the app's home screen again.

☞ **Close the *Photo Fun Animal* app** ℰℰ⁷

In this chapter you have applied various effects to a number of photos. With the exercises in the next section you can practice using these effects once more.

3.11 Exercises

The following exercises will help you master what you have just learned. Have you forgotten how to perform a particular action? Use the number beside the footsteps to look it up in the appendix *How Do I Do That Again?*

Exercise 1: Special Effects in the Aviary App

In this exercise you will be using the effects, frames, and stickers in the *Aviary* app.

☞ Open the *Aviary* app 🐾[2] and open the photo . 🐾[3]

☞ Add the Keylime effect. 🐾[45]

☞ Lower the intensity of the effect to 50%. 🐾[46]

☞ Add the Stamp frame. 🐾[47]

☞ Add the sticker from the Signature group. 🐾[48]

☞ Place the sticker over the lighthouse and slant it a bit. 🐾[49]

☞ Remove the sticker. 🐾[50]

☞ Do not save the edited photo. 🐾[5]

☞ Close the *Aviary* app. 🐾[7]

Exercise 2: The Filter in the Handy Photo App

In this exercise you can apply the filter to a specific area of a photo using the *Handy Photo* app.

☞ Open the *Handy Photo* app. 🐾2

☞ Open the photo . 🐾51

☞ Add the Black-and-White filter. 🐾52

☞ Lower the Drama control to 30%. 🐾53

☞ Select the linear gradient mask. 🐾54

☞ Rotate the mask diagonally. 🐾55

☞ Reverse the effect. 🐾56

☞ Apply the edit. 🐾23

☞ Do not save the edited photo 🐾30 and close the *Handy Photo* app. 🐾7

Exercise 3: Animal Head

In this exercise you can add an animal head to a photo. Please note: in the exercises and footsteps we will not mention the actions needed to close the ads.

☞ Open the *Animal Face* app \wp^2 and open the photo ___ . \wp^{57}

☞ Move the frame, so you cannot see the billboard on the right side. \wp^{58}

☞ Add an animal head to the figure on the left. \wp^{59}

☞ Save the edited photo. \wp^{60}

☞ Go back to the app's home screen. \wp^{61}

☞ Close the *Animal Face* app. \wp^7

3.12 Background Information

Dictionary

Filter	An effect you can apply to a photo in order to make the photo look different.
Looks	Another word for effects, used in the *PS Express* app.
Sticker	An image you can add to a photo.
Texture	An effect that displays a pattern on a photo.

Source: Wikipedia

3.13 Tips

 Tip

Watermark

On the photo you have created with the free *Face Bomb* app, you will see a text:

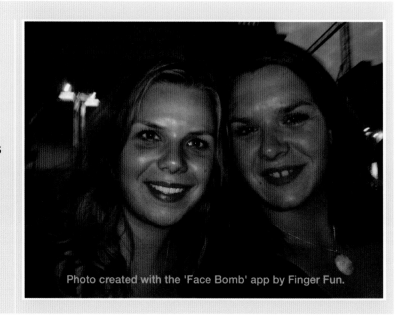

Photo created with the 'Face Bomb' app by Finger Fun.

Unfortunately, there is no option for saving the photo without this text. Neither was there a paid version available, when we were writing this book.

Of course, you can crop the photo in such a way that the text is no longer visible. You can do this with one of the other apps.

 Tip

Photo Fun apps

The creators of the *Photo Fun Animal* app have issued multiple free apps that all work according to the same principle.

This is how you add your own photo to a photo of someone with a special haircut, in the *Photo Fun Haircut* app:

In the *Photo Fun Baby* app you can do the same thing with a baby photo, and in *Photo Fun Sports Legends* you can use a sport celebrity photo.

These apps are operated in the same way as *Photo Fun Animal*. Because these are free apps, you will always see some ads.

4. Creative Projects

By now you have discovered that photo editing is more than just enhancing photos. While working with the practice photos you have already made good use of some creative enhancements by adding special effects, borders, and text. In this chapter we will explore these possibilities even further.

One of the things you can do with your photos, is create a photo collage. In a collage, you can combine a number of photos to give a quick impression of a vacation or an event, such as a wedding, a graduation or a family reunion. There are various apps that will help you create a collage. In this chapter you will learn how to work with the *Photo Grid - Collage Maker & FX Editor* app. You will create a collage, then add text, stickers and special effects to the collage.

The *Pic Sketch Free* app lets you turn a simple photo into an artistic pencil drawing, in seconds.

The *Photo2Fun -1- click Photo Montage* app gives you other possibilities of expressing your creativity while working with photos. Imagine your picture on the cover of a famous international magazine, or your photo as part of a zany, humorous photo compilation. *Photo2Fun* makes all of these things possible.

In this chapter you will learn how to:

- compile and arrange a collage with *PhotoGrid*;
- switch photos;
- use filters;
- add text;
- add stickers;
- turn a photo into a sketch with *Pic Sketch Free*;
- place a photo on the cover of a magazine with *Photo2Fun*;
- create a 1-click photo montage with *Photo2Fun*.

4.1 Creating a Collage

In the following sections you will be creating a collage with the *Photo Grid - Collage Maker & FX Editor* app. First you need to download the app:

☞ **Download the app**

☞ **Press the Home button**

After the installation, the name of the app is shortened to *PhotoGrid*:

☞ **Open the *PhotoGrid* app** 🐾²

You may see a window:

☞ **If necessary, tap**
Done

Select a template for the collage:

☞ **Tap** Grid

You may first see another screen regarding access to your photos:

👉 **If necessary, tap** Give Access

When you see the screen below, you can allow the app to access your photos:

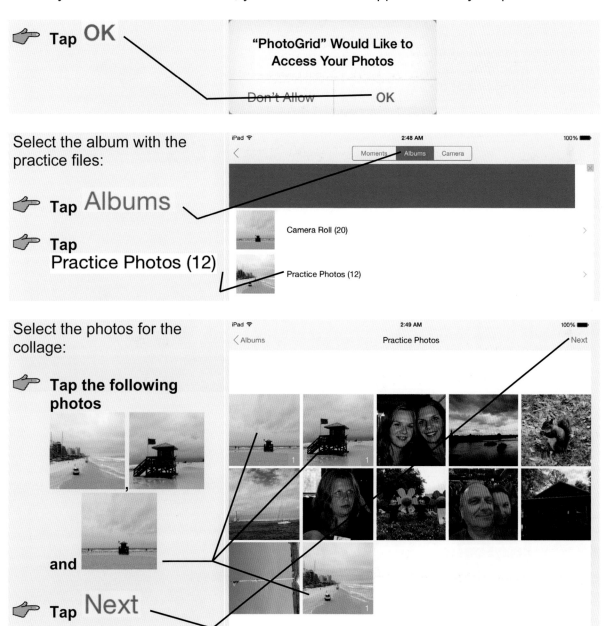

👉 **Tap** OK

> "PhotoGrid" Would Like to
> Access Your Photos
>
> ~~Don't Allow~~ OK

Select the album with the practice files:

👉 **Tap** Albums

👉 **Tap** Practice Photos (12)

Select the photos for the collage:

👉 **Tap the following photos**

and

👉 **Tap** Next

You may see another tip:

☞ **If necessary, tap** `OK`

You will see the initial draft for the collage:

The photos are arranged randomly. You may see a different arrangement on your iPad.

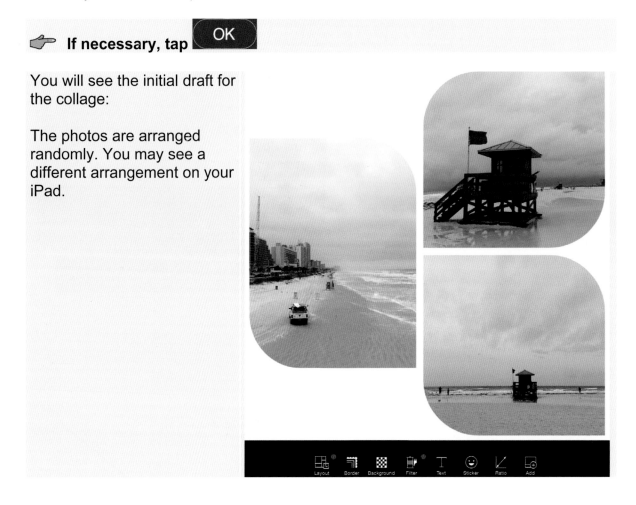

4.2 The Collage Layout

You can easily change the layout of the collage and the order of the photos:

☞ **Tap** `Layout`

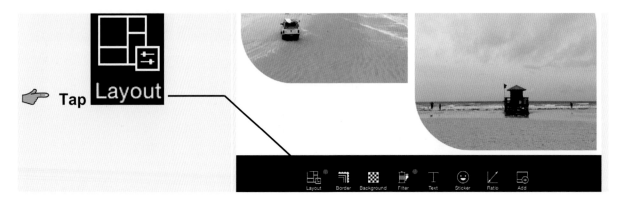

You will see a number of different layouts:

☞ Tap

The layout has changed:

☞ Tap Done

You can enlarge the top segment:

☞ Tap the photo

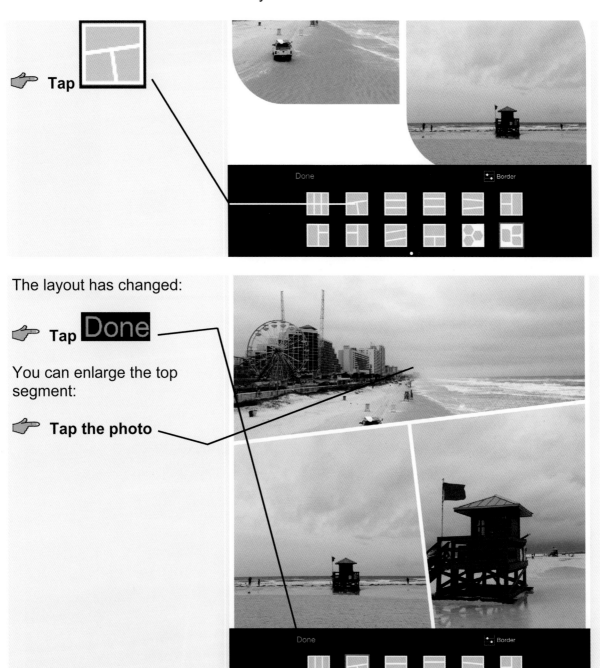

If this is the first time you are using this app, you will see a tip concerning the adjustment of the borders of the collage:

Close the window:

 Tap next to the window

You will see a blue frame around the photo, and a green dot on the bottom edge:

 Drag the green dot downwards

Now you can see the car:

Within this collage, you can practice switching places with two of the photos:

The top photo is already selected:

☞ **Tap** Swap

Select the box where you want to place the photo:

☞ **Tap the photo in the lower right corner**

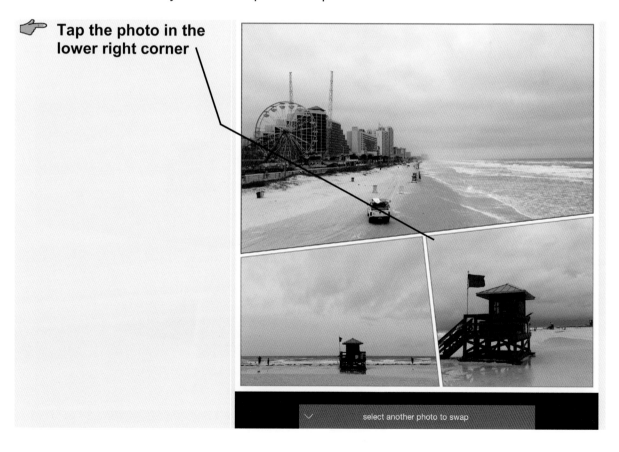

The photos have been swapped:

If the photos on your screen are placed in a different order:

☞ **If necessary, change the order of the photos, so they look like this example**

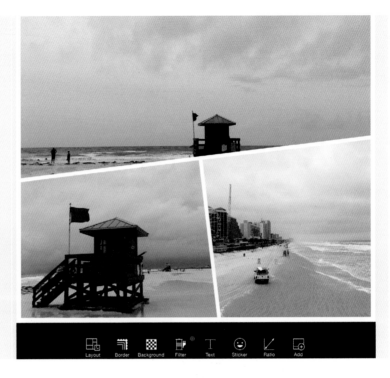

You can also move a photo within its defined area, to display just a specific part:

☞ **Tap the top photo**

☞ **Drag the photo upwards**

You can zoom in on a photo within its defined area, if you wish. For now this will not be necessary.

You can practice moving the photo in the lower right segment so that it displays the ferris wheel:

☞ **Tap the photo**

☞ **Drag the photo to the right**

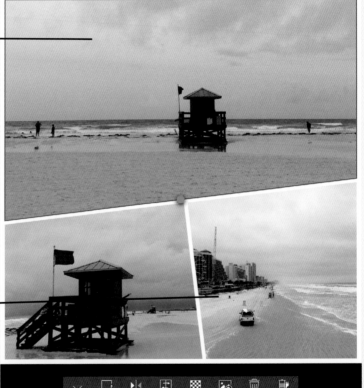

4.3 Using Filters and Borders

PhotoGrid comes with a number of filters that can be used to add some nice effects to your collage. You can give these a try:

☞ Tap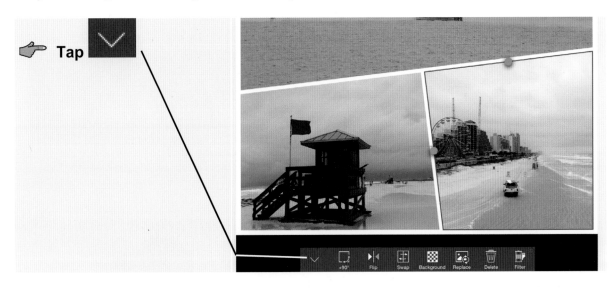

The photo is no longer selected and the blue menu disappears:

☞ Tap Filter

You will see five groups of filters in the dark bar above the thumbnail pictures:

☞ Tap (Scenery)

Each group contains multiple filters:

👉 **Tap** SC4

The filter has been applied to the whole collage:

👉 **Tap** Done

If you select the photo first

and then select Filter in the blue menu, you can set a different filter for each photo.

You can edit the collage a bit further by widening the borders. First, you need to tap Layout and then Border Adjust. Afterwards you can use the sliders to make the borders wider or narrower:

👉 **Tap** Layout

👉 Tap 🎚️ Border

Both the outer borders and the borders between the photos could be a bit wider:

👉 **Drag the slider ⬜ by 🔲 to the right a bit**

👉 **Drag the slider ⬜ by ✚ to the right a bit**

You will see that the borders have become wider:

👉 Tap **Done**

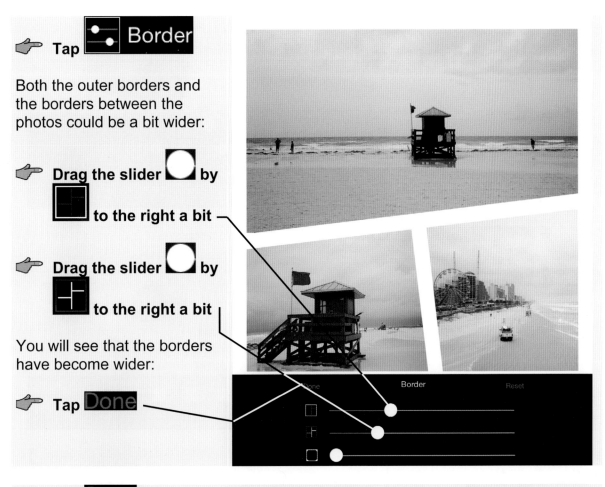

👉 Tap **Done**

You can also add a pattern to the outside border of a collage:

👉 Tap **Border**

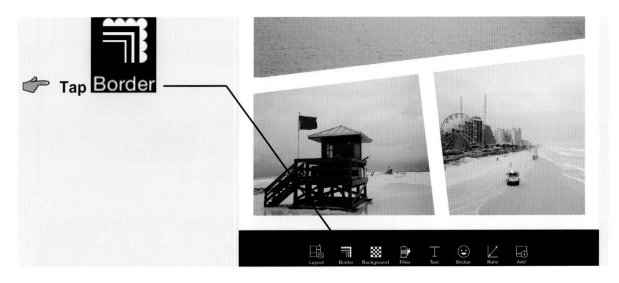

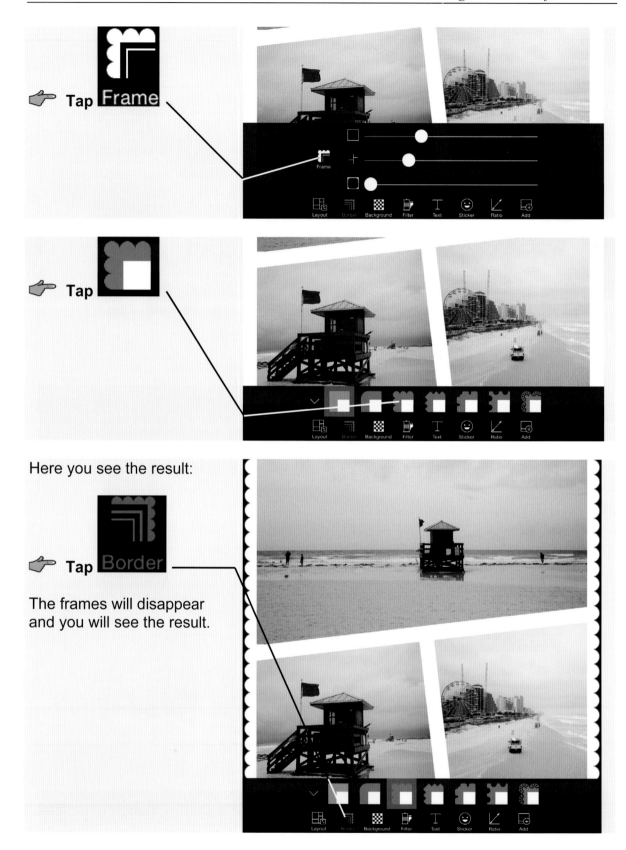

Tap **Frame**

Tap

Here you see the result:

Tap **Border**

The frames will disappear and you will see the result.

4.4 Adding Text

You can now add a brief text:

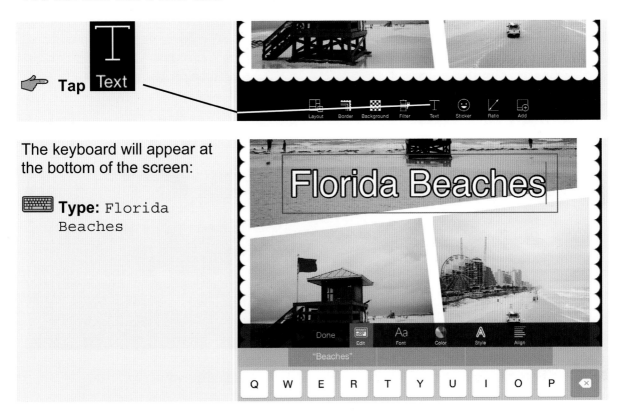

👉 **Tap** Text

The keyboard will appear at the bottom of the screen:

⌨️ **Type:** Florida Beaches

This is how you change the font:

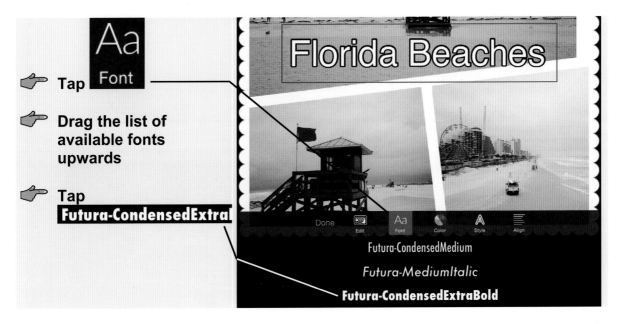

👉 **Tap** Font

👉 **Drag the list of available fonts upwards**

👉 **Tap**
Futura-CondensedExtraBold

The letters can be outlined with a different color:

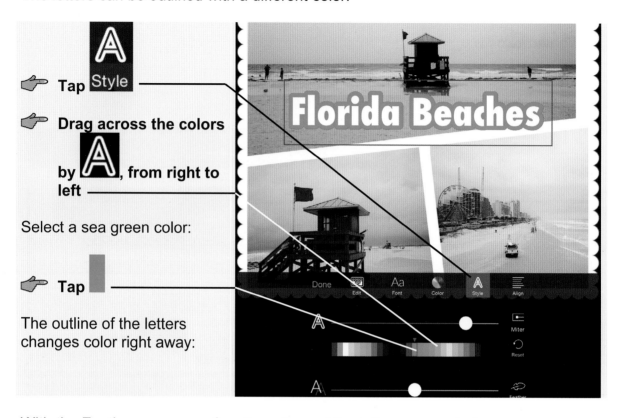

☞ Tap Style

☞ **Drag across the colors**

by , **from right to left**

Select a sea green color:

☞ Tap

The outline of the letters changes color right away:

With the Feather you can soften the edges of the letters somewhat:

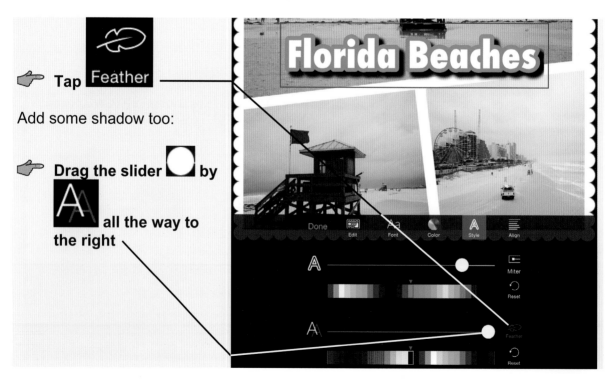

☞ Tap Feather

Add some shadow too:

☞ **Drag the slider** by

all the way to the right

Move the text:

👉 **Drag the text box to the upper right corner**

The text looks rather harsh compared to the photos in the collage. It will look nicer if you render the text (partly) transparent:

👉 **Tap** Color

👉 **Drag the slider ⚪ by** **Opacity** **to the middle**

👉 **Tap** Done

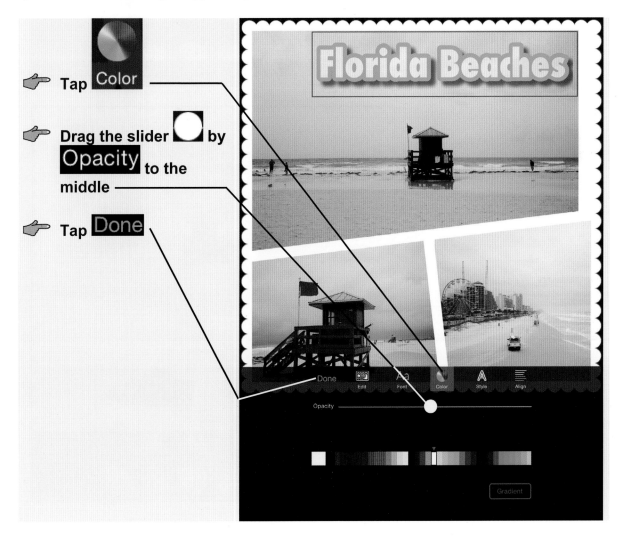

4.5 Adding Stickers

With the Sticker function you can add a standard illustration or a cutout from another photo to the collage. You do that like this:

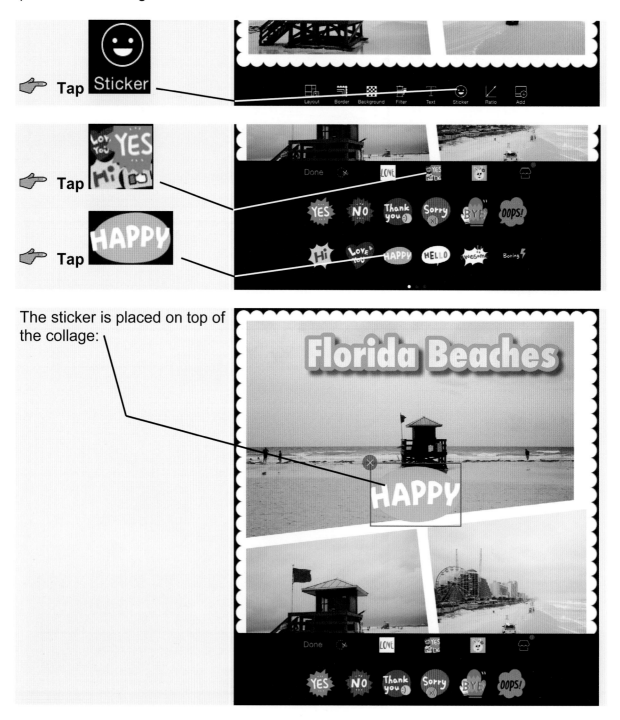

☞ Tap **Sticker**

☞ Tap

☞ Tap

The sticker is placed on top of the collage:

👉 **Drag the sticker to the desired spot** ──

To make the sticker smaller:

👉 **Place your thumb and index finger on the sticker and move them towards each other (pinch)**

To rotate the sticker:

👉 **Place your thumb and index finger on the sticker and turn them**

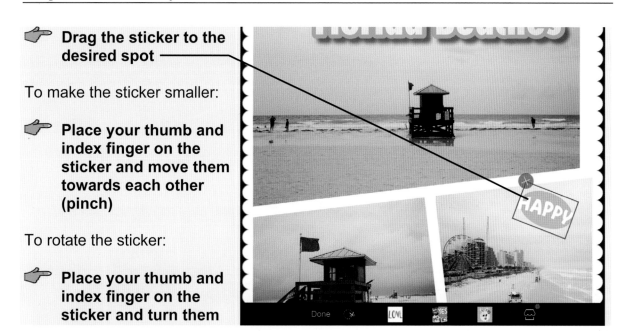

Remove the sticker again:

👉 **Tap**

Instead of using the standard stickers, you can also cut out a specific area of a photo and use that as a sticker:

👉 **Tap** Sticker

👉 **Tap**

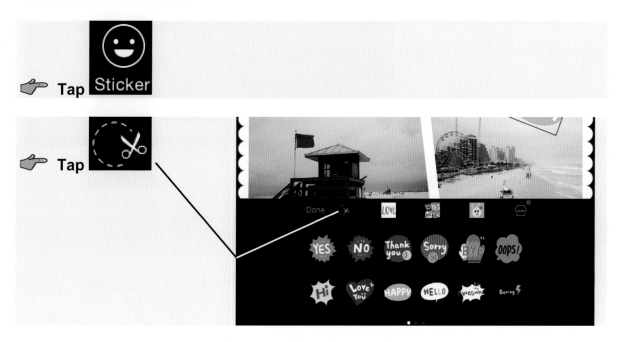

👉 **Tap** Add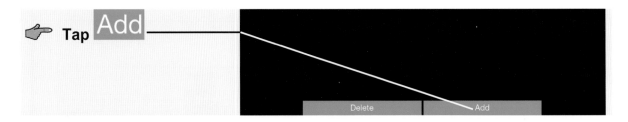

In this example you will be selecting a photo that has already been used in the collage:

👉 **Tap**

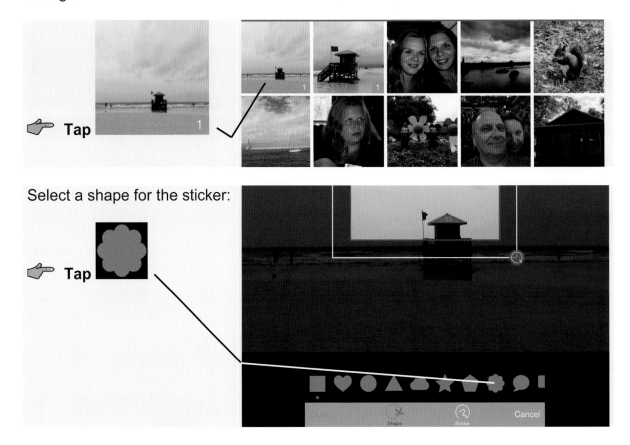

Select a shape for the sticker:

👉 **Tap**

👉 **Drag the shape on top of the shack**

If you wish, you can use the handles ⬛⬛ to adjust the size of the shape:

Tap 🔄 to rotate the shape:

👉 **Tap** Done

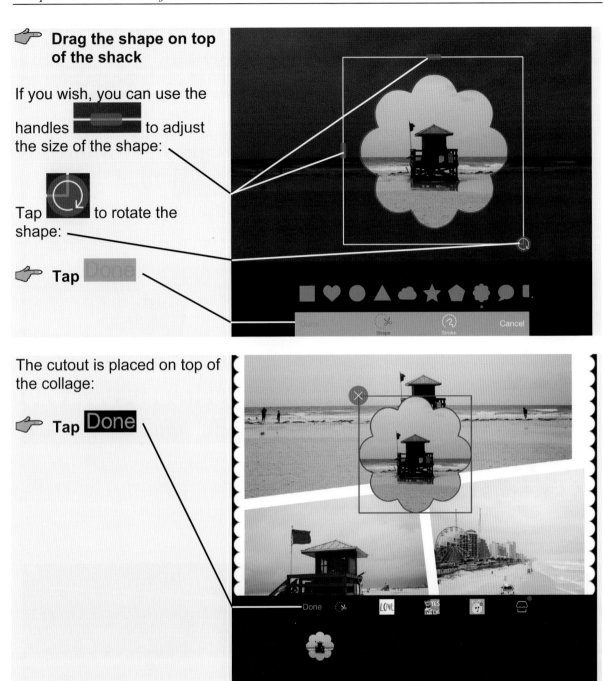

The cutout is placed on top of the collage:

👉 **Tap** Done

☞ **Drag the sticker to the desired spot** ——

You can render the sticker a little more transparent:

☞ **Drag the slider ⚪ by** **Opacity** **to the middle** ——

Remove the sticker again:

☞ **Tap** ⊗

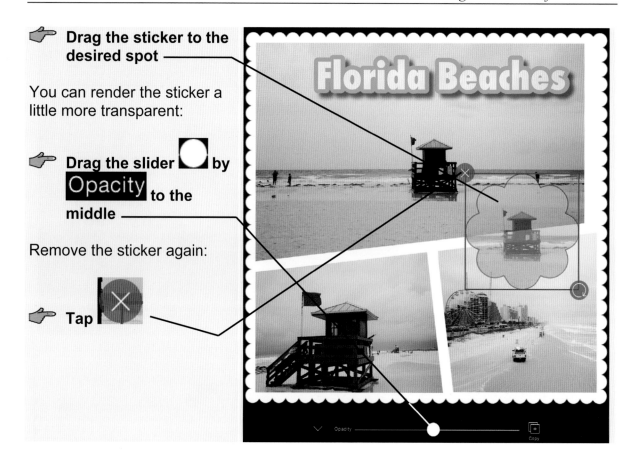

4.6 Saving a Collage

This is how you save the collage in the Camera Roll:

☞ **Tap Save** ——

The collage is saved in the Camera Roll:

You can share the photo through social media, if you wish: ——————

☞ **Tap** Home

You may see an ad:

☞ **If necessary, tap** ⊗ ✓

You will see the app's home screen again.

☞ **Close the *PhotoGrid* app** 🐾⁷

4.7 Turning a Photo into a Drawing

With the *Pic Sketch Free* app you can turn a photo into an artistic sketch in seconds.

☞ **Download the app**

☞ **Press the Home button**

Once it is installed onto your iPad, the app will be called *Sketch*:

☞ **Open the *Sketch* app** *ϐϐ*2

It is not necessary for this app to send you messages, and you do not need to rate the app:

☞ **Tap**
No Thanks!

★★★★★
Enjoy this awesome app? Leave us a 5 star rating, thanks!

No Thanks! | Rate Now!

In this free app, ads are shown frequently:

☞ **If necessary, tap** ✖

If you wish, you can take a new picture with the iPad camera and edit it:

In this example we will select a photo from the Camera Roll:

👉 **Tap**

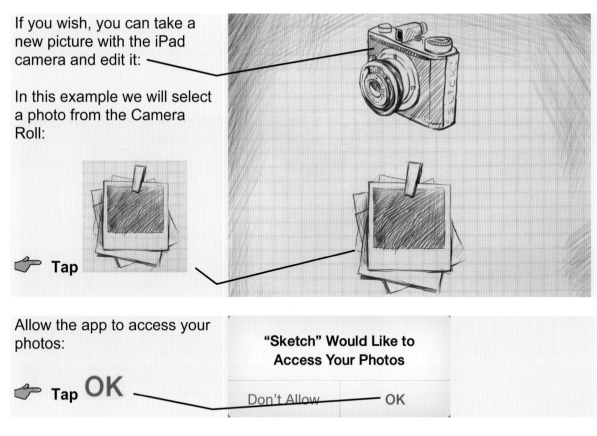

Allow the app to access your photos:

👉 **Tap OK**

"Sketch" Would Like to Access Your Photos

Don't Allow OK

You may see another ad:

👉 **If necessary, tap** ❌

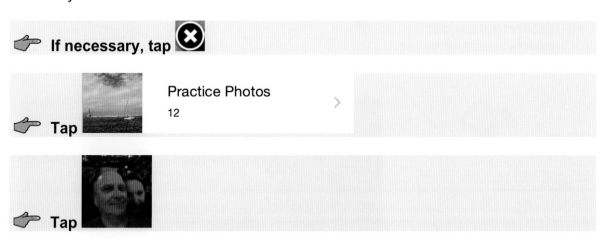

Practice Photos
12 >

👉 **Tap**

👉 **Tap**

☞ **Drag the frame across the faces**

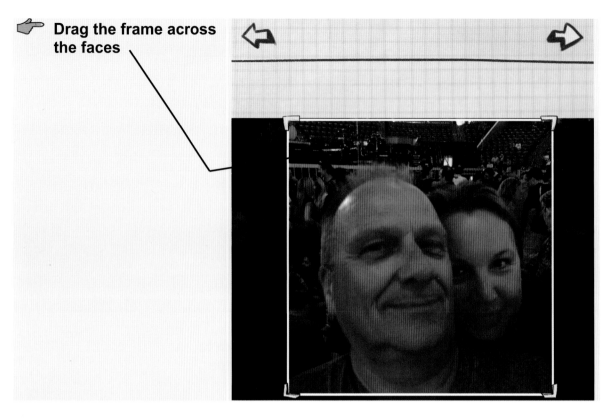

Make the frame a bit smaller:

☞ **Drag the handle in the upper right corner downwards and to the left**

☞ **Tap**

You will see that the photo has turned into a sketch.

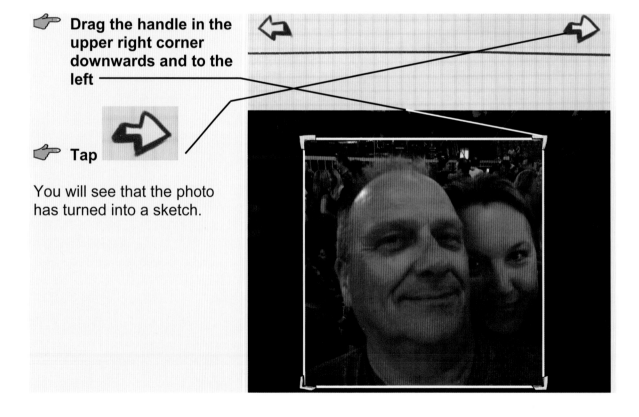

☞ **Tap**

You will see various designs for your sketch.

💡 **Tip**

Adding colors

Unfortunately, the option for adding colors is no longer free of charge. You can

purchase this option in the *App Store*. Tap [img] or [img] and follow the instructions on the screen in order to buy the additional options.

☞ **Tap**

You will see a new toolbar with various black-and-white styles:

☞ **If necessary, swipe the toolbar from right to left**

☞ **Tap**

Please note: this is the fifth icon in the row of styles.

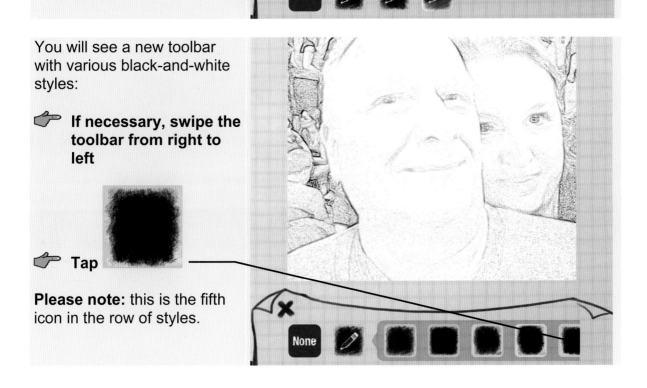

The sketch is created:

Tap to adjust the brightness and contrast, if necessary:

For now this will not be necessary.

Tap

If you wish, you can also add a frame to the list, with

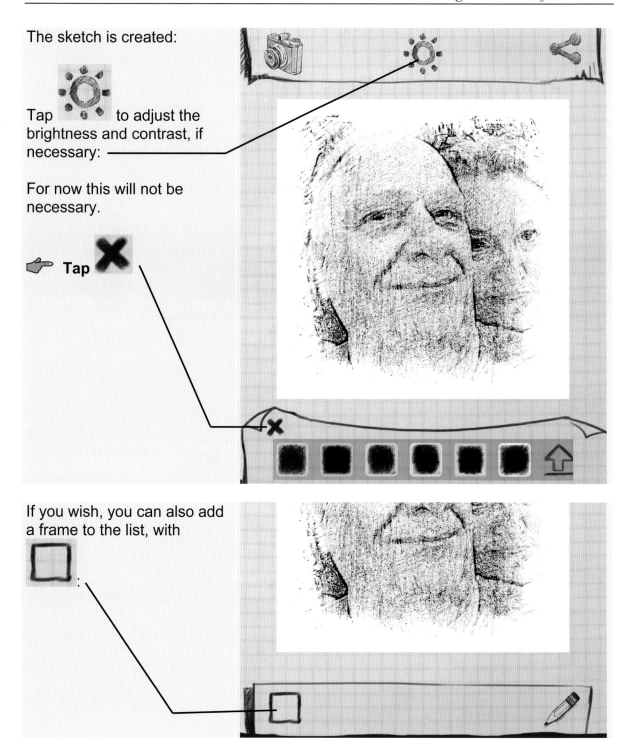

This is how you save the sketch:

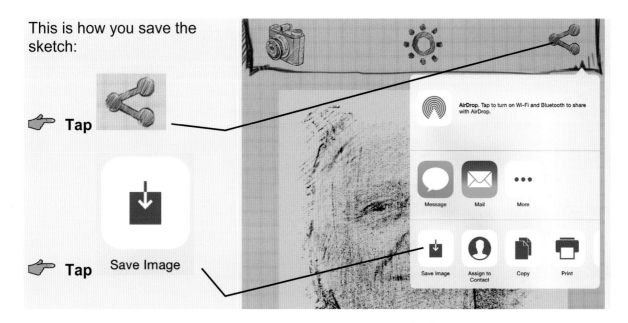

☞ **Tap**

☞ **Tap** Save Image

The sketch will be saved. Use the camera icon at the top to go back to the home screen:

☞ **Tap**

☞ **Close the *Sketch* app** 7

4.8 Your Photo on the Cover of a Magazine

Have you always dreamed of seeing your picture on the cover of a famous magazine? With the free version of the *Photo2Fun - 1- click photo montage* app, this dream can come true with just a few taps. First, you download the app:

☞ **Download the app**

Photo2Fun - 1- click photo mont…
Brand&Nobel Mark…
★★★★☆ (16) 👣1

☞ **Press the Home button**

☞ **Open the *Photo2Fun* app** 👣2

It is not necessary for the app to send you messages:

☞ **Tap** Don't Allow

"Photo2fun" Would Like to Send You Notifications
Notifications may include alerts, sounds, and icon badges. These can be configured in Settings.

Don't Allow OK

When you start up the app for the first time, you will see a number of screens with information about the app's features:

☞ **Tap** Start

Start

You will see a tip showing where the options menu is located and how to proceed:

☞ **Tap the screen**

In the free version of the app you will see ads:

☞ **Tap**

HELP! I cannot close the ad.
If you do not succeed in closing the ad, you will need to close the app itself first
👣77 and then open it again.

This app is used in landscape mode:

☞ **If necessary, rotate the iPad a quarter turn**

You are going to place a photo on the cover of a magazine:

You will see many covers that look just like the covers of well-known international magazines. But the names are just slightly different from the real names. Select the cover of the 'International Geographic' magazine:

Allow the app to access your photos:

👉 **Tap OK**

> **"Photo2fun" Would Like to Access Your Photos**
>
> Don't Allow OK

The photo you are going to use is located in the *Practice Photos* folder:

👉 **Tap** Practice Photos (12)

👉 **Tap**

You will see a tip on how to position the photo:

The frame is fixed, but you can drag the photo and zoom in or out. This will not be necessary for this example.

To close the tip:

👉 **Tap the screen**

👉 **Tap Done**

The photo has been placed on the cover. The onscreen keyboard has appeared too, so you can edit the text right away. Each cover contains one line that can be edited. Delete the current text:

Tap ❌

Type: Everything you did not yet know about squirrels

Hide the keyboard:

Tap ⌨

Tap **Done**

You may see yet another tip:

👉 **If necessary, tap the screen**

This is how you save the cover:

The photo has been saved in the Camera Roll. Now you can go back to the menu of the *Photo2Fun* app:

You may see another ad:

The menu is still hidden:

You will see the menu again.

4.9 Fun with Your Photo

In the Fun section, the *Photo2Fun* app truly lives up to its expectations. Just try it:

In the Fun section you can replace the sample photo shown in the photo montage with your own photo:

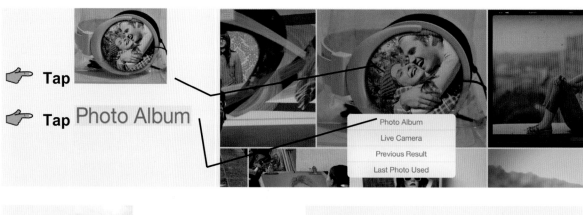

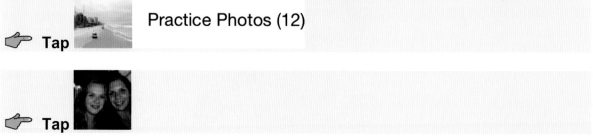

You may see another tip:

👉 **If necessary, tap the screen**

👉 **Drag the photo to the left in order to fit both faces into the photo**

👉 **Tap** Done

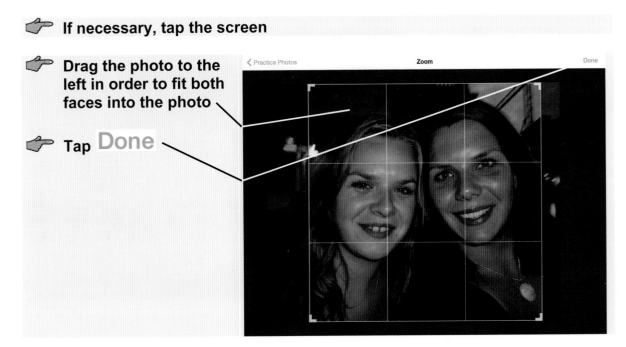

You may see yet another tip:

👉 **If necessary, tap the screen**

You will see the result:

The watermark shown in the lower right corner cannot be removed in the free version of this app. In the paid version you can disable it.

Do not save the photo:

👉 **Tap** 🏠

Try another montage:

👉 **Drag across the samples from right to left**

👉 **Tap**

You can use the same photo as before:

👉 **Tap**
Last Photo Used

Photo Album
Live Camera
Previous Result
Last Photo Used

👉 **Drag the photo to the left**

👉 **Tap** Done

Now the photo is on the fornt page of the paper:

☞ **Tap** 🏠 ────────────

🖝 **Close the *Photo2Fun* app** 👣⁷

In this chapter you have used various creative apps. Now you can try applying some of these methods with your own photos. In the exercises on the following pages you can practice doing this.

4.10 Exercises

The following exercises will help you master what you have just learned. Have you forgotten how to perform a particular action? Use the number beside the footsteps
[1] to look it up in the appendix *How Do I Do That Again?*

Exercise 1: Collage

In this exercise you will practice creating a collage in the *PhotoGrid* app.

☞ Open the *PhotoGrid* app. [2]

☞ Start a collage [62] and select four photos. [63]

☞ Select the ⬚ layout. [64]

☞ Make the top box smaller. [65]

☞ Zoom in on the top photo. [66]

☞ Swap the photos on the bottom left and right. [67]

☞ Widen the outer border and the borders between the photos. [68]

☞ Apply filter V5 from the Vintage group. [69]

☞ Add a sticker. [70]

☞ Place the sticker in the top right corner. [71]

☞ Make the sticker smaller. [72]

☞ Remove the sticker. [73]

☞ Save the collage and go back to the app's home screen. [74]

☞ Close the *PhotoGrid* app. [7]

Exercise 2: Sketch

In this exercise you will create a sketch with *Sketch*.

☞ Open the *Sketch* app. ℘²

☞ Select the photo . ℘⁷⁵

☞ Turn the photo into a sketch. ℘⁷⁶

☞ Add a list. ℘⁷⁸

☞ Save the sketch. ℘⁷⁹

☞ Go back to the app's home screen. ℘⁸⁰

☞ Close the *Sketch* app. ℘⁷

Exercise 3: Cover

In this exercise you will place a photo on the cover of a magazine.

☞ Open the *Photo2Fun* app ℘² and select a magazine. ℘⁸¹

☞ Select a photo. ℘⁸²

☞ Place the correct part of the photo in a frame. ℘⁸³

☞ Add a suitable text. ℘⁸⁴

☞ Do not save the cover and go back to the app's home screen. ℘⁸⁵

☞ Close the *Photo2Fun* app. ℘⁷

4.11 Tips

 Tip

Arranging collages

You can create collages in various sizes and layouts. On the *PhotoGrid* home screen you can choose from the options below:

With **Single** you use just one photo:

You can create a postcard for example, and add some of the effects you learned about in this chapter.

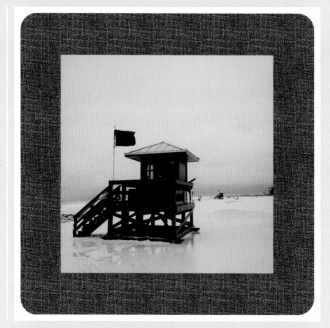

With **PinBoard** you can arrange the photos on the sheet yourself:

By dragging, you can place the photos anywhere you want, rotate them to turn them a bit, or adjust their size.

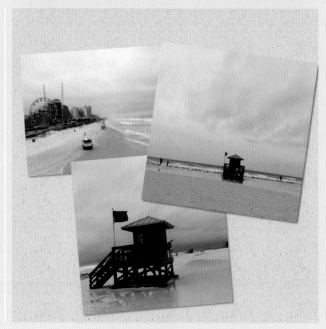

- Continue on the next page -

With the photos are stacked one below the other:

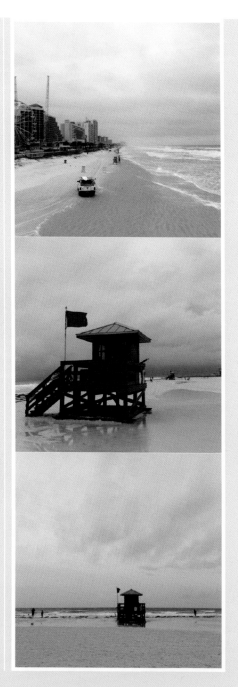

With you can create slideshows. We will discuss this option in the next chapter.

 Tip

Extra options in Photo2Fun
Besides the magazine covers and the photo montage option in the Fun section, *Photo2Fun* has even more to offer:

In the Cards section you will find a wide range of postcards:

You can enter your own text on some of the postcards, while others have a pre-printed text:

In the Collage section you will find all sorts of pre-printed collages of various subjects:

You can create a collage or postcard with the same method used to create a magazine cover in the Fun section.

5. Sharing Your Photos

If you have taken some beautiful or interesting pictures, you will often want to show them to others. You have several options for this. For example, you can print your photos, individually or in an album. You can use the *Shutterfly Photo Book* app for this, for instance. In this chapter you can read how to create a photo book with this app, and order the printed photos.

Instead of an album you could also create a slideshow of your pictures with the *Photo Grid* app. You can save the slideshow as a video clip and show it on your iPad, or share it through social media websites such as *Facebook, Twitter* and *Instagram*. Of course you can do this with your own photos too. In this chapter you will learn how to share your photos using the *Instagram* and *Facebook* apps.

In this chapter you will learn how to:

- create a slideshow with the *Photo Grid* app;
- work with *Instagram*;
- share photos through *Facebook*;
- create a photo book with the *Shutterfly Photo Story* app.

5.1 Creating a Slideshow

You can use the *PhotoGrid* app not only for collages but also for creating a slideshow. *PhotoGrid* transforms the slideshow into a short video clip that you can watch on your iPad or share through social media websites such as *Instagram*.

☞ **Open *PhotoGrid*** 𝒫²

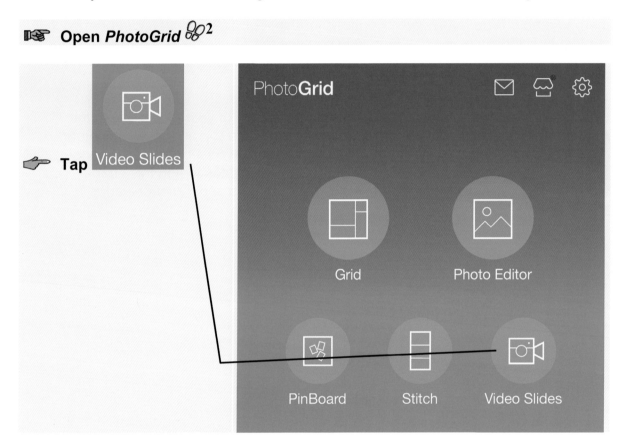

☞ **Tap** Video Slides

Select the photos you want to use for the slideshow:

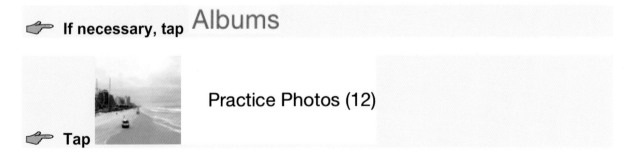

☞ **If necessary, tap** Albums

☞ **Tap** Practice Photos (12)

☞ **Tap five photos**

The selected photos will be placed at the bottom of the screen:

☞ **Tap** Next

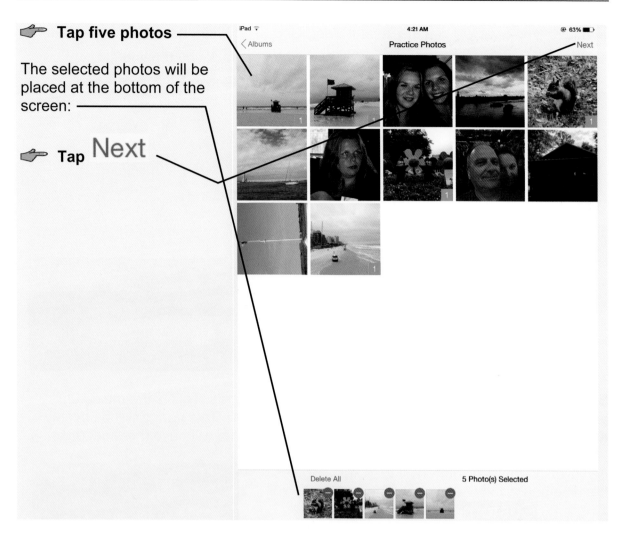

Adjust the settings of the slideshow, starting with the music that accompanies the slideshow:

☞ **Tap** Music

In this example we will use the default *PhotoGrid* tune. If you have any music files saved on your iPad, you can also select one of these tracks by tapping My Music:

☞ **Tap**
PhotoGrid Song

The music has been added.

☞ **Tap** Time

By default, the duration of the slideshow is fifteen seconds. This is the maximum length for a video that can be shared through *Instagram*. This period will be evenly divided among the photos, so in this example each photo will have three seconds.

If you wish, you can shorten the time period between photos by Custom, which will also shorten the total duration of the slideshow. For now this will not be necessary:

☞ **Tap** Transition

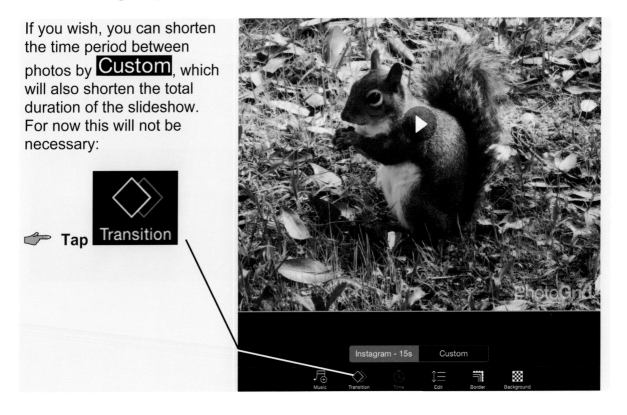

A transition is the way in which the slides blend into each other, one by one. After you have selected a transition, the slideshow will start playing right away:

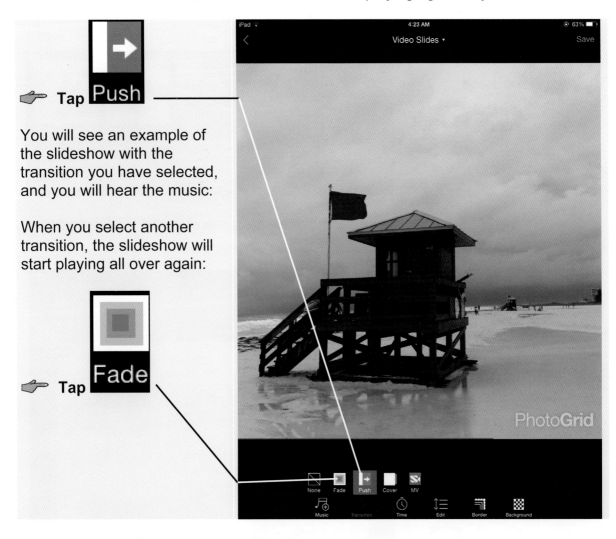

☞ Tap **Push**

You will see an example of the slideshow with the transition you have selected, and you will hear the music:

When you select another transition, the slideshow will start playing all over again:

☞ Tap **Fade**

You can also change the order of the slides in a slideshow. You do that like this:

☞ Tap **Edit**

You may see a tip:

☞ **If necessary, tap the screen**

You can rearrange the order of the photos in the slideshow by dragging them to another position:

☞ **Drag the fifth photo into the first position**

The photos will automatically adjust.

☞ **Tap** Done

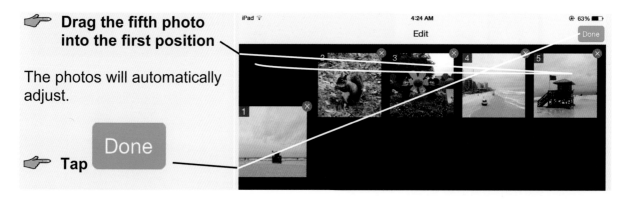

By adjusting the border of the photos, you can create a more playful look for the slideshow:

☞ **Tap** Border

Make the outer edge larger and create rounded corners:

☞ **Drag the slider** by to the right, just like in the example

☞ **Drag the slider** by to the right, just like in the example

Now the watermark is placed just outside the photo:

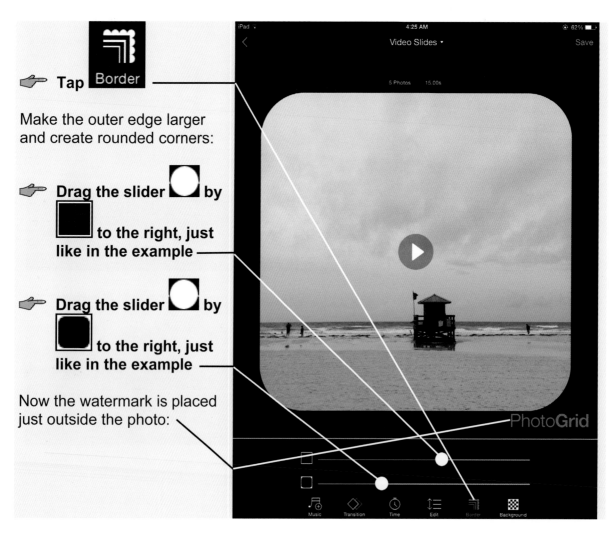

You can replace the black border that has appeared with a more cheerful background:

☞ **Tap** Background

You will see various groups of backgrounds:

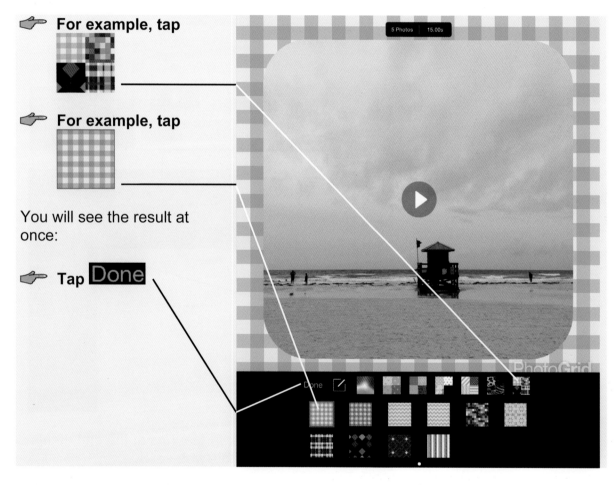

☞ **For example, tap**

☞ **For example, tap**

You will see the result at once:

☞ **Tap** Done

Play the slideshow once more:

☞ **Tap**

If you are satisfied with the result, you can save the slideshow:

☞ Tap **Save**

The slideshow will be saved as a video clip. This may take a little while:

The amount of time remaining is shown on your screen:

You may see an ad:

☞ If necessary, tap **Cancel**

The video clip has been saved in the Camera Roll:

There are various options for sharing the clip:

☞ Tap **Home**

In the next section you will learn more about *Instagram*. In the *Tips* at the end of this chapter you can see how to share the video clip using this web service.

☞ **Close the *PhotoGrid* app** 🐾⁷

5.2 Using Instagram

Instagram is a popular, free social networking service that lets you upload and share photos. Other users can view your photos and comment on them. You can keep your *Instagram* page private, if you wish, and decide who can view your photos. In the *Tips* at the end of this chapter you can read how to do this. If you use *Facebook*, you can post the photos on *Facebook* through the sharing option in the *Instagram* app.

First, you will need to download the *Instagram* app. You can do this by going directly to the *Instagram* website as the app is a little hard to find in the *App Store*:

☞ **Open the www.instagram.com website in *Safari*** 🦶**86**

☞ **Tap**

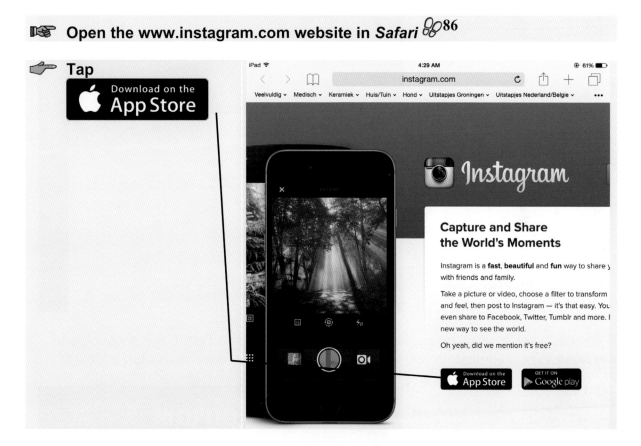

The *App Store* will then be opened on the right page:

☞ **Download** 🦶**1**

👉 **Press the Home button**

👉 **Open *Instagram*** 👣²

In this section we will present a brief introduction and show you how to post a photo on *Instagram*. In order to work with *Instagram*, you need to register and sign in.

You can do this with your *Facebook* account, or by registering with *Instagram* itself:

If you want to sign in with your *Facebook* account, you tap 🅕 Log In with Facebook and follow the instructions on the screen. Then continue on page 245.

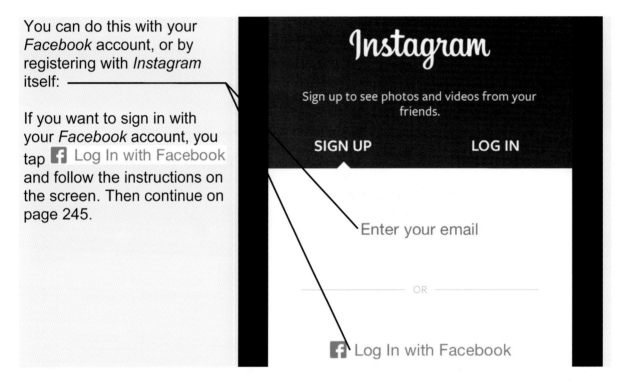

If you have never used *Instagram* before, or do not have a *Facebook* account, you will need to register first. In this example we will create a new *Instagram* account:

👉 **Tap** Enter your email

⌨ **Type your email address**

👉 **Tap** Next

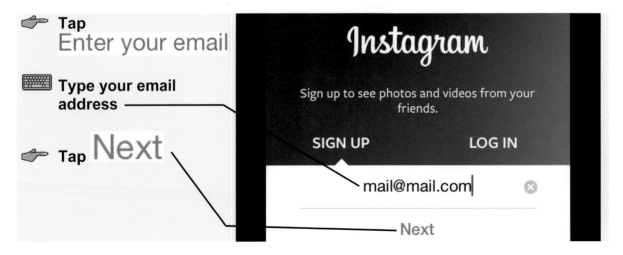

Type a name —

☞ **Tap** Next

Instagram suggests that you use the first part of your email address as a user name:

You can also enter a different user name, if you wish.

If necessary, type a username —

☞ **Tap** Next

⌨ **Type a password you have invented yourself**

☞ **Tap** Next

If you want to, you can add a profile photo. In this example, this step will be skipped:

☞ **Tap** SKIP

For now, you do not need to look for people to follow on *Instagram*:

☞ **Tap** Skip

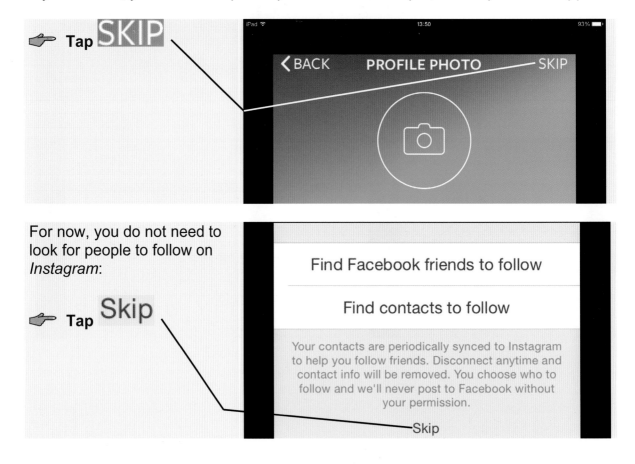

In the next window:

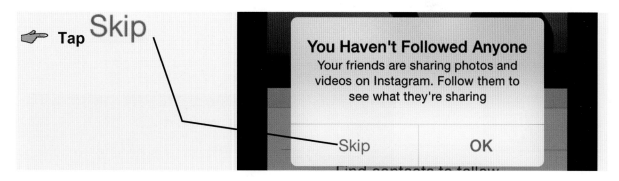

In the next window:

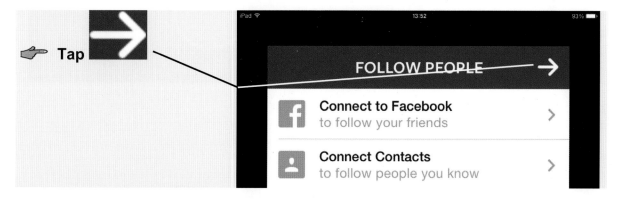

You see window about notifications:

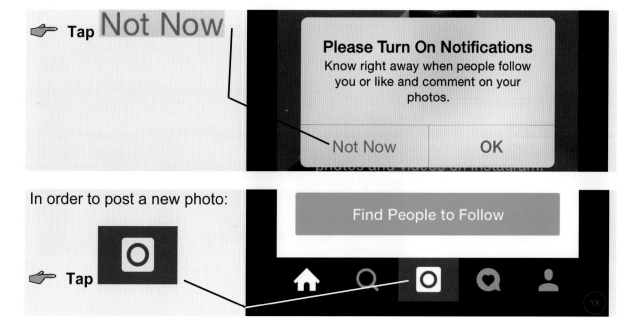

Instagram wants to access the camera:

☞ **Tap** OK

You are going to add an existing photo:

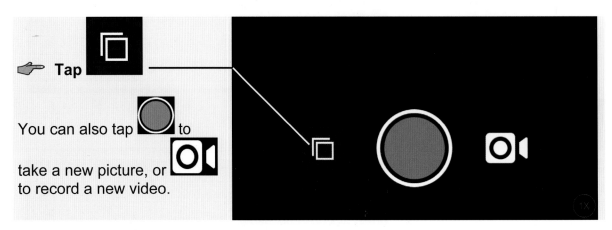

☞ **Tap**

You can also tap ⬤ to

take a new picture, or 📹
to record a new video.

Allow *Instagram* to access your photos:

☞ **Tap** OK

If you do not have any additional photos or video clips saved after you created the slideshow in the previous section, the slideshow will now be played. You can find the practice files as follows:

☞ **Drag downwards across the thumbnails**

☞ **By** CAMERA ROLL,

tap ←

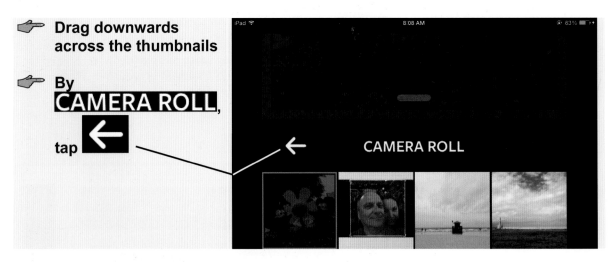

☞ **Tap** Practice Photos

☞ **Drag upwards across the thumbnails**

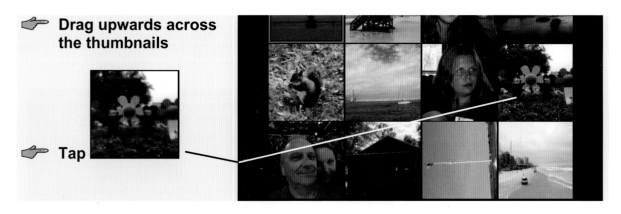

☞ **Tap**

Instagram uses a square photo format. If your photo is in a different format, a cut out will be made.

You will see the photo in a square frame. By zooming in you can display only the characters:

☞ **Spread your thumb and index finger**

☞ **Drag the photo, so you no longer see the board**

In the upper right corner of the screen:

☞ **Tap** NEXT

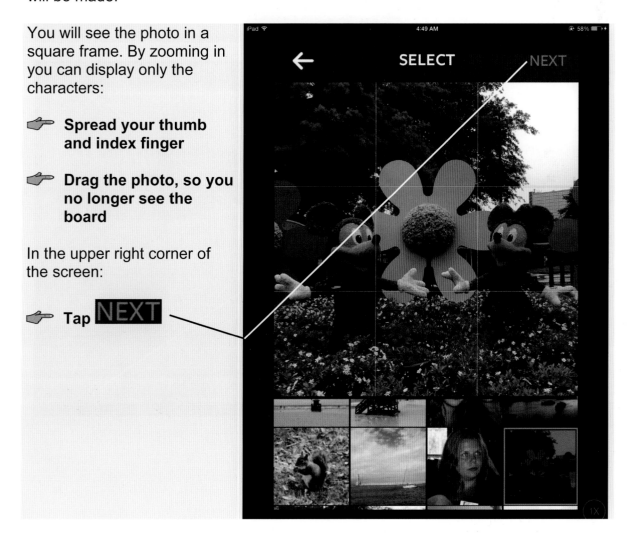

In order to lend a special atmosphere to your photo, you can add a special effect. In the following step, we will use the Walden effect, but this effect is not displayed in *Instagram* right away. You can display the effect like this:

👉 **Drag across the bottom row of effects from right to left**

👉 **Tap** MANAGE

👉 **Drag upwards across all the effects**

👉 **By** W Walden

(Walden), tap ⬤

The effect has been selected:

Go back to the photos:

👉 **By** MANAGE FILTERS,

tap ✖

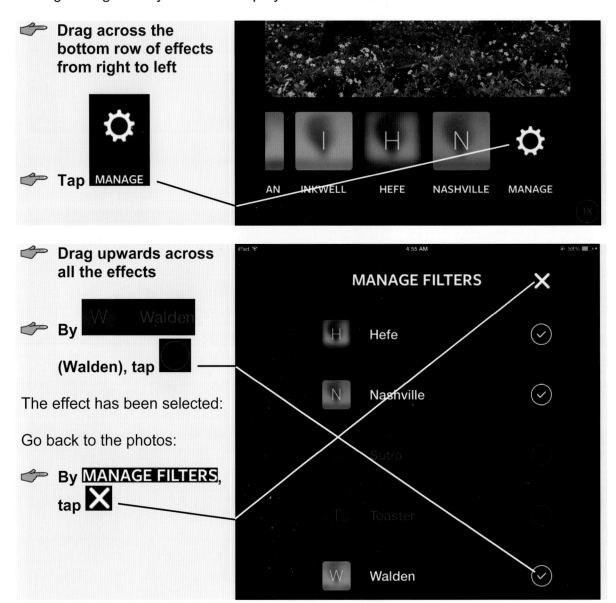

Here you see the square cut out with the Walden effect:

☞ **If necessary, drag across the effects from right to left**

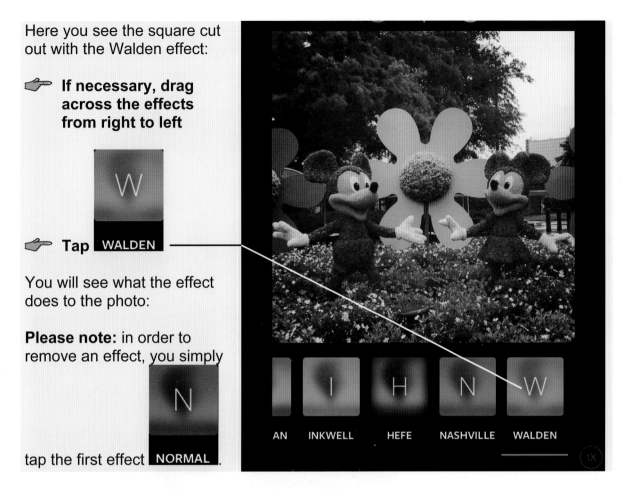

☞ **Tap** WALDEN

You will see what the effect does to the photo:

Please note: in order to remove an effect, you simply

tap the first effect NORMAL.

The settings of the effect can be further adjusted:

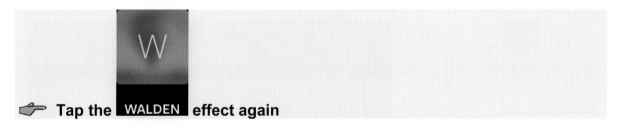

☞ **Tap the** WALDEN **effect again**

You can intensify or weaken the effect:

☞ **Drag the slider** 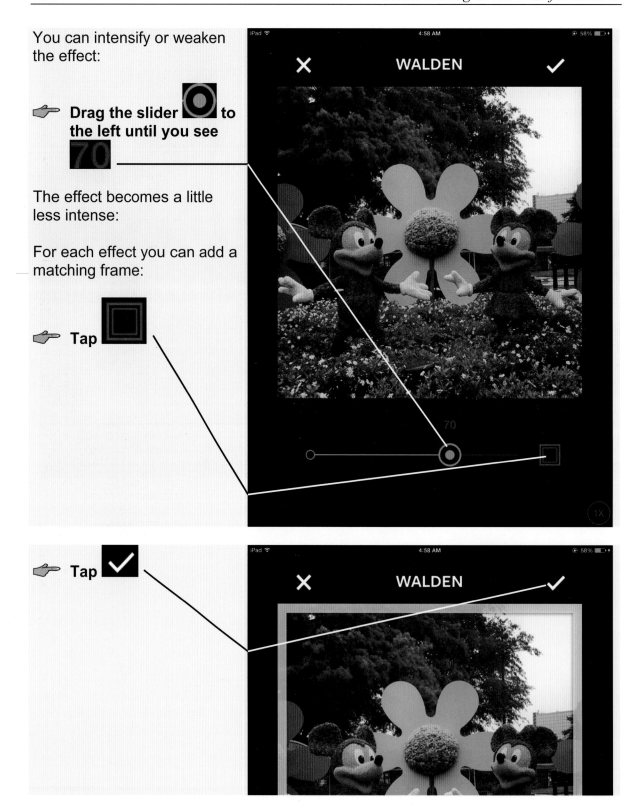 **to the left until you see**

70

The effect becomes a little less intense:

For each effect you can add a matching frame:

☞ **Tap**

☞ **Tap** ✓

To change the contrast:

☞ **Tap**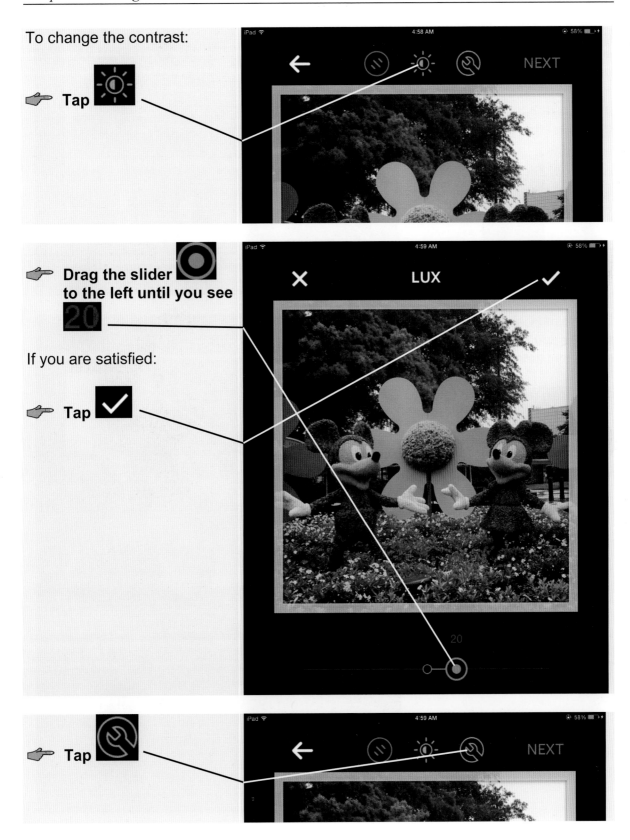

☞ **Drag the slider**
to the left until you see
20

If you are satisfied:

☞ **Tap**

☞ **Tap**

You will see some additional icons for more options that you can adjust:

In this example we will discuss the Adjust option:

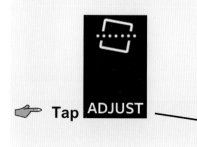

☞ **Tap** ADJUST

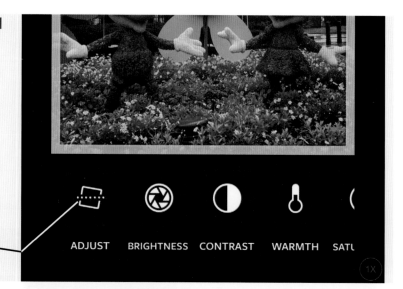

Instead of keeping the photo straight you can add a special effect by tilting or skewing it:

☞ **Drag across the lines to the right, until you see** -8.50°

The photo has rotated a bit:

☞ **Tap**

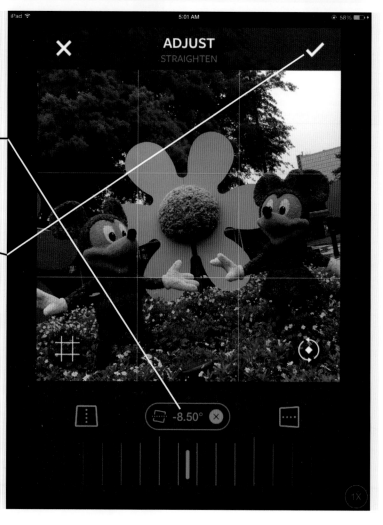

Now you can post the photo:

☞ **Tap** NEXT

Add a caption:

☞ **Tap**
Write a caption...

⌨ **Type:** Look who we met...

☞ **Tap** OK

When you share a photo, you can choose between FOLLOWERS and DIRECT.
All the people who follow you on *Instagram* are followers. If you tap the DIRECT
option, you can share the photo directly with one or more selected persons. Add a
description and share the photo with your followers on *Instagram*:

By default, the
FOLLOWERS option is
already selected:

If you want to share the photo
through *Facebook* at the
same time, you tap

f Facebook.

The first time you will be
asked to enter your user
name and password. This will
link your *Facebook* account to
Instagram. Once you have
done this, you can share
photos directly on *Facebook*.

☞ Tap SHARE →

The photo is posted:

If you receive any comments
on your photo, they will be

displayed if you tap 💬 :

View your *Instagram* profile
for a moment:

☞ Tap 👤

You will see the overview with the photos you have posted. In this example there is just one photo:

By tapping the photo you can enlarge it, and you will see the previous screen.

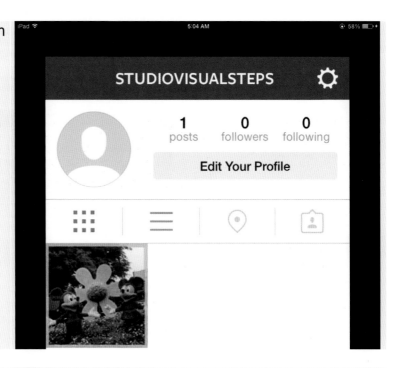

👉 **Close the *Instagram* app** 🐾7

5.3 Sharing a Photo through Facebook

Of course you can also share photos through the *Facebook* app right away. In this example we assume that you already have a *Facebook* account. If you do not have a *Facebook* account, you can just read through this section, or create a *Facebook* account.

👉 **Download the** [Facebook icon] **app** 🐾1

👉 **Press the Home button** [Home button]

👉 **Open the *Facebook* app** 🐾2

It is best to use this app in the landscape position. Before you can use the app, you will need to sign in with your username and password:

⌨ **Type your username and password**

☞ **Tap** Log In

If you do not have a *Facebook* account, you can create one by tapping Sign Up for Facebook.

If you do not want to receive any notifications from *Facebook*:

☞ **Tap** Don't Allow

You may see a tip on how to log in faster:

☞ **If necessary, tap** Not Now

You will see the news feed. This is how you post a photo:

☞ **Tap** 📷 Photo

Allow *Facebook* to access your photos:

☞ **Tap** Continue

☞ **Tap** OK

Open a photo from the *Practice Photos* folder:

☞ **If necessary, drag across the albums from right to left**

☞ **Tap** Practice Photos

☞ **Tap**

☞ **Tap** Done

You may see a tip:

☞ **If necessary, tap** Done

When you share photos, you can add different kinds of information. For example, where the picture was taken:

☞ **Tap** 📍

You will see a number of suggestions right away, based on the GPS location that was saved when the picture was taken:

☞ **Tap**
Siesta Key Beach. Voted # Beach
4700 mi · 93,261 were here

The location will be added to the description. You can also edit the photo in *Facebook*:

☞ **Tap the photo**

The photo will be opened in a new window. Apply the automatic enhancement:

☞ **Tap**

After adding the automatic enhancement the photo has not really changed that much. You can add an effect to the photo:

☞ **Tap**

Select an effect that makes the photo brighter:

Instead of posting individual photos, you can also create an album with a group of related photos. You can group your vacation photos in this way, for example.

 Tip

Album is not really necessary
It is not really necessary to create an album in order to post a photo, so you can also skip the next three steps.

In order to create an album:

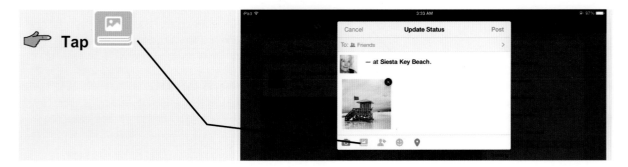

👉 **Tap**

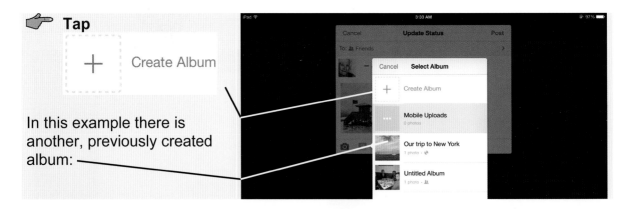

In this example there is another, previously created album: ⎯⎯⎯⎯⎯

Enter a name for the new album:

⌨️ **Type:** Siesta Beach

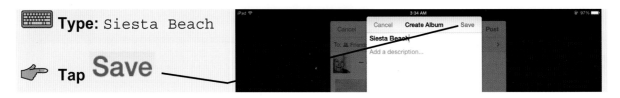

👉 **Tap Save** ⎯⎯⎯⎯⎯⎯

Add some text to describe the photo, if you wish:

⌨️ **Type:** Luckily it just stopped raining!

If you upload the photo to *Facebook*, it will be shared with (Friends) (in this example). If you wish you can change this by tapping (Friends) and adjust the settings: ⎯⎯⎯⎯⎯

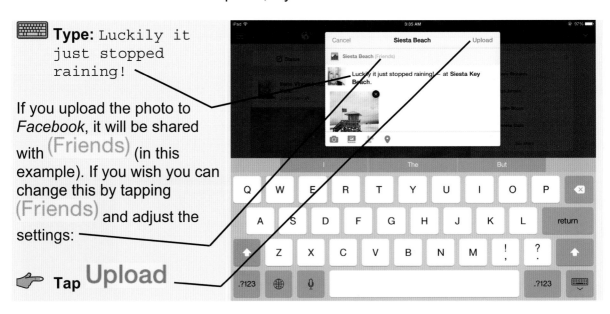

👉 **Tap Upload** ⎯⎯⎯⎯

The photo will be uploaded and you will see the news feed again. If there are a lot of new posts from other people or organizations you follow, you may not see your photo right away. But you can view it easily on your own page:

👉 **Tap your name in the upper right corner**

👉 **Drag the page upwards**

You will see the photo you just posted:

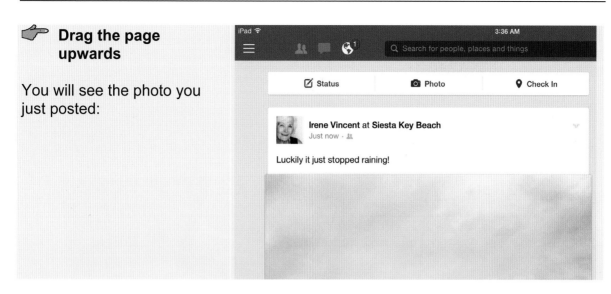

👉 Close the *Facebook* app 👣⁷

5.4 Creating a Photo Book with the Shutterfly Photo Story App

If you want to have a photo book printed, you can use an app from a printing service. The *Shutterfly Photo Story* app is such an app. In this section you will learn how to create a photo book.

👉 **Download the** Shutterfly Photo Story Shutterfly ★★★☆☆ (91) **app** 👣¹

👉 **Press the Home button**

👉 Open the *Shutterfly Photo Story* app 👣²

This app is best used in the landscape position.

You may see this window:

☞ **If necessary, tap**
Don't Allow

☞ **Tap Skip Tour**

In order to use the app, you will need to sign in with *Shutterfly Photo Story*. If you are using the app for the first time, you need to sign up:

☞ **Tap Sign up**

⌨ **Type the required**
information

☞ **Tap Join**

You will see the app's home screen:

A new photo book is already opened:

At the bottom of the screen you will see different styles to choose from. If you select a style with an 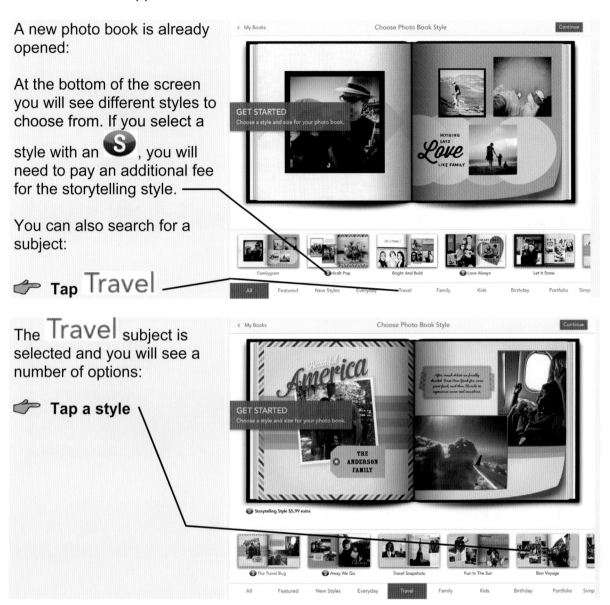, you will need to pay an additional fee for the storytelling style.

You can also search for a subject:

👉 **Tap** Travel

The Travel subject is selected and you will see a number of options:

👉 **Tap a style**

You will see the layout that goes with this style:

You can leaf through the book:

☞ **Swipe across the right-hand page from right to left**

In order to select this style:

☞ **Tap** Continue

Select the size. In this example we will create an 8x11 inch photo book:

☞ **Tap** 8x11

☞ **Tap** Continue

The app has several options for importing photos:

☞ **Tap**

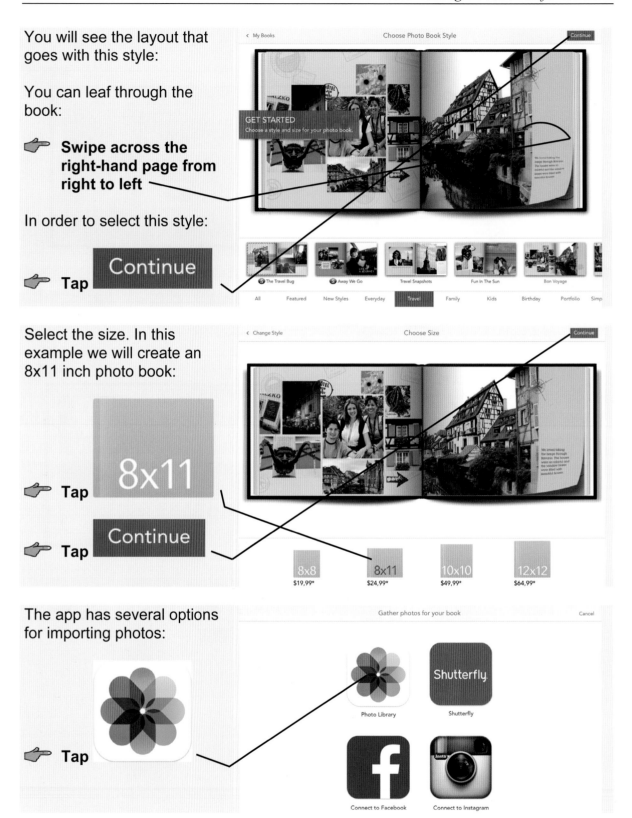

Allow *Photo Story* to access your photos:

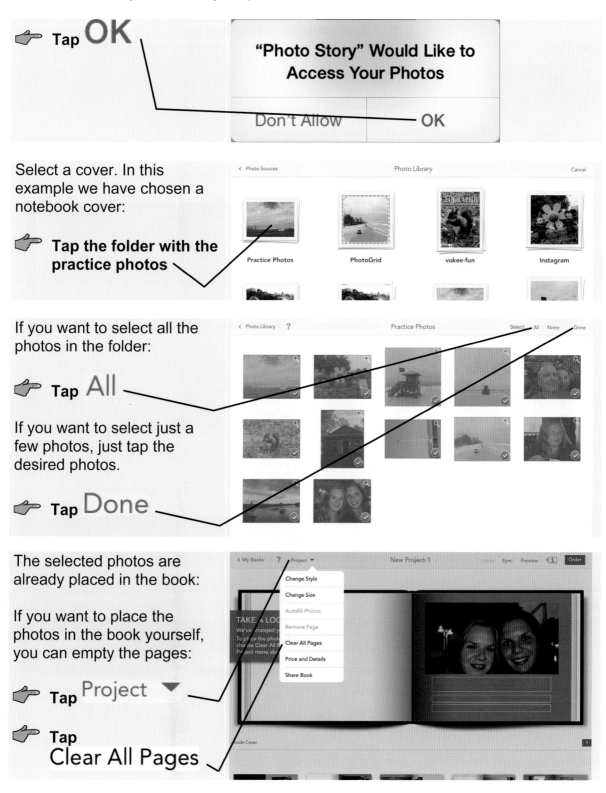

☞ **Tap** OK

"Photo Story" Would Like to
Access Your Photos

Don't Allow OK

Select a cover. In this example we have chosen a notebook cover:

☞ **Tap the folder with the practice photos**

Practice Photos PhotoGrid vukee-fun Instagram

If you want to select all the photos in the folder:

☞ **Tap** All

If you want to select just a few photos, just tap the desired photos.

☞ **Tap** Done

The selected photos are already placed in the book:

If you want to place the photos in the book yourself, you can empty the pages:

☞ **Tap** Project ▼

☞ **Tap** Clear All Pages

Change Style
Change Size
Autofill Photos
Remove Page
Clear All Pages
Price and Details
Share Book

You will be asked if you really want to clear the pages:

👉 **Tap**
Clear Pages

Clear All Pages
This will remove all pictures, text and audio from every page of the book. Are you sure you want to continue?

Cancel — Clear Pages

By **Layouts** you will find various styles that you can apply to the page:

👉 **Tap Layouts**

👉 **Tap the desired layout**

The layout will be visible on the page right away:

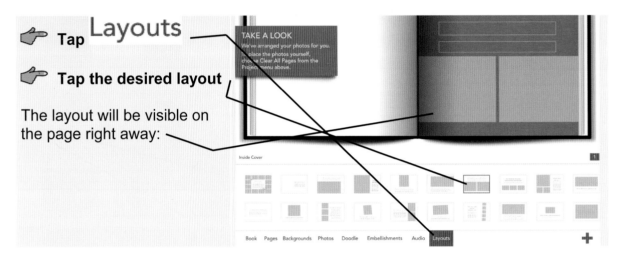

In this example you can add two photos and a text:

👉 **Tap Photos**

👉 **Drag the desired photo to the box**

A checkmark ✓ will appear by the photo that has been used. You can also hide the photos you have used. You do this by dragging the slider ◯ by **Hide used** to the right.

👉 **Drag a photo to the second box**

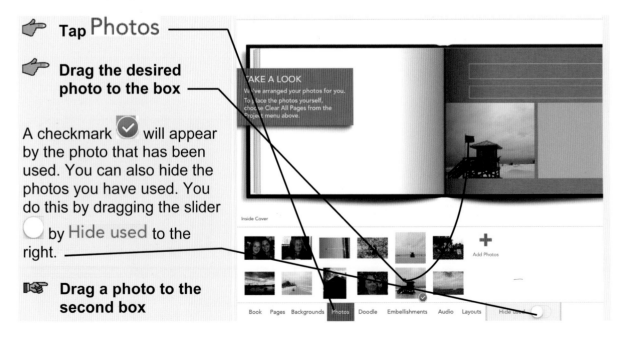

In order to change the background:

☞ **Tap** Backgrounds

You will see an overview of all the backgrounds:

☞ **Tap the desired background**

The background is adjusted right away:

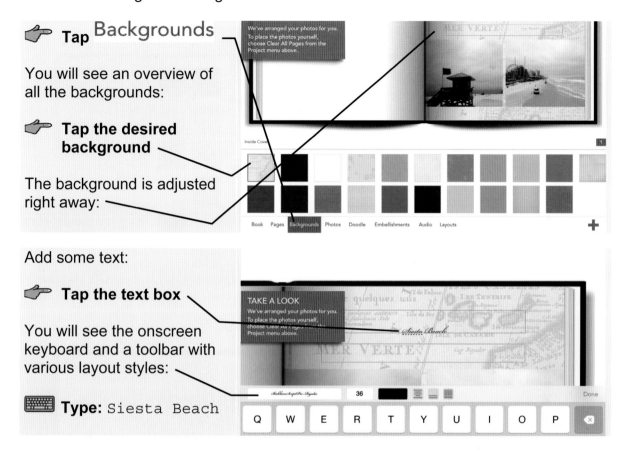

Add some text:

☞ **Tap the text box**

You will see the onscreen keyboard and a toolbar with various layout styles:

⌨ **Type:** Siesta Beach

🖐 **Please note:**

When we were writing this book, the app had no option for enlarging the text boxes. If the text does not fit into the box, you will see an error message. The text that lies outside the frame, will not be printed in the book. If the text does not fit in the text box you will need to select another style that uses a larger text box.

Enlarge the size of the text:

☞ **Tap the box with the font size, for example:**

> 36

☞ **Tap the desired size**

You can adjust the color as well:

☞ **Tap the box with the text color,**

☞ **Tap the desired color**

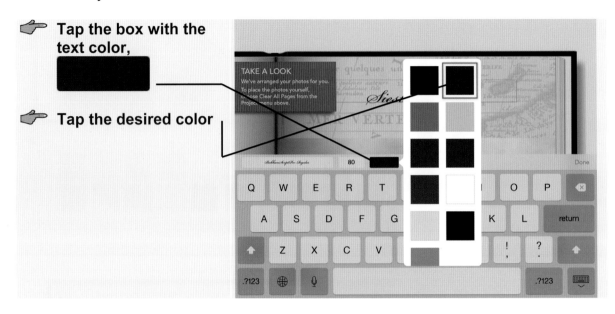

The color has changed: ——

You can select a different font in the same way: ——

You can also adjust the alignment and line spacing: ——

After all the edits have been applied:

☞ **Tap** Done

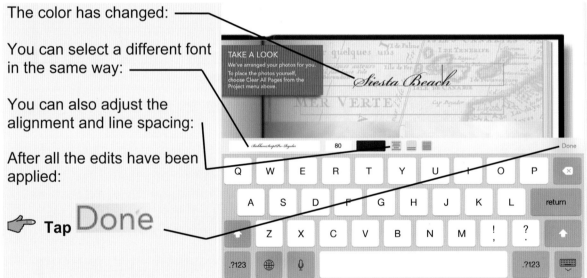

You can enhance the photos in the photo book even further:

☞ **Tap the photo**

The edit window appears. This is how you reposition the photo:

☞ **Drag the photo to the desired position**

To add an effect:

☞ **Tap the desired effect**

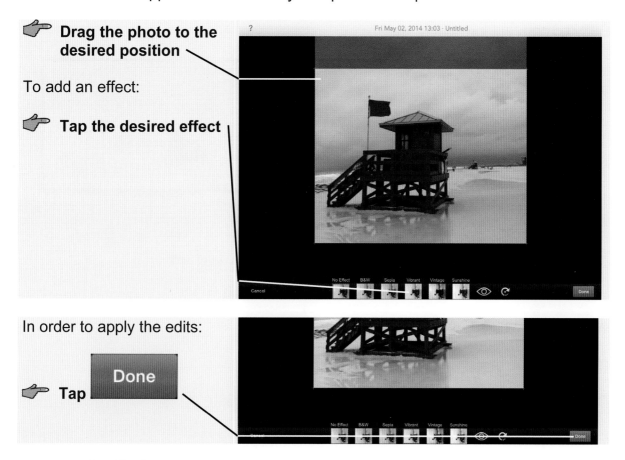

In order to apply the edits:

☞ **Tap** Done

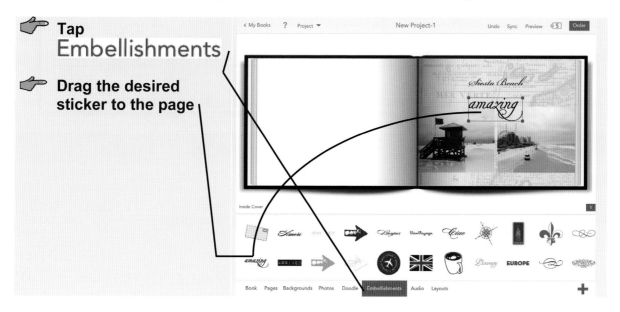

With Embellishments you can add a fun 'sticker' to the page:

☞ **Tap Embellishments**

☞ **Drag the desired sticker to the page**

You can move the sticker and adjust its size:

 Tap the sticker

You will see a window with handles:

 Drag the sticker's frame to the desired position

To adjust the size of the frame:

 Drag one of the handles to the desired size

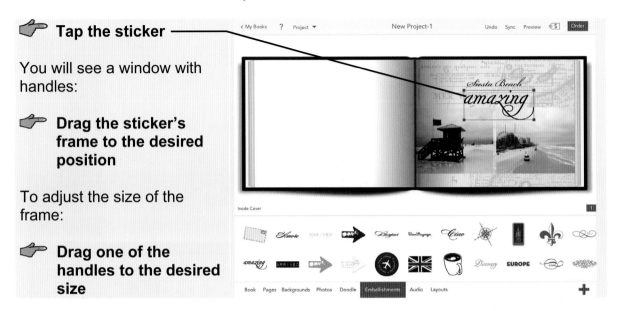

When you are satisfied:

 Tap next to the sticker

Once the page is finished, you can leaf to the next page:

 Swipe across the right-hand page from right to left

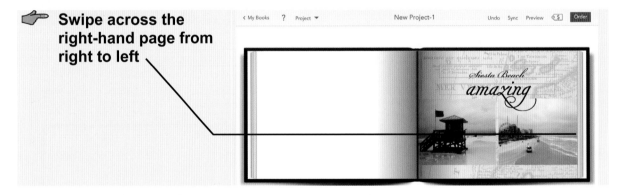

You can format the page in the same way as you did before:

 Select a layout for the page

 Drag the desired photos to the photo boxes on the page

A doodle is another great addition. You can create this and add is to a page or a photo:

Select the other photo in order to edit it:

☞ **Tap**

☞ **Tap** Add Doodle

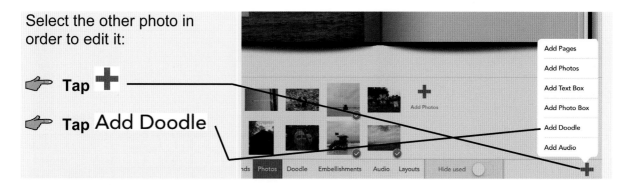

Create a doodle on a photo:

☞ **Tap**
Doodle on a Photo

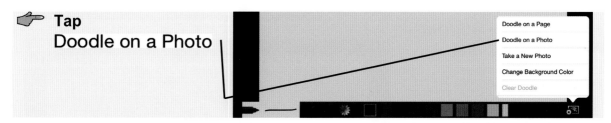

☞ **Tap the folder that contains the photo**

☞ **Tap the desired photo**

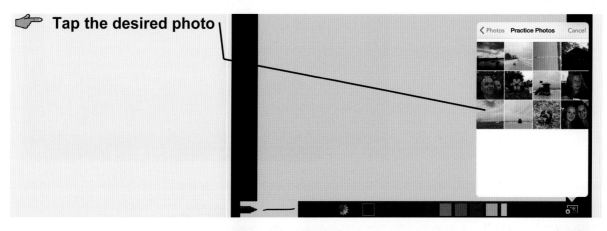

Use another brush:

☞ **Tap**

☞ **Tap the desired brush**

Use a yellow color to paint the sun:

☞ **Tap**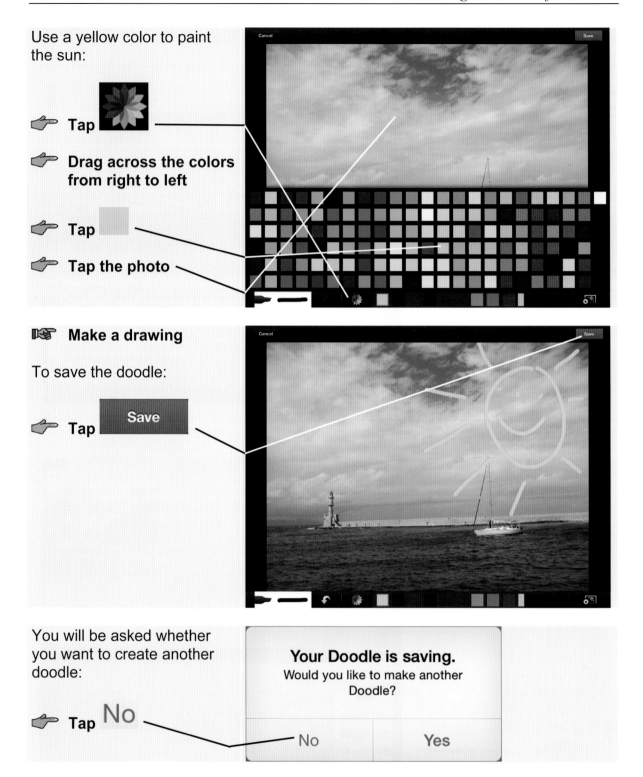

☞ **Drag across the colors from right to left**

☞ **Tap**

☞ **Tap the photo**

☞ **Make a drawing**

To save the doodle:

☞ **Tap** Save

You will be asked whether you want to create another doodle:

☞ **Tap** No

Your Doodle is saving.
Would you like to make another Doodle?

| No | Yes |

The doodle is saved. Now you can add the photo with the doodle to the book. In this example you will replace the photo that was on the page:

☞ **Drag the photo to the desired photo box**

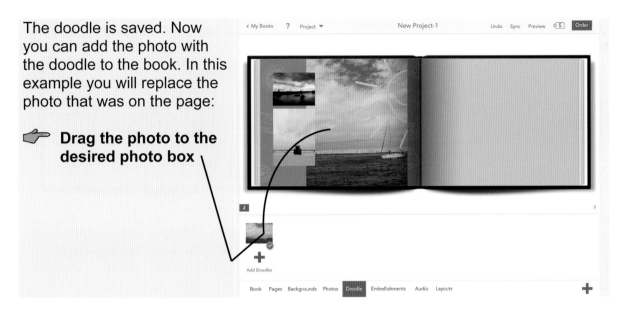

Half of the doodle is outside the photo box. You can easily adjust this:

☞ **Tap the photo**

☞ **Drag the photo to the desired position**

☞ **Tap** **Done**

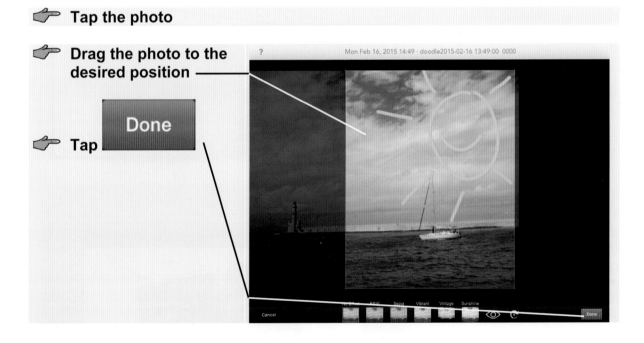

Now you can clearly see the doodle: ————

With Preview you can view a sample of your photo book: ————

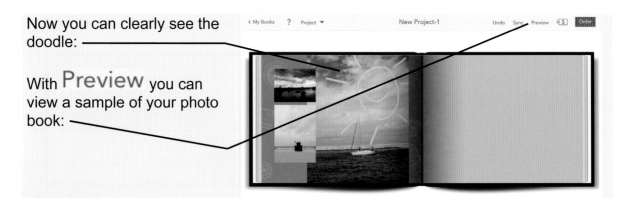

You have now seen and worked with a number of features this app has to offer. When you create your own photo book, you will fill all the pages, of course. When you have finished creating the book, you can order it.
If you have followed the steps in this book by using the practice photos and not by creating your own book, then just read through the remainder of this section.

☞ **Tap** Order

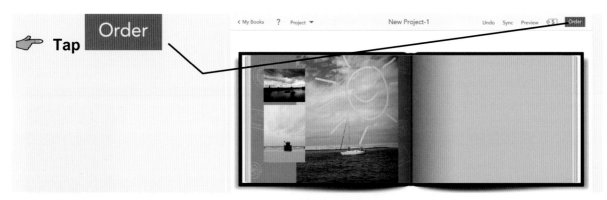

You will see a window asking you whether you want to add a hard matte cover. This will cost an additional fee. The costs are stated in the window:

☞ **Tap the desired option**

If you tap Details, you will see a frame with a detailed explanation of the costs of the photo book: ————

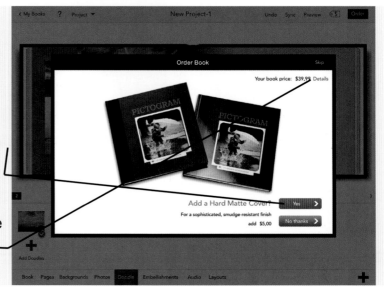

You may see some windows with options for adding additional features to the book, such as a dust jacket.

 Select the desired option in the windows

The photo book will be uploaded to *Shutterfly*:

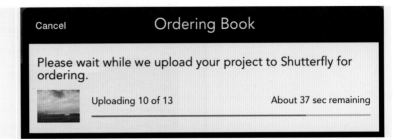

You need to add contact information before you can place your order:

☞ **Tap** Add new contact

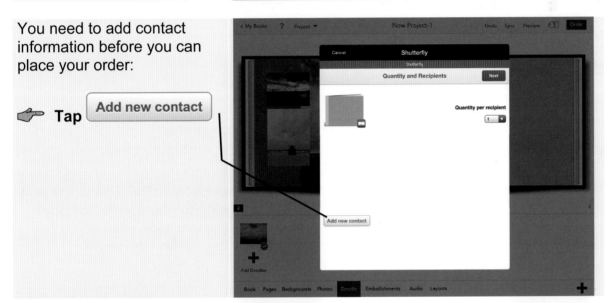

☞ **Enter the required data**

☞ **Tap** Save

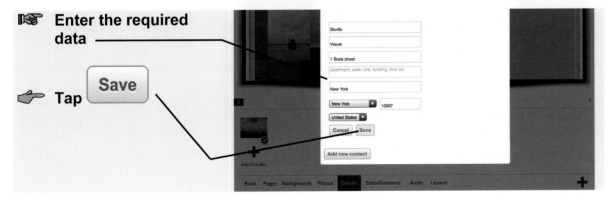

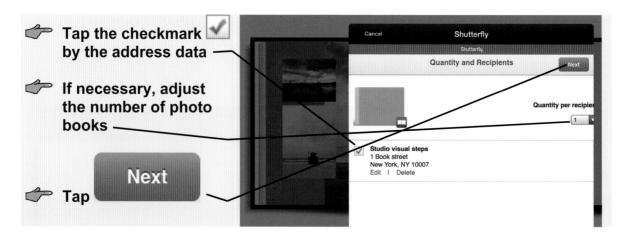

☞ **Tap the checkmark by the address data**

☞ **If necessary, adjust the number of photo books**

☞ **Tap**

In the next screens you will need to enter your billing information, and the checkout procedure will be started:

☞ **Follow the instructions in the screens**

Or:

☞ **Close the *Shutterfly Photo Story* app** 🦶[7]

You can also share the photo book through email or *Facebook*. In the *Tips* at the end of this chapter you can read how to do this. If you are going to share a photo book, you may want to consider adding some narration to it. You are allowed to add a 30 second audio clip to a page. You can read more about this in the *Tips* section.

💡 Tip

Special Offers

Before you order a book or another kind of photo product, it is certainly worthwhile to check out the special offers from the online service. You might just find an offer that suits you. This is how you check for special offers in the *Shutterfly Photo Story* app:

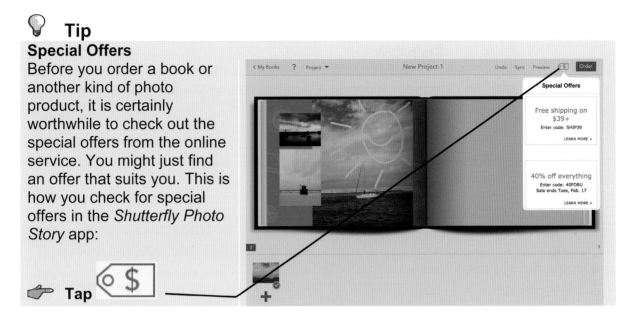

👉 **Tap** ⬛$

Now you have come to the end of this book. You have become acquainted with various photo editing apps, and other apps that can be used for creative projects. By working with practice photos you have seen how to use the main features and editing options available in these apps to resize, crop, correct, retouch or straighten photos. You also learned how to enhance and embellish photos by applying a wide range of special effects. Now you can start working with your own photos.

5.5 Visual Steps Website and Newsletter

By now we hope you have noticed that the Visual Steps method is an excellent method for quickly and efficiently learning more about computers, tablets, other devices and software applications. All books published by Visual Steps use this same method.
In various series, we have published a large number of books on a wide variety of topics including *Windows*, *Mac OS X*, the iPad, iPhone, Samsung Galaxy Tab, Kindle, photo editing and many other topics.

On the **www.visualsteps.com** website you will find a full product summary by clicking the blue *Catalog* button. For each book there is an extensive description, the full table of contents and a sample chapter (PDF file). In this way, you can quickly determine if a specific title will meet your expectations. You can order a book directly online from this website or other online book retailers. All titles are also available in bookstores in the USA, Canada, United Kingdom, Australia and New Zealand.

Furthermore, the website offers many extras, among other things:
- free computer guides and booklets (PDF files) covering all sorts of subjects;
- frequently asked questions and their answers;
- information on the free Computer Certificate that you can acquire at the certificate's website **www.ccforseniors.com**;
- a free email notification service: let's you know when a new book is published.

There is always more to learn. Visual Steps offers many other books on computer-related subjects. Each Visual Steps book has been written using the same step-by-step method with short, concise instructions and screenshots illustrating every step.

Would you like to be informed when a new Visual Steps title becomes available? Subscribe to the free Visual Steps newsletter (no strings attached) and you will receive this information in your inbox.
The Newsletter is sent approximately each month and includes information about
- the latest titles;
- supplemental information concerning titles previously released;
- new free computer booklets and guides;
- contests and questionnaires with which you can win prizes.
When you subscribe to our Newsletter you will have direct access to the free booklets on the **www.visualsteps.com/info_downloads.php** web page.

5.6 Exercises

To be able to quickly apply the things you have learned, you can work through the following exercises. Have you forgotten how to do something? Use the numbers next to the footsteps ℰℰ¹ to look the item up in the appendix *How Do I Do That Again?*

Exercise 1: Slideshow

In this exercise you can practice creating a slideshow in the *PhotoGrid* app.

☞ Open the *PhotoGrid* app. ℰℰ²

☞ Start a slideshow. ℰℰ⁸⁷

☞ Select five photos. ℰℰ⁶³

☞ Add the default music. ℰℰ⁸⁸

☞ Select a transition. ℰℰ⁸⁹

☞ Let the second and fourth photo switch places. ℰℰ⁹⁰

☞ Widen the edge around the photos and make the corners round. ℰℰ⁹¹

☞ Add a nice background. ℰℰ⁹²

☞ Play the slideshow. ℰℰ⁹³

☞ Save the slideshow and go back to the app's home screen. ℰℰ⁷⁴

☞ Close the *PhotoGrid* app. ℰℰ⁷

5.7 Background Information

Instagram
Instagram is a social network where you can share photos and video clips. Instead of working with friends with whom you share messages and photos like *Facebook*, *Instagram* works with followers. By default, all your posts are visible to everyone, and anyone can follow you. When you follow someone, you will automatically see

his or her new photos in your news feed by tapping ⌂. Fanatical Instagrammers try to get as many followers as possible, in order to attract attention to their photos. That is why Instagrammers often add *hashtags* to their photos.

A hashtag is a word that is preceeded by a number sign (#), for example, #squirrel:

Since you can also search for hashtags in *Instagram*, along with user names, well-chosen hashtags can generate attention for a photo. People who view the photo can decide to 'like' it, or follow your account.

If you do not want your photos on *Instagram* to be visible to everyone, you can protect your account. New followers will need to obtain your permission first, before they can view your photos in their news feed.

With a secure account your photos are not visible to others, even if they search for a particular hashtag that was added to your photo. In the *Tip Shield your Instagram account* you can read how to secure your account.

5.8 Tips

 Tip

Posting photos or projects directly on social media
In many apps you can also post photos and projects directly on social media. If it concerns *Facebook* or *Twitter*, you will need to have installed the *Facebook* or *Twitter* app to your iPad, or have linked your account through the *Settings* app.

For example, when you save a collage in the *PhotoGrid* app:

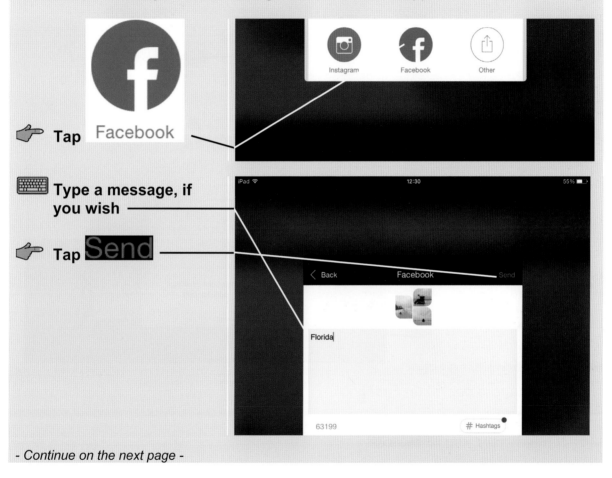

☞ **Tap** Facebook

⌨ **Type a message, if you wish**

☞ **Tap** Send

- Continue on the next page -

Now you need to allow the app to post messages on *Facebook* in your name. This does not mean that the app will post messages all by itself, it only concerns the photos you yourself want to post on *Facebook* in the *PhotoGrid* app:

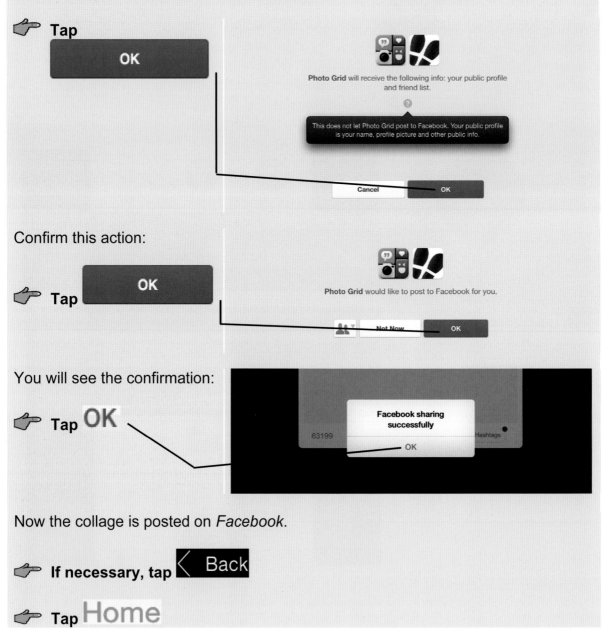

☞ **Tap**

> OK

Photo Grid will receive the following info: your public profile and friend list.

This does not let Photo Grid post to Facebook. Your public profile is your name, profile picture and other public info.

Cancel OK

Confirm this action:

☞ **Tap**

> OK

Photo Grid would like to post to Facebook for you.

Not Now OK

You will see the confirmation:

☞ **Tap** OK

Facebook sharing successfully

63199 Hashtags

OK

Now the collage is posted on *Facebook*.

☞ **If necessary, tap** ❮ Back

☞ **Tap** Home

 Tip

Share a slideshow through Instagram

The slideshow you have made at the beginning of this chapter with *PhotoGrid*, is suitable for sharing through *Instagram*. A video clip is shared in the same way as a photo:

Tap

Tap the thumbnail in the bottom left-hand corner

The video clip is saved in the Camera Roll. If you see the album with the practice photos:

Drag downwards across the thumbnails

Tap

Tap

Tap

The slideshow video clip will be played right away.

Tap NEXT

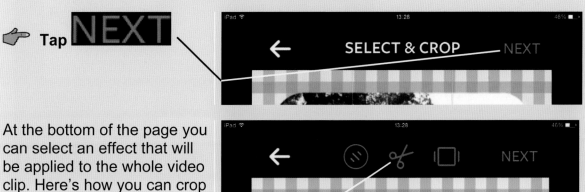

At the bottom of the page you can select an effect that will be applied to the whole video clip. Here's how you can crop a video clip:

Tap ✂

- Continue on the next page -

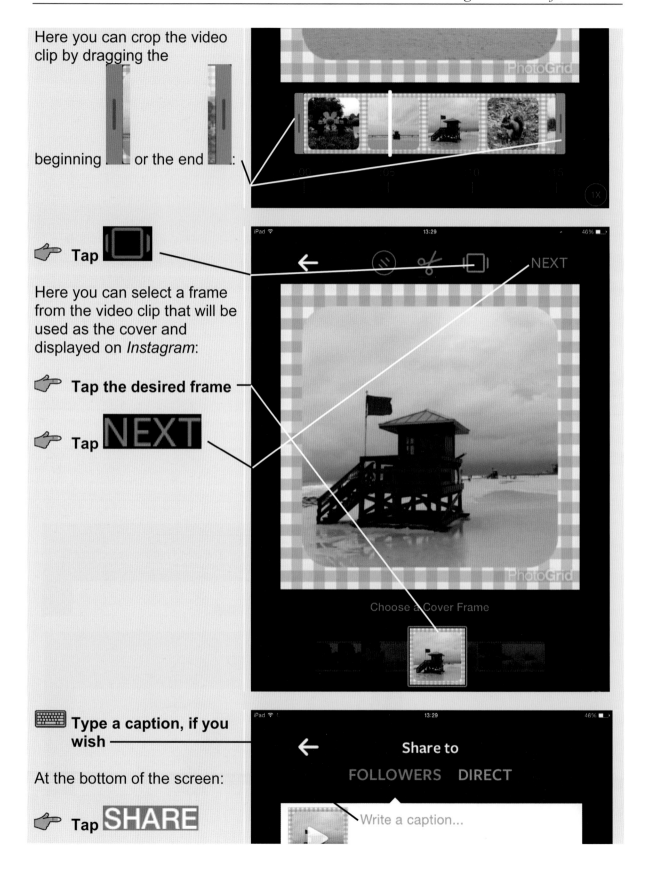

Here you can crop the video clip by dragging the

beginning or the end :

Tap

Here you can select a frame from the video clip that will be used as the cover and displayed on *Instagram*:

Tap the desired frame

Tap NEXT

Type a caption, if you wish

At the bottom of the screen:

Tap SHARE

💡 Tip

Add a photo to a Facebook album
This is how you add a photo to an existing *Facebook* album:

☞ Tap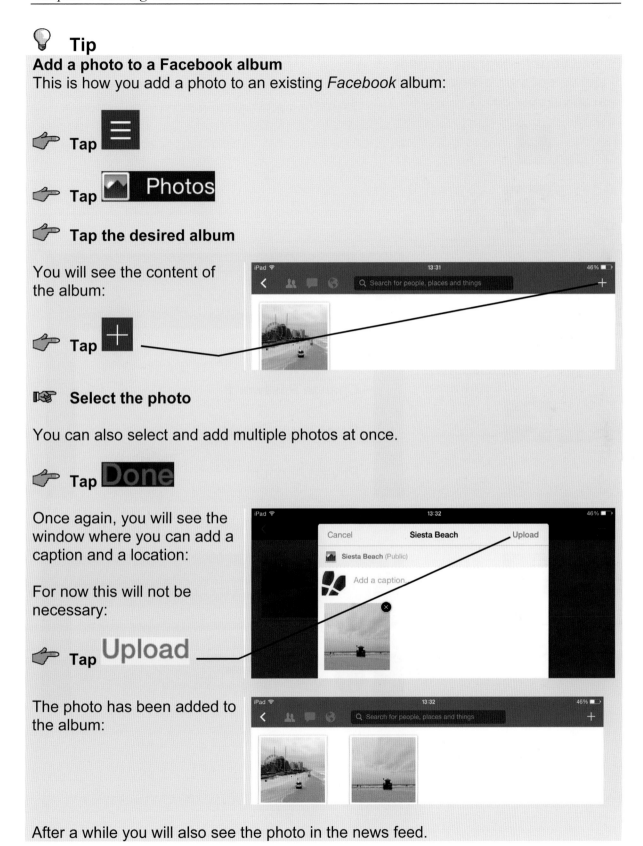

☞ Tap 🖼 Photos

☞ Tap the desired album

You will see the content of the album:

☞ Tap ✚

☞ Select the photo

You can also select and add multiple photos at once.

☞ Tap Done

Once again, you will see the window where you can add a caption and a location:

For now this will not be necessary:

☞ Tap Upload

The photo has been added to the album:

After a while you will also see the photo in the news feed.

 Tip

Shield your Instagram account

If you do not want everybody to find your photos on *Instagram* and follow you, you can shield your account. You do that like this:

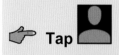 **Tap**

 Tap

 Drag the screen upwards

 By Private Account tap

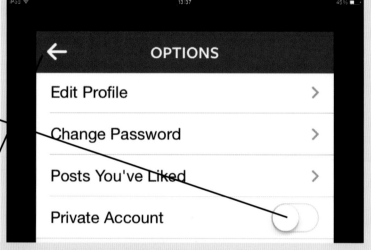

 Tap

You will see a request for following you on your profile page:

 Tap

Tap Follow Requests

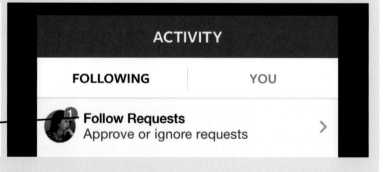

- Continue on the next page -

To approve the request:

👉 **Tap** ✔

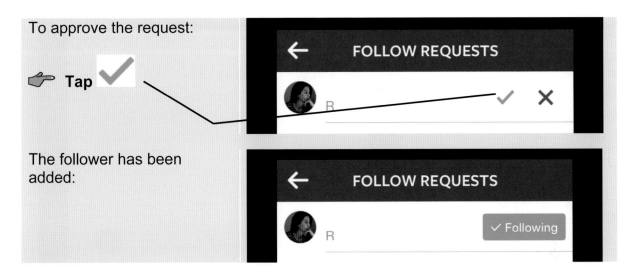

The follower has been added:

👉 **Tip**

Sharing directly

If you want to share a photo on *Instagram* with one or more select followers instead of everybody, you can do this:

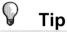

👉 **Tap** 🏠

👉 **Tap** ⬇

👉 **Tap** ➕

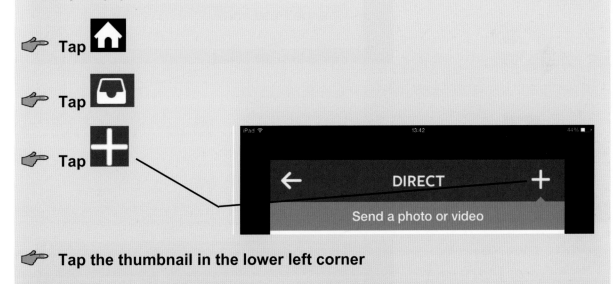

👉 **Tap the thumbnail in the lower left corner**

👉 **Select the desired photo**

👉 **Move the photo, if you wish, and tap** NEXT

👉 **Select a filter, if you wish, and tap** NEXT

- Continue on the next page -

⌨ Type a caption, if you wish

☞ Tap the desired followers

☞ Tap SEND TO

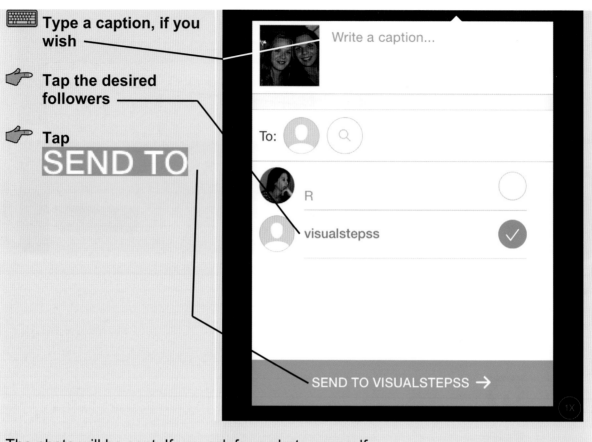

The photo will be sent. If you ask for a photo yourself:

☞ Tap 🏠

☞ Tap 📥

☞ Tap Photo >

The photo is opened. By tapping 🤍 you can indicate you like the photo. By **Add a comment...** you can comment on the photo.

 Tip

Open a photo book
As you compile a photo book, it is often saved automatically. You do not need to finish a photo book all in one session. You can open a photo book later on and continue working on it. In the *Shutterfly Photo Story* app, you do that like this:

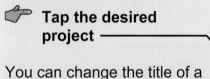 **Open the *Shutterfly Photo Story* app** 👣²

👉 **Tap the desired project**

You can change the title of a photo book, if you wish. You do this by tapping the current title. Next, you type a new name.

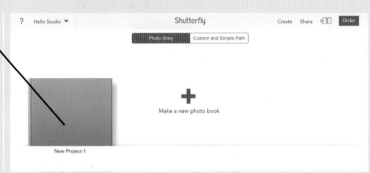

To make a new photo book, tap **Make a new photo book**.

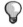 **Tip**

Share a photo book
The *Shutterfly Photo Story* app has an option for sharing your photo book with others. You can share the book through an email message or through *Facebook*. You do that like this:

👉 **Tap** Project ▼

👉 **Tap**
Share Book

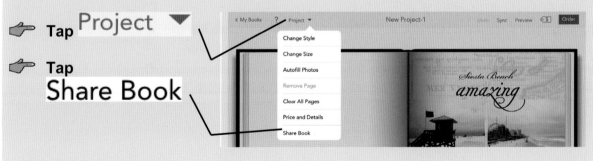

- Continue on the next page -

The *Share* window appears. The **Email** option is already selected. You can also share the photo book through *Facebook*:

You can add an email address and a message. When you are ready to send the message, tap **Send**.

If the message is successfully sent, you will see a notification.

💡 Tip

Add narration to the photo book

If you are going to share the photo book, for example through an app, it can be fun and a little more informative, if you add some narration to it. You can add an audio clip on every page. Here is how you do that:

☞ Tap **+**

☞ Tap **Add Audio**

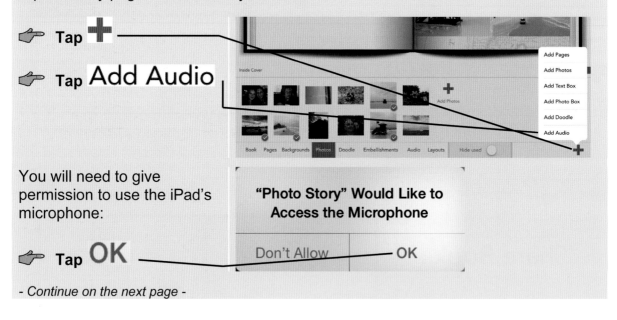

You will need to give permission to use the iPad's microphone:

"Photo Story" Would Like to Access the Microphone

Don't Allow | OK

☞ Tap **OK**

- Continue on the next page -

The mike appears at the bottom of the screen:

To record audio:

👉 **Tap** **Record**

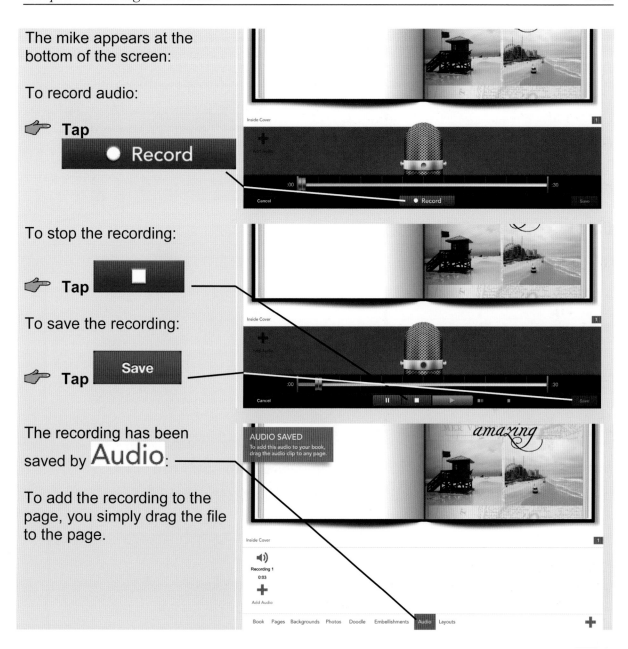

To stop the recording:

👉 **Tap**

To save the recording:

👉 **Tap** Save

The recording has been saved by Audio:

To add the recording to the page, you simply drag the file to the page.

💡 **Tip**

Adding and deleting pages

If you want to add more pages:

👉 **Tap** ➕

👉 **Tap** Add Pages

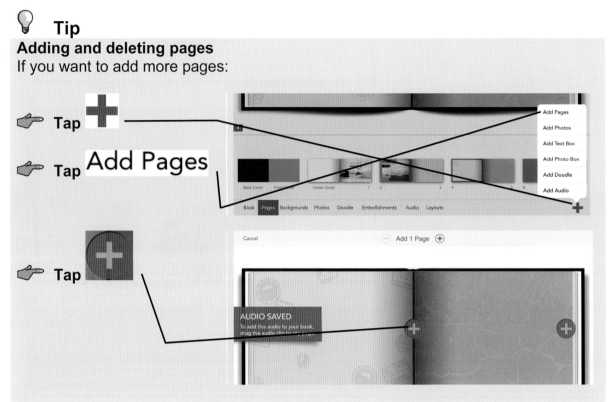

👉 **Tap** ➕

The new pages will be added.

If you have added too many pages, you can delete them easily like this:

👉 **Tap** Project ▼

👉 **Tap** Remove Page

👉 **Tap** ✕

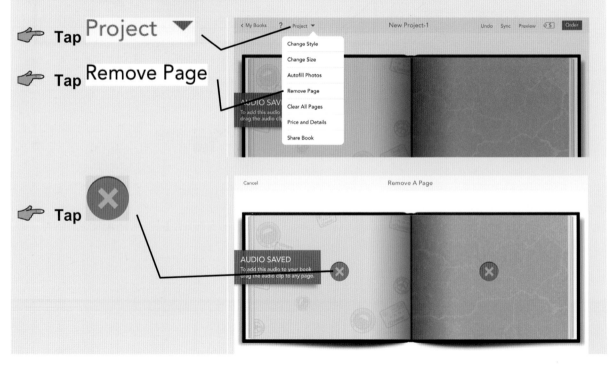

Appendix A. How Do I Do That Again?

The actions and exercises in this book are marked with footsteps:

If you have forgotten how to do something, you can read how to do it again by finding the corresponding number in the list below.

1 Downloading an app

- Tap **App Store**
- Tap the search box
- Type the name of the app
- Tap **Search**
- By the app, tap **+ GET**
- Tap **INSTALL**
- Type your password
- Tap **OK**

2 Open an app
- If necessary, drag across the screen from right to left
- Tap the app

3 Open a photo
- Tap the photo

4 Zoom in with *Aviary*
- Spread your thumb and index finger across the photo

5 Do not save an edited photo
- Tap **Cancel** (possibly multiple times)
- If necessary, tap **Leave editor**

6 Save an edited photo
- Tap **Save**
- If necessary, tap **Finish and Share**
- Tap **Done**

7 Close an app
- Press the Home button

8 Use automatic enhancement

- Tap **Enhance**

- Tap the desired type of enhancement, for example

- Tap

- Tap Left or Right

13 Straighten a photo

- If necessary, tap Orientation

- Drag a little to the left or right

- Tap Apply

9 Crop a photo

- Tap Crop

- Tap the desired ratio, for example Square

- Drag the desired handle to the desired spot

- Drag the frame to the desired spot

- Tap Apply

14 Zoom out with *Aviary*
- Move your thumb and index finger towards each other (pinch)

15 Sharpen a photo

- Tap Sharpness

- Drag the slider to the right

- Tap Apply

10 Undo last edit
- Drag across the screen from left to right

11 Redo last edit
- Drag across the screen from right to left

12 Rotate a photo to the left or right

- Tap Orientation

16 Remove redeye

- Tap Redeye

- Tap the desired brush size

- Tap the eye a few times, until the red color has gone

- Tap **Apply**

17 Use splash

- Tap **Splash**

- Tap **Smart Color**

- Place your finger on the color you want to retrieve and swipe across the screen without releasing the screen

- Tap **Apply**

18 Enhance brightness

- Tap **Lighting**

- Tap **Brightness**

- Drag the slider to the right

- Tap **Apply**

19 Open *iTunes* on the computer

In Windows 8.1, on the desktop:

- Double-click **iTunes**

In Windows 7 and Vista:

- Click

- Click ▶ **All Programs**

- Click **iTunes**

- Click **iTunes**

20 Safely disconnect the iPad from the computer

- By the name of your iPad, click ⏏

21 Close a window

- Click **✕**

22 Use Auto Levels

- Tap

- Tap

- Tap

- Drag across the photo from left to right until you see the desired level of correction, for example **Auto Levels: 50%**

 23 Apply an edit
- Tap

 24 Disable control
- Tap the photo

25 Zoom in with *Handy Photo*
- Tap the photo twice in rapid succession

Zoom in even further:
- Spread your thumb and index finger

 26 Sharpen a photo
- Drag upwards across the palette with the controls

- Tap

- Drag across the photo from left to right until you see the desired level of correction, for example **Sharpness: 25%**

27 Compare the difference with the original photo
- Briefly depress

28 Zoom out with *Handy Photo*
- Tap the photo twice in rapid succession

Zoom out even further:
- Move your thumb and index finger towards each other (pinch)

 29 Go back to original photo
- Tap

- Tap

- Tap

30 Close the photo and do not save the edits
- Tap

- Tap

- If necessary, tap

31 Rotate a photo to the right
- Tap

- Drag the main palette upwards

- Tap

- Tap

- Tap

32 Straighten a photo
- Tap

- If necessary, move your thumb and index finger towards each other in order to zoom out

- Below the frame, drag a little from right to left

33 Uncrop a photo

- Drag the handle on the bottom right downwards and to the right

34 Reset parameters

- Tap

35 Make an object disappear with Retouch

- Tap

- If necessary, drag the main palette downwards

- Tap

- Drag around the object and any shadows, if necessary

In order to select additional parts:

- Tap

- Swipe across the parts you want to add to the selection

To remove the parts you do not want to select:

- Tap

- Swipe across the parts you do not want to select

To remove the object:
- Tap the photo outside of the selected area

36 Save an edited photo

- Tap

- Tap

- Tap

37 Close a photo

- Tap

- Tap

38 Select the Move Me tool

- Tap

- If necessary, drag the main palette downwards

- Tap

39 Move an object to a new layer
- Drag around the object and any shadows, if necessary

In order to select additional parts:

- Tap
- Swipe across the parts you want to add to the selection

To remove the parts you do not want to select:

- Tap
- Swipe across the parts you do not want to select

To move the object to a new layer:

- Tap

40 Move a layer
- Drag the frame to the desired spot

41 Undo an operation
- Tap

42 Duplicate a layer
- Tap

43 Vertically mirror a layer
- Tap
- Tap
- Tap

44 Merge layers
- Tap

45 Add an effect
- Tap Effects
- Tap the desired effect

46 Adjust and apply an effect
- Tap the effect, for instance

Keylime

- Drag the slider to the left
- Tap
- Tap Apply

47 Add a frame
- Tap Frames
- Drag across the frames from right to left
- Tap the desired frame
- Tap Apply

48 Add a sticker

- Tap

- Tap the desired group

- Drag across the stickers from right to left

- Tap the desired sticker

49 Adjust a sticker

- Drag the sticker to the desired spot

- Move in order to adjust the size and position of the sticker

50 Delete a sticker

- Tap

51 Open a photo in *Handy Photo*

- If necessary, tap

Gallery

- If necessary, tap

12

Practice Photos

- Tap the desired photo

52 Add a filter

- Tap

- If necessary, drag the main palette upwards

- Tap

- Tap the desired filter

53 Adjust the control settings

- Tap

- Tap the control

To weaken the effect:
- Drag across the screen from right to left

To strengthen the effect:
- Drag across the screen from left to right

54 Select a linear gradient mask

- Tap

- Tap

55 Rotate mask

- Tap the dot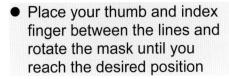

- Place your thumb and index finger between the lines and rotate the mask until you reach the desired position

⚇ 56 Reverse an effect

- Tap

⚇ 57 Open a photo in *Animal Face*

- Tap

- Tap Practice Photos
 12

- Tap the desired photo

⚇ 58 Move frame

- Drag the frame to the desired spot

- Tap

⚇ 59 Add an animal head

- Tap *Add*

- Tap the desired head

- Drag the head over the head of the figure

- Make the head larger or smaller by spreading or pinching your thumb and index finger

- Tap *Done*

⚇ 60 Save a photo

- Tap *Share*

- Tap **SAVE**

- Tap ✕

⚇ 61 Close photo and go back to the home screen

- Tap *Back*

- Tap ❮

⚇ 62 Start a collage

- Tap Grid

⚇ 63 Select photos

- If necessary, tap Albums

- Tap **Practice Photos**

- Tap the desired photos

- Tap Next

⚇ 64 Select a layout

- Tap Layout

- Tap the desired layout

- Tap Done

65 Make a box smaller
- Tap the photo
- Drag the green dot upwards

66 Zoom in
- If necessary, tap the photo
- Spread your thumb and index finger

67 Swap photos
- Tap the first photo
- Tap
- Tap the second photo
- If necessary, tap

68 Widen the borders between photos
- Tap
- Drag the slider by a bit to the right
- Drag the slider by a bit to the right

69 Apply a filter
- Tap

- Tap the desired group of filters
- Tap the desired filter
- Tap Done

70 Add a sticker
- Tap Sticker
- Tap the desired group of stickers
- Tap the desired sticker
- Tap Done

71 Move a sticker
- Drag the sticker to the desired spot

72 Make a sticker smaller
- Move your thumb and index finger towards each other, over the sticker

73 Delete a sticker
- Tap

74 Save a collage or slideshow and go back to the app's home screen
- Tap Save
- Tap Home

75 Select a photo
- Tap

- Tap Practice Photos
- Tap the desired photo

76 Turn a photo into a drawing

- Tap

- Tap [pencil icon]

- Select the desired design

- Tap [X icon]

77 Completely close app

- Press the [home button icon] button twice in succession

- Drag upwards over the app

78 Add a frame

- Tap [frame icon]

- Tap the desired frame

- Tap [X icon]

79 Save the drawing

- Tap

- Tap Save Image

80 Go back to the app's home screen

- Tap [camera icon]

81 Select a magazine

- Tap [book icon] **Covers**

- If necessary, drag across the samples from right to left

- Tap the desired magazine

82 Select a photo

- Tap Photo Album

- Tap **Practice Photos**

- Tap the desired photo

83 Place a photo in a frame
- Drag the photo

- Tap Done

84 Add text
- Delete the sample text with

 or [delete icon]

- Type the text

- Tap Done

85 Do not save the cover and go back to the main menu

- Tap [home icon]

- Tap

86 Open a web page

- Tap Safari
- Tap the address bar
- If necessary, tap
- Type the web address
- Tap Go

87 Start slideshow

- Tap Video Slides

88 Add music

- Tap Music
- Tap PhotoGrid Song

89 Select a transition

- Tap Transition
- Tap the desired transition

90 Change the order

- Tap Edit
- Drag the photo to the desired position
- Tap Done

91 Widen the outer border and make rounded corners

- Tap Border
- Drag the slider by to the right
- Drag the slider by to the right

92 Add background

- Tap Background
- Tap the desired group
- Tap the desired background
- Tap Done

93 Play slideshow

- Tap

Appendix B. Downloading the Practice Files

You can use practice photos to perform the tasks described in this book. This way you can keep your own photos untouched while you get acquainted with the various apps to edit photos and become more comfortable using them. You can download the photo files from the website accompanying this book:

☞ **Open the www.visualsteps.com/photoipad website in the *Safari* app on your iPad** 👣⁸⁶

☞ **Tap**
Practice photos

You will see the practice photos and you can download the first photo:

☞ **Tap the first photo**

The photo will be opened on a new tab. This may take a while as the photos are large.

☞ **Press your finger on the photo for a few seconds**

☞ **Release the screen**

☞ **Tap**
Save Image

The photo will be downloaded. Close the tab:

☞ **By the second tab, press ⊗**

Now you will see the tab with all the photos again. You can download all the other photos as well. You do this in the same way as you did with the first photo.

☞ **Download the other eleven photos**

☞ **Press the Home button**

On an iPad, the photos will be saved in the Camera Roll. You can place the photos in an album called Practice Photos, so you can find them more easily later on:

☞ **Open the *Photos* app** ℘℘2

At the bottom of the screen:

☞ **If necessary, tap**

Albums

☞ **Tap ╋**

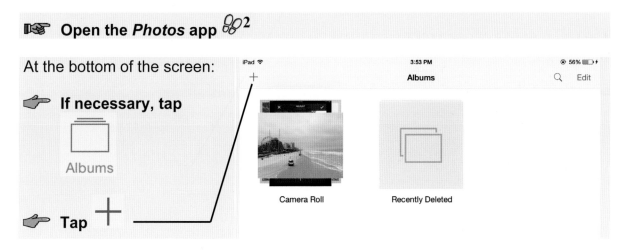

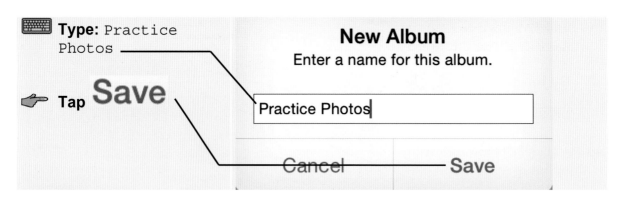

Type: Practice Photos ————

Tap **Save**

New Album

Enter a name for this album.

Practice Photos

Cancel · Save

At the bottom of the screen:

Tap Albums ———

Tap Camera Roll ———

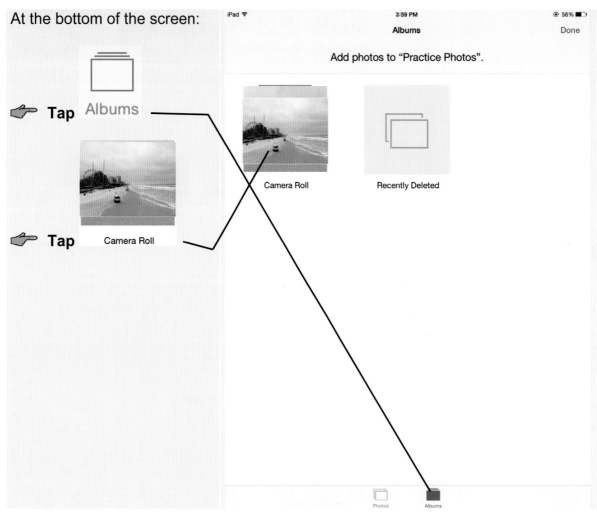

☞ **Tap the photos you have just downloaded**

You will see a checkmark by the photos:

☞ **Tap** Done

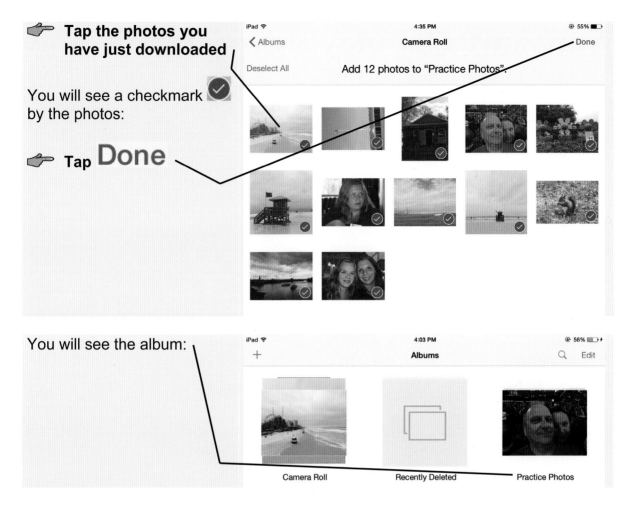

You will see the album:

Go back to the iPad's Home screen:

☞ **Press the Home button**

Now you can start with *Chapter 1 Photo Editing with Aviary*.

Appendix C. Index